Nobrow

John Seabrook's articles appear regularly in *The New Yorker*. He has also written for *Vanity Fair*, *Harper's*, and *The Nation*, and he is the author of *Deeper: My Two-Year Odyssey in Cyberspace*. He lives in New York City.

For Lisa

Nobrow

The Culture of Marketing
The Marketing of Culture

John Seabrook

Methuen

Published by Methuen 2001

1 3 5 7 9 10 8 6 4 2

First published in 2000 by Methuen Publishing Ltd
215 Vauxhall Bridge Road
London SW1V 1EJ

Copyright © by John Seabrook 2000, 2001

Parts of this book originally appeared in *The New Yorker*

John Seabrook has asserted his right under the Copyright, Designs
and Patents Act, 1988, to be identified as the author of this work.

Methuen Publishing Limited Reg. No. 3543167

A CIP catalogue record for this book is available from the British Library

ISBN 0 413 74480 9

Printed and bound in Great Britain by
Cox and Wyman Ltd, Reading

Acknowledgments

Thanks to everyone who allowed me to interview them, including Roger Greenawalt, Danny Goldberg, George Lucas, David Geffen, Judy McGrath, Tom Freston, Sara Levinson, and Ben Kweller. Thanks to my parents for putting up with me writing about them, yet again.

Massive shouts to my agent, Joy Harris, and to Marty Asher at Knopf, and of course to Bob Gottlieb, Tina Brown, and David Remnick. Deb Garrison did great work on my writing, and Lee Aitken, David Scott, Ann Goldstein, and David Kuhn also improved it. I got a lot of help from friends who read the manuscript. They are, in descending order of cruelty, Rob Buchanan; Peter Kreutzer, late-night pop philosopher; John Homans; and Eric Schlosser, who got me into all this in the first place.

Thanks also to: Bruce Diones, for keeping me tuned to Radio West 43rd St.; all the cats in the mailroom; Liesl Schillinger, Ted Katauskas, Aaron Retica, Alex Abramovich, Ben Soskis, and Dan Kaufman for fact checking; and for support and inspiration thanks to Bill Finnegan, the Foundry Theatre, Gil Friesen, Hilton Als, Harold Ambler, Lillian Ross, John McPhee, Nancy Franklin, Matt Stewart, Harry, and C. S. Ledbetter III.

1

A Place in the Buzz

SHHHsss sighed the subway doors as I stepped on the train at Franklin Street. Almost eleven a.m. and the car was half empty. I stuck my legs out into the passageway and started reading the *New York Post* according to my usual formula: one stop for gossip, two stops for media news, and four stops for sports, although on this day I was allowing myself five stops to bone up on the upcoming Knicks-Pacers game. I wore expensive black headphones for the Discman over a black nylon convict-style cap, a fashion I picked up from the homeys in the rap videos.

Biggie Smallz, *Ready to Die*, was on the Discman.

I get swift with the lyrical gift
hit you with the dick
make your kidneys shift
Here we go, here we go
But I'm not Domino
I got the funk flow
To make your drawers drop slow
So
Recognize
The dick size

Nobrow

In these Karl Kani jeans
I wear thirteens know what I mean

Over the top of the newspaper, I looked down the train at the other passengers. Mostly people coming in from Brooklyn, a few also wearing rap in their ears. The outward face of civic urban blankness, nodding along with the inward roil and extremity of the music. It was the same weird, disconnected feeling you got walking around the newly cleaned-up, barricaded, Giuliani-time streets of New York City. On the surface things couldn't be better—a time of great economic prosperity for the few, money everywhere, a paradise of consumables in the shops. But underneath that was the world of desperate people with their heads pinned down onto filthy carpets while the police cuffed them from behind, that other life that Americans like me only ever saw on TV shows like *Cops*. Rap, especially gangsta rap, connected the materialism and the racism: the unreal spectacle of wealth and happiness in Manhattan and the real social relations between the people in the street. At least in the '80s there were lots of homeless people around to remind you of the massive inequity in this society, but now most of them had been cleaned up, too.

Lowering my eyes to the *Post* again, I let the gangsta style play down into my whiteboy identity, thinking to myself, *Man, you are the illest, you are sitting here on this subway and none of these people are going to FUCK with you, and if they do FUCK with you, you are going to FUCK them up. What's MY muthafuckin' name?*

Coming up out of the subway into Times Square, I stuffed the Discman into the pocket of my leather coat, stabilizing the right side with my hand so that the swinging of the coat didn't

make the CD skip. I started walking uptown. No snow was on the ground, but the city pavement had the brittle chalky finish of frost it gets in January that makes heels sound especially hard on landing. The air was fuzzy with the weird yellow tornado light of Times Square by day, a blend of sunlight and wattage, the real and the mediated—the color of Buzz. Buzz is the collective stream of consciousness, William James's "buzzing confusion," objectified, a shapeless substance into which politics and gossip, art and pornography, virtue and money, the fame of heroes and the celebrity of murderers, all bleed. In Times Square you could see the Buzz that you felt going through your mind. I found it soothing just to stand there on my way to and from work and let the yellow light run into my synapses. In that moment the worlds outside and inside my skull became one.

As I was walking I noticed everyone coming toward me was looking up at the big Panasonic Astrovision TV screen, fixed high on the side of One Times Square, behind me. I looked around, and there on the screen was a live picture of President Clinton—hand raised, breath frosting, swearing solemnly to uphold the Constitution of the United States. It was Inauguration Day. Jesus, I'd sort of forgot today was the big day. Taking shelter from the cold wind behind a bank of pay phones at Broadway and Forty-third, I watched the swearing-in, reading the words of the oath on the closed captions at the bottom of the screen.

Directly under the president's huge image, the Dow Jones electronic zipper on One Times Square was bubbling along with more good news from the stock market. Above the president's head was a thirty-foot-high bottle of Budweiser, and, above that, a giant, steaming cup of noodles. A nice juxtaposition of signs: money at the bottom, the rich soil in which the culture grows; presidential politics in the middle,

where the job is not so much to lead as to entertain and divert; and at the apex—product. Clinton seemed to fit into this system seamlessly, and here in the new Times Square, in the boundaryless overbleed of images and brands, all thrusting into Las Vegan proximity with one another—Coke, Disney, MTV, Star Wars, Calvin Klein—our leader was doing very well at the moment. Virtually everyone had been distracted from whatever other distraction they had come to Times Square for, and was momentarily transfixed by the immense image of the newly reelected president on the big Astrovision screen.

Duly sworn, Clinton moved toward the lectern to give his acceptance speech. I stayed where I was, next to a black man wearing an Oakland Raiders jacket. I read the closed captions on the screen with the sexy and murderous funk of the Bee Eye Gee bouncing along in my ears, seeing in my mind's eye (overlaid on the image of our president) the stylized gang finger signals that the rappers flashed one another in the rap videos, while the president issued his morning wake-up call to personal responsibility.

Each and every one of us, in our own way, must assume personal responsibility, not only for ourselves and our families but for our neighbors and our nation. . . .

> *Fuck the past,*
> *Let's dwell*
> *On the 500 SL,*
> *The E and J and ginger ale*
> *The way my pockets swell*
> *To the rim*
> *With Benjamins*

Though I was trying to concentrate on the president's message, I could not stop myself from playing the mental cryptic I always played with rap. The 500 SL was a Mercedes, obviously, and Benjamins were Benjamin Franklins— $100 bills. "E and J" . . . hmm . . . oh, Ernest and Julio Gallo.

> But let us never forget: The greatest progress we have made and the greatest progress we have yet to make is in the human heart. In the end, all the world's wealth and a thousand armies are no match for the strength and decency of the human spirit.

Ronald Reagan's handlers had manipulated his image, but in hindsight Reagan seemed to me like an old-fashioned tastemaker. Moral authority, based on Reagan's personal convictions, was still an important quality in his leadership. The Clinton presidency was showing that it was possible to lead without moral authority, if you had good enough spin. Clinton relied on opinion polls to an extent that had never been seen before in any White House. His surveys of public opinion were not so much polls as market research. The same project going on in the White House was also going on in the offices of the media executives around Times Square, and in the culture at large. It was an attempt to match consumption to production: to figure out what the public wanted and then give it to them. Polls, focus groups, and other forms of market research had made it possible to replace the old gut-based value judgments, for which the individual himself was responsible, with judgments beholden only to "the numbers"—to assign a kind of Q Rating to cultural experience that had never been quantified or measured numerically before. Clinton was the perfect steward of this society.

I started walking up Seventh Avenue. Times Square was changing. As the peep shows disappeared from Times Square, the art movie houses disappeared from the Upper West Side, and for the same reason—the loss of the distinction between pornography and art. Gone were the Flame Steak places where the pimps and prostitutes used to hang out; gone too were the video arcades where I spent many hours playing Missile Command in 1983. Gone too Missile Command itself, where the object was to try to save the world; in the "first-person shooter" games like Doom and Quake the best you could hope for was to save yourself. In place of the arcades were the sneaker stores and the Gap and Starbucks and the Virgin Megastore, selling the kind of merchandise you could buy in every other commercial space in Brand USA, soon to be Brand World. The new Times Square had been widely hailed as an improvement over the funky old square (the *New York Times*, the leading organ of opinion on this matter, owned a big chunk of Times Square), but insofar as the new place meant the destruction of a unique local culture and the substitution of a generic market culture, this Times Square did not seem like an improvement to me. It was a fucking disaster.

Crossing Forty-fifth Street, I passed the All Star Cafe and went into the Virgin Megastore. The random experience of the street clicked and grooved pleasantly into the controlled environment of the megastore. My fellow consumers glided through the aural and visual cacophony, oblivious to the virtual event going on outside, hips cocked coolly, eyeing one another as they rode the escalator, slowly sinking or rising into the vast tepid bath of popular culture. Music videos were flashing on small monitors everywhere, as well as on two huge multi-TV screens overhead. All the light and action seemed to

have an irresistible effect on the old reptilian brain, still, after all these centuries of evolution, unable to ignore movement (still looking for flies? predators?), a phenomenon that Andy Warhol made into his principle of cinesthetics: "If it moves, they will watch it."

Right inside the door of the Virgin Megastore was a vast section of popular music labeled Rock/Soul, which ran the gamut from the Eagles to Al Green to Pere Ubu, with vast stretches of irony, allusiveness, camp, and boring stuff in between. This giant culture deposit was thick with association. Here were bands that were the pop cultural equivalent of the pencil marks parents put inside the closet door to show how much Junior has grown since last year. Jackson Browne, James Taylor, Neil Young, and the early '70s folk and country rockers, many of them on the Asylum label started by the young David Geffen, oozing that peaceful, easy feeling that was my first pop love, and that I listened to in my bedroom, a sullen and mopey twelve-year-old with the lights out. Punk rock rescued me from the Dan Fogelbergian miasma of folk rock: Iggy Pop, Patti Smith, the Sex Pistols, then the Talking Heads, who made punk mainstream. Although I did not understand it at the time, the shift from the California sound to British punk rock—from the "fake" mainstream California to the "real" British underground punk—was the decisive antithesis that would in one way or another determine all my subsequent pop musical experience. After Talking Heads came the bands like Duran Duran, the Cure, and the Cars, who marketed the "authentic" sound of punk into the "fake" New Wave and turned me off pop music in my early twenties. Then the big-hair bands of the '80s like Van Halen, Guns n' Roses, and the second coming of Aerosmith, which had kept me away from pop. And then Nirvana, the band that changed everything.

Before Nirvana my cultural experience had followed a

more-or-less stately progress up the taste hierarchy from com-
mercial culture to elite culture. But after I heard Nirvana, at
the age of thirty-one, the stream of culture as it flowed
through me slowed, stopped, and started moving in the other
direction. After Nirvana, I began to pursue pop music with an
energy I had never devoted to it as a teenager, when I was too
worried about how my adult life was going to turn out to pay
that much attention to pop. Pop became a way of hanging on
to my teenage self, which had become a kind of touchstone for
me as an adult. I got into hip-hop, and then the subgenres of
hip-hop, like gangsta, and then techno, and now I was into the
rich ground between techno and hip-hop—acid, trance, jun-
gle, big beat, ambient—which seemed to be where the future
of pop music lay.

As a kid I thought that becoming an adult would mean
putting away pop music and moving on to classical, or at least
intelligent jazz. The taste hierarchy was the ladder you
climbed toward a grown-up identity. The day you found your-
self putting on black tie and going to enjoy the opening night
of *Aïda* as a subscriber to the Metropolitan Opera was the day
you crossed an invisible threshold into adulthood. But for the
last five years, pop music had provided me with peaks of lyri-
cal and musical transcendence that I long ago stopped feeling
at the opera and the symphony, those moments when the mu-
sic, the meaning, and the moment all flowed together and
filled you with the "oceanic feeling" that Freud said character-
izes powerful aesthetic experience.

A month earlier I had had an oceanic experience at
a Chemical Brothers' show that my friend had taken me
to hear at the Roxy. The Chemical Brothers were two young
musician/programmers from the dance/Ecstasy subculture of
Manchester, England, who had begun by deejaying in the
clubs that flourished in the dark satanic mills left over from the

nineteenth-century industrial revolution, and that were now
dark satanic malls of late-twentieth-century street style.

We waited in a long line outside the Roxy for an hour, freez-
ing, while scalpers in big down parkas cruised by murmuring
"whosellingticketswhosellingticketswhosellingtickets." As usual
when we went gigging, we were just about the oldest people
there. Going out to hear hot new pop acts was one of the
greatest cultural pleasures of our grown-up lives. These in-
tense moments of ecstatic communion with youth stood out
from our otherwise predictable diet of respectable culture—
interesting plays, the Rothko show, the opera, and, sometimes,
downtown happenings at the Kitchen or the Knitting Factory.
Afterward, we would go home to our wives and kids and our
tasteful diet of highbrow and middlebrow and lowbrow cul-
ture, each in its proper place, but here in the uncategorizable
present of pop music, we felt alive in a way we never felt when
experiencing elite culture.

Finally we got inside and worked our way down into the
crush of kids on the dance floor. Most were trying to figure out
the optimum time to drop the drugs they had brought along,
so that they could peak when the music peaked. After a long
time somebody walked out onto the darkened stage and a buzz
rippled through the crowd. An evil-sounding pulse started to
beat, pumping a black squishy liquid out of a computer and
swirling it around the room. Then came a sampled sentence
from a Blake Baxter song, repeated four times: *dabrothers-
gonnaworkitout*. With each set of four beats a new computer-
modulated drum sound entered the mix, and on the last set a
distorted-sounding guitar made an appearance. Because the
music was made on synthesizers it had the geometric regular-
ity of code, and this made it possible to feel intuitively where
the lines of sound were headed and when they would con-
verge. It was like reading a sonnet: you anticipated the shape

of the form before the content arrived. Such a sonic conver-
gence was coming up. All the rhythmic variations and distor-
tions that had previously been at counterpoint with one
another were about to come together into what promised to
be an amazing blast of unified sound.

My friend turned to me and yelped, "It's about to get
REALLY loud . . . !"

Then—*THHHHRRRRUUUNKKK*—enlightenment struck
in the form of a solid cleaver chop of sound to the breastbone—
from their hooooooouuuussse to our house—that knocked us
backward like bowling pins. The flashing lights illuminated
the flailing hair of the blond Chemical Brother as he worked
his instrument board, catching him at the perfect moment—
streaking upward from his subculture of clubs and drugs and
computers, rushed into the mainstream by the music industry
and MTV, which was hoping to consolidate the different small
grids of techno and house music into a single big-grid cate-
gory, "Electronica," in order to supplement the sagging sales
of the "Alternative" marketing category that Nirvana's success
had spawned. Within a month, the Brothers would be all over
MTV. At one point in the frenzy of that night, I remember
looking behind me and seeing Judy McGrath, the president of
MTV, rocking out in the VIP area.

Then another flash—*POP!*—revealing a new kind of icon:
the information artist at his console, reeling with sounds,
styles, light and insight, the jittery agonized struggle of the
cerebral cortex trying to absorb the digital information pour-
ing into it. The heat in the club, the frenzy of the crowd, the
potency of the joint my friend and I were now passing, all pro-
duced an intense cultural experience, a Nobrow moment—
neither high nor low, and not in the middle, a moment that
existed outside the old taste hierarchy altogether. That mo-
ment was still fresh in my mind as I rode the megastore esca-

lator down to Level B1, gently sinking into the bath of Buzz, heading for the Imports section, where I hoped to find a compilation CD of the legendary Chemical Brothers shows at the Heavenly Social in London.

The megastore's Classical Music section was also down here, to the right of the escalator. Encased inside thick glass walls to keep out the raucous sounds of the World Music section, just outside, where salsa, Afro-Gallic drumming, reggae, and Portuguese fado mingled in a One World jambalaya, the Classical Music section was an underground bunker of the old elite culture, its last refuge here in Times Square. There were a few discreet videos, usually showing James Levine conducting or Vladimir Horowitz at the piano. Inside these thick glass walls of silence you could feel the sterility of the academy to which the modernists had condemned classical music, by coming to believe that popularity and commercial success meant compromise. All the most original innovations of the modernists, the electronics and the atonal variations and the abrupt yaws in pitch had long ago been spirited away from this room and found popular expression in the Jazz and Techno sections in other parts of the store. Meanwhile, by continuing to put out, year after year, recordings of the world's great orchestras performing the standards—in spite of the fact that the difference in performances was only interesting or even discernible to a very few people—the classical music industry had all but destroyed itself, imprisoning what might be a vibrant genre in the forbidding confines of a room like this. The classical music room in the megastore was almost always empty: a good place, I'd discovered, to ring up purchases of pop music when there was a line upstairs.

I didn't find what I was looking for in Imports, but I did find some other CDs I wanted—one by the "junglist" L. T. J. Bukem, as well as a compilation of rock/techno hybrid tracks

called *Big Beat Manifesto*. (That was the trade-off in the mega-store experience, refinement for breadth and unexpected synchronicity.) Also, back upstairs, I found a CD by an Essex-based group, Underworld, *Dubnobasswithmyheadman*, which I'd heard was good. Twenty minutes later I was back in Times Square with $59.49 worth of music in a red plastic Virgin bag. At Forty-fifth I stopped, unwrapped the Underworld CD, cracked open the jewel box, extracted the precious polyurethane wafer, and popped it into my Discman.

Clinton had finished addressing the citizenry, and the people in Times Square were turning their attention to other distractions. I stood there for a moment longer in the yellow tornado light while the techno music in my ears reorganized my consciousness into cleaner lines than the gangsta vibe, the vocals—"Mmmmskyscraper I love you"—implanting in the folds of my cortex the way poetry used to before I got a Discman and made pop music the soundtrack to the movie of me walking around in the city.

I headed east on Forty-fourth Street, past the delicate neoclassical scrollwork on either side of the Belasco Theater, and then into the fluted columns of the old elite culture of New York City. East of Sixth Avenue, I cut through the Royalton Hotel. The restaurant in the lobby of the Royalton, "44," was a kind of Condé Nast commissary. Almost every day at the four banquettes, done in lime-green velvet, you could see the most important of the Condé Nast editors, the arbiters of my world: Anna Wintour of *Vogue*, Graydon Carter of *Vanity Fair*, and Tina Brown of *The New Yorker*, with, perhaps, Art Cooper of *GQ* at the fourth table, or maybe some up-and-comer who had finagled a marquee spot for the day. The place was often compared to the old Algonquin across Forty-fourth Street,

but whereas the latter was associated with wit, "44" was all about status. The air felt thick with appraising glances.

It was too early for the magazine editors I worked for to be lunching in their respective booths, but there were some other media types lounging around, studiously turned out in the suit-with-expensive-black-T, High-Low style that Si Newhouse, owner of Condé Nast, favored.

On Forty-third Street I made a left and walked a half a block east to 20 West, where *The New Yorker,* my employer, was located. Three young women in black, who had been in the atrium of the building having a smoke, scooted into the revolving doors in front of me.

The New Yorker occupied three floors, from sixteen to eighteen. The editors and writers worked on sixteen and seventeen, and the people who sold the ads and ran the business were above them. Though the businesspeople were sometimes seen on the editorial floors—and in greater numbers, since Tina Brown took over—still for the most part the traditional church and state separation of advertising and editorial was observed at the magazine. This rigorous separation of the writers from the ad sales force had been reflected in the look of the old *New Yorker,* where blocks of text signified the editorial, and photographs and other attention-grabbing flourishes signified ads.

The only time I ever went up to the business floor was to attend functions in the elegant *New Yorker* conference room, which our editor persuaded Si Newhouse to build for her and where a variety of synergistic events took place that helped to promote the brand, including *The New Yorker's* regular "Roundtables," which were fabulous juggling acts by Tina— *New Yorker* writers interviewing famous subjects for an audience of advertisers, with a celebrity like Elton John or Lauren Hutton in attendance. The most infamous of these Round-

tables was the recent breakfast starring Dick Morris, the former presidential adviser, who the week before the breakfast had resigned as Clinton's main strategist because of Morris's relationship with a prostitute. The conference room's walls were decorated with famous faces and cartoons from the magazine. A portrait of a sodden-faced, seen-it-all Dorothy Parker, an authentic member of the old Round Table, looked despairingly across the room at a picture of a frolicsome Donald Trump, a Tina-era profile subject.

The shiny interiors of the elevator doors slid together, a machine went *whirrrrrp*, and I felt upward pressure on the soles of my feet. I prepared for reentry into the editorial offices. In that thirty-second ride (without stops) up to the sixteenth floor, it was necessary to decompress, leave behind the culture of the street and enter a world where "culture" still meant civility and the process of cultivating. I stripped off the headphones, removed my black cap and my sunglasses, and smoothed my long hair in the polished metal interior of the elevator doors.

As a young reader I got an idea of what culture was like from the pages of *The New Yorker*, which sat on my parents' coffee table in southern New Jersey along with middlebrow magazines like *Holiday*, *Life*, and *Look*. Culture as it was presented by *The New Yorker* was elite, but it was also decent and even quaint. Culture was something to aspire to, but it was democratic, too: anyone could have it, even if they didn't have a coffee table to display it on. *The New Yorker's* famous editorial "we" suggested that there was a center to the culture, a perspective from which one could see all the useful things, and what one couldn't see was not so important. We cared passionately about the so-called legitimate, elite, canonical, or

high culture, those pursuits that made up the traditional arts of the aristocracy: painting, music, theater, ballet, and literature. We were quite interested in jazz, and we had learned to appreciate movies from Pauline Kael, and even to take TV semi-seriously, thanks to Michael Arlen, but we were not much concerned with rock and roll, street style, or youth culture, per se. Preserving the authority of that "we"—the implicit claim that the kinds of hierarchical distinctions and judgments practiced by *The New Yorker* were universal, and not narrowly elitist—forced the magazine, over time, to keep an ever-greater share of the commercial culture out of its pages. We might not like rap, but as rap entered the mainstream, we weren't able to comment knowledgeably on it, and we ended up seeming kind of out of it.

In the old *New Yorker* a sentence was a sentence, and each took no more than a polite, passing interest in its neighbors. Facts were presented one after another, with an almost self-conscious lack of ornament. Fancy leads, precious writing, sociological jargon, academic theory, anything that was obviously intended to attract attention or to start an argument— all were scrupulously scrubbed from *The New Yorker*'s photograph-free text. Most important of all, in no way did the sentences attempt anything that might be called hype. *The New Yorker* subscriber could count on coming home and opening the magazine with at least a slice of the same feeling of privilege with which an aristocrat sauntered into his gentleman's club, knowing he was leaving the crass world of getting and spending at the door.

For more than a century, this was how status had worked in America. You made some money in one commercial enterprise or another, and then to solidify your social position and to distinguish yourself from others, you cultivated a distaste for the cheap amusements and common spectacles that made up the

mass culture. The old *New Yorker* had been almost perfectly in sync with this system, and that was what made the magazine so appealing to advertisers. Just as the Cadillac offered the quietest of rides to drivers, just as the Patek Phillipe watch was the ultimate in understated luxury, so *The New Yorker* provided a tasteful, discreet, and quietly snobbish take on the affairs of the world, blissfully free from the bawling, hollering carnival outside its covers.

There was a certain amount of hypocrisy involved in this attitude—*The New Yorker* was, after all, a commercial cultural enterprise itself. But there was much to admire in the magazine's standards. Resisting the dumbing down of cultural life through advertising, Babbittry, and tacky talk show hosts, keeping the writing that the magazine provided to its readers blessedly free from that thing now called the Buzz was a primary source of the old *New Yorker*'s moral authority, as it had been part of the larger moral authority of the classic arbiters elegantiae, those tastemakers of old, who practiced criticism in Matthew Arnold's definition: "a disinterested endeavor to learn and propagate the best that is known and thought in the world."

At the magazine that authority was derived from the personal convictions of William Shawn, the editor of *The New Yorker* from 1951 to 1987. Shawn's editorial philosophy was later expressed in the April 22, 1985, Comment he wrote shortly after Si Newhouse bought *The New Yorker* for $168 million from Peter Fleischmann, whose father, Raoul, had started the magazine with Harold Ross in 1925. "We have never published anything in order to sell magazines," Shawn wrote, "to cause a sensation, to be controversial, to be popular or fashionable, to be 'successful.'" Shawn's words seem incredible now. How could one possibly run a magazine that way? And a very "successful" magazine at that?

In 1987, after five years of writing reviews and journalism for other magazines, I sent a couple of pieces to Robert Gottlieb, the successor to Shawn at *The New Yorker*. About a week later, Gottlieb called me and asked me to come see him at his office.

The memory of this meeting, which took place in the old *New Yorker* building at 25 West Forty-third Street, remains in my mind like a postcard from a time that now seems as vanished as the world of medieval courtly love. The offices in the old building were filled with ratty couches, scarred desks, mounds of moldering manuscripts, dust, and grime: a style that personified William Shawn's attitude toward glitz and glamour. Some first-time visitors to *The New Yorker*, expecting to find interiors that lived up to their exalted idea of the place—some sort of actual town house to match the town-house view of culture in the magazine—were puzzled and crestfallen to find the offices so dowdy. But to me, this was the too-cultured-to-care attitude that I aspired to myself.

Gottlieb called me into his office, and we began chatting. It soon became clear that on the basis of two clippings and a one-page letter I had sent him proposing to write a story on a modern gold-mining bonanza taking place in a small Nevada town, he was going to offer to fund me to go out West for as long as I thought necessary and take a crack at writing the piece I wanted to write, for which he would pay me regardless of whether the magazine published it.

"About how long a piece?" I managed to ask.

"Any length you'd like," Gottlieb said. "Whatever you think the piece needs to be successful juuuuurnalism." Gottlieb's way of pronouncing the word *journalism*—"juuuu-urnalism"—had a note of *nostalgie de la boue* in it, as though one were doing something deliciously lowbrow in even discussing

journalism. That attitude would later find its way into one of Gottlieb's greatest triumphs as editor, the publication of Janet Malcolm's long piece about Joe McGinniss and Jeffrey Mac-Donald, "The Journalist and the Murderer."

Formerly the editor in chief of Alfred A. Knopf, and before that a wunderkind at Simon & Schuster, Gottlieb had been chosen by Newhouse to replace Shawn—less than two years after Newhouse pledged he would keep Shawn as editor for as long as Shawn wanted to remain. Gottlieb, whose own cultural preferences ran higher than Shawn's—he was a famously de-voted patron of the ballet—had taken on the almost impossi-ble job of caretending Shawn's distinctions about what sort of culture was appropriate for *New Yorker* readers, while at the same time trying to make the magazine more commercial for Newhouse. Gottlieb, insofar as he tried to compromise, did so with camp. Camp was a way of being hierarchically nonhier-archical—of bringing highbrow connoisseurship to lowbrow pleasures, and thereby preserving the old High-Low structure of culture as status, though it was necessary to wittily invert it. Since taking over Gottlieb had published highbrow pieces about lowbrow subjects like Hollywood divas, Miami Beach, and a convention of the Wee Scots, who collect Scottie-dog memorabilia.

I suggested that forty thousand words might be necessary to convey the complete gold-mining story in all its complexity and to flesh out the many charmingly eccentric characters I was sure to meet in the pursuit of my idea of an old *New Yorker* piece.

"Great, that would be a two-part article," Bob responded cheerfully.

I asked about the deadline. At the other places I had been writing, deadlines were much on editors' minds.

"Oh, we don't have deadlines around here," Gottlieb said, frowning slightly, as if a faux pas had been committed, al-

though his camp manner made it hard to tell if he was being serious.

"Work on it until you feel it's finished," he went on, "then we'll take a look."

Risking an even greater faux pas, I asked, "And how much will I get paid?"

"A lot," he replied. He didn't say how much. Just "a lot."

If I needed money, I was to call the managing editor, Sheila McGrath.

"Now, it's spelled McGrath but it's said 'mac-graw.'" Vague on all the usually important matters, Gottlieb was very precise on this point, which, although I didn't know it then, involved an elaborate in-house distinction between the people who said "mick-graath" and the people who said "mac-graw."

And that was all. I went away, struggled, despaired, missed my self-imposed deadline, and finally wrote Gottlieb a letter explaining myself and asking for more time and money, which was swiftly answered with a phone call from Bob who told me to call Sheila McGrath. ("Now remember, it's spelled McGrath but pronounced . . .") Eventually I produced a twenty-thousand-word piece, and in less than a week Gottlieb called to accept it. The piece had no peg, of course—pegs were part of the vulgar world of juuuuurnalism—but it was an out-doors piece and felt springlike to Bob. In good time it was set up in type, meticulously fact-checked, beautifully edited by Bob and Nancy Franklin, and published in April at something like eighteen thousand words. It all happened just the way it was supposed to happen at *The New Yorker.* And that was the last time it ever happened that way for me.

In fact, I arrived at the magazine just in time to see the remains of the old *New Yorker* literally packed into boxes and carried

past my office door and out into the street. The problem was that *The New Yorker* did not make money. In the '50s and '60s and into the early '70s, *The New Yorker* had made lots of money, its holiday issues stuffed fat as turkeys with ad pages. The commercial decline began in the late '70s. By 1987, when Gottlieb took over, the magazine was losing $12 million a year. The reason why *The New Yorker* no longer made money was the subject of much debate, inside and outside the editorial offices. The editors and writers tended to blame it on the ad sales people, who worked on a different floor, for not being smart enough to translate what we meant by quality into what the advertisers meant. But the real problem was that the culture of the writers and the culture of the ad people were too disconnected from each other to have much in common. This was another consequence of the decline of the more orthodox idea of culture that the old *New Yorker* had represented. No one could translate the old *New Yorker* values of amateurism, whimsy, good taste, and tradition into the values of sizzle, edginess, "home runs," and "hot books." Anyway, the twenty-two-year-old media buyers who bought ads for big advertisers by and large didn't read *The New Yorker*. For them, *Vanity Fair* was *The New Yorker*.

Some of the older writers, Shawn loyalists, felt that the magazine began losing money because it started trying to make money—that *The New Yorker*'s financial woes were the fault of its owner, Newhouse, the publisher of such highly successful magazines as *Vogue*, *GQ*, and *Vanity Fair*. Certainly Newhouse had brought a much more aggressive style of doing business to the magazine. He had paid $168 million for *The New Yorker* in 1985 (the first year the magazine began to lose money), and he no doubt wished a return on his investment. Some thought that *The New Yorker*'s financial problems began

because Newhouse had overpaid for it. Theories about why Newhouse had wanted the magazine so badly also abounded, including the Euripidean notion that Newhouse Jr. had been avenging insults that the famous *New Yorker* writer A. J. Liebling heaped on Newhouse's father in his Wayward Press column, calling Newhouse Sr. among other things, "a ragpicker of second-class newspapers" and a man with "no political ideas, just economic convictions." (Ved Mehta, one of Shawn's writers, reported in his book *Remembering Mr. Shawn's New Yorker* that Newhouse Sr. once called up Raoul Fleischmann, *The New Yorker*'s founder, and asked what it would cost to buy the magazine, and that "Fleischmann spat out some obscenities and hung up on him.") Or maybe, more generously, Newhouse Jr. had simply placed a naively high commercial value on the cultural value of *The New Yorker*, one that the magazine could never hope to earn up to.

At any rate, Newhouse's strategy for growing the brand, implemented by Steve Florio, the former publisher of *GQ* and now the president of Newhouse's magazine company, was to raise the magazine's circulation base from 500,000 to 850,000 through expensive mailings, cheap subscription rates, and energetic publicity. Once the circulation went up, the magazine raised the rates it charged advertisers. This strategy had made *GQ* a success, but it had not yet proved successful for *The New Yorker*. The smaller advertisers, no longer able to afford the rates that Florio's big-circulation magazine now commanded, began dropping out, while the big advertisers had not yet grasped how this necessarily less elite *New Yorker* could help sell their Cadillacs and Patek Phillipe watches any better than *GQ* or *Fortune* or *Vanity Fair*.

The old *New Yorker* had also traded on its New York–based cachet. The same reason people like my parents traveled to

New York to shop at Saks or Bloomingdale's made them "take" *The New Yorker:* it offered the kind of merchandise you couldn't get anywhere else. But in the '80s and '90s, many of those formerly exclusive New York brands became nationwide—now one could go to a Saks in the local mall—and as that happened, *The New Yorker's* regional appeal to those old advertisers diminished. The obvious solution was to make *The New Yorker* a nationwide brand too—a magazine of "quality" that advertisers who wanted to project an image of quality should want to invest in. But that hadn't happened, yet. It appeared that what the writers and editors meant by quality and what Bloomingdale's meant by quality were not the same thing.

The magazine's problems went beyond the business strategy and increased competition from other media, and beyond the problematic younger readers, who didn't read long articles about foreign affairs, bees, or geology anymore, or if they did they were part of the "churn," while the old loyalists were alienated by the magazine's effort to reach the twenty-five-year-old smart people whom the advertisers wanted to reach. The very culture had changed. Few cared about the best that had been thought and known anymore, or at least few trusted an old elite institution like *The New Yorker* to make a fair selection of the best. Instead of being celebrated by the smart people for attempting such a selection, *The New Yorker* was more likely to be accused of "hegemony." Hegemony, a familiar word in the seminar room today, is the idea that power becomes embedded in cultural distinctions as common sense. Taste is the ideology of the tastemaker, masquerading as disinterested judgment.

Readers would say, "It's a great magazine, but I don't get it anymore, because it made me feel too guilty to see it sitting

there and not read it." Thus, in striving to fulfill its old mission, that ancient and privileged task of the arbiter elegantiarum—to offer its readers a selection of the best and to filter out the time-wasting stuff—*The New Yorker*, instead of making readers feel grateful or enlightened, made them feel guilty, because they didn't have the time or the necessary seriousness to read the magazine.

That serene, knowable middle ground staked out by the magazines on my parents' coffee table—the culture that *The New Yorker*'s editorial "we" silently kept watch over by night so that its subscribers could sleep soundly—had disappeared, and in its place was a landscape of niches and categories. Because *The New Yorker* was not a men's magazine, nor a shelter magazine, nor a health magazine, nor a literary magazine, nor a news magazine, nor a sports magazine—it was all those things—it had a hard time fitting into this fragmented marketplace. *The New Yorker* was one of the last of the great middlebrow magazines, but the middle had been obscured by the Buzz, and with it had gone whatever status being in the middle would get you.

By 1992, Newhouse replaced Gottlieb with Tina Brown, the well-known editor who had made a success of *Vanity Fair*. Gottlieb departed in a final burst of camp, telling the *Times* in regard to his severance package, "I'm the happiest girl in the whole U.S.A."

Tina Brown's arrival at *The New Yorker* was part of a larger change in American society, the end of a particular kind of cultural life and the beginning of another kind. The old aristocracy of high culture was dying, and a new, more democratic but also more commercial elite was being born—a meritoc-

racy of taste. The old cultural arbiters, whose job was to decide what was "good" in the sense of "valuable," were being replaced by a new type of arbiter, whose skill was to define "good" in terms of "popular." This vast change in our civilization made itself felt in virtually every museum, library, university, publishing house, magazine, newspaper, and TV station in the country. *The New Yorker* was where I witnessed the transformation, and although the changes there may have been more dramatic than at some other places, *The New Yorker* was only a part of the larger tectonic shift in the uses of culture-as-status in America, from the old town-house world of High-Low to the new megastore of Nobrow.

For more than a century, the elite in the United States had distinguished themselves from consumers of commercial culture, or mass culture. Highbrow/lowbrow was the language by which culture was translated into status—the pivot on which distinctions of taste became distinctions of caste. The words *highbrow* and *lowbrow* are American inventions, devised for a specifically American purpose: to render culture into class. H. L. Mencken discussed the brow system in *The American Language*, and the critic and scholar Van Wyck Brooks was among the first to apply the terms to cultural attitudes and practices. "Human nature itself in America exists on two irreconcilable planes," he wrote in *America's Coming-of-Age*, "the plane of stark intellectuality and the plane of stark business," planes that Brooks referred to as *highbrow* and *lowbrow* respectively.

In those words, there's more than a whiff of their rank etymological origin in the pseudoscience of phrenology. But the words' roots also underscore the earnestness with which Americans believed in these distinctions: they were not merely cultural, they were almost biological. In the United States,

making hierarchical distinctions about culture was the only acceptable way for people to talk openly about class. In less egalitarian countries, like Brown's homeland, a class-based social hierarchy existed before a cultural hierarchy evolved, and therefore people could afford to mix commercial and elite culture. Think of Dickens and Thackeray, who were both artistic and commercial successes, or, more recently, Monty Python, or Tom Stoppard, or Laurence Olivier. But in the United States, people needed highbrow-lowbrow distinctions to do the work that social hierarchy did in other countries. Any fat cat could buy a mansion, but not everyone could cultivate a passionate interest in Arnold Schönberg or John Cage.

The difference between elite culture and commercial culture was supposed to be a quality distinction. One could confidently say that Mozart's *Requiem* was better than Nirvana's "Lithium" simply on the level of artistic quality. But these aesthetic distinctions easily lent themselves to High-Low distinctions in social status too (i.e., people who liked Mozart were highbrows; people who liked Nirvana were lowbrows). As long as commercial culture was assumed to be inferior to elite culture—TV was a dumbed-down form of theater; Elvis-on-velvet paintings a bastardized form of art; mass-produced furniture of lower quality than handmade furniture; off-the-rack clothes less stylish than handmade suits, and so forth—so the people who patronized commercial culture ("the masses," or, more recently, Joe Six-Pack, that reliable lower-middle-class redneck against whom everyone, both rich and virtuous poor, can distinguish themselves) could be conveniently placed lower on the social hierarchy than the people who patronized elite culture. This system had the added benefit of giving rich people a practical reason to support the arts. The status advantages that accrued from one's patronage of elite culture

were like the tax benefits one got for giving money to chari-
ties: they might not be your reason for doing it, but they were
a powerful incentive.

Brown represented the coming of Nobrow to the magazine.
The old distinction between the elite culture of the aristocrats
and the commercial culture of the masses was torn down, and in
its place was erected a hierarchy of hotness. Nobrow is not cul-
ture without hierarchy, of course, but in Nobrow commercial
culture is a potential source of status, rather than the thing the
elite define themselves against.

Some of the older writers predictably dismissed Brown as a
lowbrow. But somehow Tina always managed to escape what-
ever shelf her antagonists tried to capture her on. While
Brown's tastes may have been low by Shawn's standards, and
were certainly low by Gottlieb's, she brought energy, zest, wit,
and argument to the magazine; she banished both camp and
cant from its pages (and printed *cunt* in them for the first time);
and she was egalitarian in a way that an American editor could
not afford to be. In all the ways that a market-oriented system
is more democratic than a standards-oriented system, so was
Brown, although she had her own elitism, the hierarchy of
hotness. And, being British, Brown could be in the middle of
the culture without appearing to be a middlebrow. The fatal
earnestness of the American middlebrows—that quality Vir-
ginia Woolf had memorably called "a mixture of geniality and
sentiment stuck together with a sticky slime of calf's-foot
jelly"—was not a part of Tina's complexion.

Under Brown, *The New Yorker* changed drastically. Articles
became much shorter, their deadlines were firm, and their
publication was pegged to Buzz-making happenings. Doing
stories that were topical, trying to get the public's attention,

trying to be controversial, trying to sell magazines—all of which Shawn had gone out of his way to avoid—became the norm. The virtue that Shawn had made of resisting the lowest forms of commercial culture was replaced by the virtue of making intelligent compromises with it—of figuring out how to do commercial subjects "in a *New Yorker* way." At the old *New Yorker,* quirky was good because it defied categorization. At the new *New Yorker,* quirky was bad for the same reason. Quirky was something that didn't fit a marketing category. In marketing terms, a quirky subject was a "tweener." It was fatally quirky.

Brown made *The New Yorker* part of the media elite of the '90s. All sorts of pop-culture subjects—rock stars, MTV, Howard Stern, *Star Wars*—that were off limits at the old *New Yorker* were now fair game. Pieces on the old cultural arbiters—the museum directors, opera house managers, and art collectors—were mixed with pieces on the new cultural arbiters: Dominique de Menil side by side with Courtney Love. At the same time, Brown broke decisively from the old *New Yorker* tradition of genteel commentary on out-of-the-way places and things, and she dragged the magazine, sometimes kicking and screaming, but other times rushing headlong forward, out of its town house and into the yellow tornado light of fashion, money, power, sex, and celebrity.

Shawn's auteur system, under which the writers appeared to have complete freedom, subject only to Shawn's own taste (which could be a lot more restrictive than it seemed), was replaced by Brown's version of the old Hollywood studio system, under which the writers worked in collaboration with the editors, who functioned more like producers—middlemen between the creative and the commercial processes. The writers were free from any one individual's taste, or rather, were subject to Brown's taste, but that was never fixed; it fluctuated in

response to market forces. Both the auteur and the studio systems had their relative freedoms and restraints. The new emphasis on stories that were "hot" was certainly annoying, but then again the market-oriented strictures of the new *New Yorker* were not without literary benefit either. For some writers, the space constraints and the need to be specific and clear about what you were looking for, instead of ranging around in a subject until something struck your fancy, could be a useful discipline in which to harness their thoughts. The situation at the new *New Yorker* was not unlike that in the old movie industry as described by Thomas Schatz, the author of *The Genius of the System*, a book that argues that movies made in the '30s and '40s, when the artists were controlled by the suits, were just as good as the movies made in the later auteur period, when the artists had creative independence. "The quality and artistry of all these films were the product not simply of individual human expression," Schatz wrote, "but of a melding of institutional forces. In each case the 'style' of a writer, director, star—or even a cinematographer, art director, or costume designer—fused with the studio's production operations and management structure, its resources and talent pool, its narrative traditions and market strategy."

Besides, if Tina could add sizzle to the steak, or whatever the right marketing term was—that is, bring the good writing in the magazine to the attention of more people by promoting it harder—well, then, fine. So one had to do a little promoting. So that was the real world. The old *New Yorker* didn't have to compete with all the other magazines and TV channels that the modern *New Yorker* had to compete with. And why shouldn't culture and marketing collaborate more? As Brown said in the *New York Observer*, it wasn't enough to give the readers culture, you had to *market* culture to them—"you have to market quality at them with everything you have."

The essential question, which was whether one was more or less independent as a writer under Brown's studio system than under Shawn's auteur system, was not as simple as it appeared. On the one hand, the kind of stories Tina favored were much more dependent on market-oriented conditions and on a whole complex of tiny compromises of one's independence that make up the space between culture and marketing. If you wrote about a pop star, or a designer, or an athlete, you were necessarily borrowing some of your subject's celebrity and using it to sell your story. And if you thought you could get away with that—with taking their Buzz and not giving up some of your creative independence in return—well, brother, you were kidding yourself. There was always a transaction involved.

But on the other hand, what Shawn called independence—the church-and-state separation of culture and marketing—was not necessarily real independence either. Real independence would involve controlling both the artistic and the commercial sides of the operation. Partly because Shawn had stayed so chaste of any business dealings at the old *New Yorker*, it was possible for Peter Fleischmann to sell the magazine to Newhouse without even consulting Shawn, as he did in 1985, and then for Newhouse, who had promised on buying the magazine to keep Shawn on as editor, to fire him in 1987.

Because Tina was from the olde country, the American Anglophiles who tend to dominate our cultural institutions would have gladly placed her higher in their hierarchy than they were, if only she had done them the favor of affirming the hierarchy itself. But Brown would not do them that favor. Instead she gleefully flogged the old guard with lowbrow stories about the Hollywood madam, O.J., pederast priests, the sleazy motel murder of a Cravath Swaine & Moore lawyer, and a

Paul Theroux piece on a dominatrix. She published things in the magazine that seemed mainly calculated to shock her antagonists: gratuitous profanity, nudity (at one point the word processing department had a pool going to guess how many times a woman's nipple would appear in the magazine each week), and provocative covers, such as Art Spiegelman's drawing of a black woman and Hasidic man kissing during the Crown Heights crisis in Brooklyn, or his Easter Bunny crucified against an IRS form (although even Brown balked at publishing as a Christmas cover his street-corner Santa Claus urinating on the sidewalk).

One of Tina's gifts as an editor was that she saw the American cultural hierarchy for what it really was: not a hierarchy of taste at all, but a hierarchy of power that used taste to cloak its real agenda. But this was also her fatal flaw as the editor of *The New Yorker:* She never really understood or took seriously enough *The New Yorker*'s intimate relationship with that old hierarchy. Oh yes, it was ludicrous—"too funny, really," as the Brits like to say—the credulity with which the American cultural elite believed in their preposterous distinctions between pop culture and high culture, and the earnestness with which they protected their precious civilization from corruption from below. But what Tina and her teabag friends liked to call "*New Yorker* fakery," meaning the snobbery of some of the old guard, who pretended to be preserving standards when they were really only protecting their own status, was infuriating but it wasn't fake. That old High-Low distinction was the only class system this country had ever known, and a lot of people took it very seriously indeed.

This became obvious during the Roseanne affair, which was one of the defining moments of the Brown editorship. In preparing the Women's Issue—one of the themed special issues of the magazine that Brown had instituted—Tina had

taken the dubious step of inviting Roseanne Barr to host an editorial meeting at her offices in Los Angeles, along with our leader and several other editors and writers, in order to discuss possible topics for the issue. Roseanne had recently been profiled in the magazine by John Lahr, and readers who had not watched her show could get an idea of Roseanne's notions of civility from Lahr's piece. "I love the word 'fuck,'" she declares at one point. "It's a verb, a noun, everything, and it's just infused with intense feeling and passion, you know, negative and positive. And women aren't supposed to say it, so I try to say it as much as I can."

Roseanne's role in preparing the issue got blown out of proportion by the *New York Observer* (which the *New Yorker* people read religiously to find out what was going on in the halls around them) and the public got the story that she was going to "edit" the Women's Issue. This confused a lot of readers, who needed to keep the distinction between *The New Yorker* and Roseanne straight in order to preserve their own place in the cultural hierarchy. The news also gave the *New York Times* an opportunity to practice a little old *New Yorker* fakery on the new *New Yorker,* with a galling column by Maureen Dowd in which she wrote, "There is something disagreeable about turning this Rabelaisian backlot brat into a feminist ideal."

Jamaica Kincaid resigned as a staff writer over the Roseanne affair, telling *Newsweek,* "Put me in a room with a great writer, I grovel. Put me in with Roseanne, I throw up." This prompted Ellen Willis, a subversive from the old *New Yorker* days, to comment drolly in the *Village Voice,* "Put me in a room with Jamaica Kincaid groveling before a great writer, I throw up." Ian Frazier faxed in his resignation from Montana and then gave an interview to Maureen Freely of the *London Observer* in which he got off several brilliant riffs. "She [Brown]

brought to this country this notion of the chattering classes. When I first read this term, which I had never heard before, I thought, whoa, wait a minute. I do not want to belong to the chattering classes. I would rather thread pipe." He also said, "She told me that Roseanne was brilliant and original, and that it was normal for someone talented to be a bit of a monster, and I said, 'You know, Tina? I'm a bit of a monster too. And my job is not to kiss the butt of other monsters.' "

More than thirty of the old *New Yorker* writers would eventually leave Tina's magazine. In the editorial hallways, bylines once synonymous with good taste, wit, or quiet elegance could be seen unceremoniously scrawled on the side of cardboard packing boxes. Some writers went with fireworks, but most went quietly and sadly when they felt that awful chill of being cut out of Tina's circle of attention.

Of all the old *New Yorker* writers, George Trow was the one whose decision to leave meant the most to me. Trow, after all, had been one of the first to describe the commercial culture that Tina had brought to the magazine, in his essay "Within the Context of No Context," published in *The New Yorker* by William Shawn in 1980. In college the cool people read George Trow, and when I got to New York he was the writer I most wanted to meet. Once I heard he was at a party in a loft I was renting in NoHo, but I didn't meet him. I never have.

After a spectacular exchange of faxes with Brown, which were passed around the office, Trow accused Tina of "kissing the ass of celebrity" and left the magazine. Clearly, there were real principles at stake here. There were new *New Yorker* people and there were old *New Yorker* people, some of whom were Gottlieb people and some Shawn people, and there was no escaping these politics, which were a complex mix of con-

victions, loyalty, relationships, and self-interest—the culture of culture.

Which side of this culture war was I on? Although I had written for Gottlieb at the old *New Yorker*, I had accepted a contract from *Vanity Fair*, which Tina was then running. I had known Tina since she called me a few years earlier, saying she wanted me to write for her. She had seen one of my first magazine pieces, a profile of Polly Mellen, then a top arbiter of fashion at *Vogue*, in *Manhattan, inc.*, magazine. Tina responded to my pop side but I was wary of her for that reason. In my mythology, Tina was the temptress of the lowbrow side of my writing, the too-eager-to-please side, the merely entertaining, which the serious writer in me distinguished himself against, along traditional High-Low lines.

But my ideas weren't clicking with Gottlieb, and when Brown offered me a contract in the high five figures to write a year's worth of pieces for *Vanity Fair*, I was intrigued, and, even though I knew Bob disapproved, I figured it would be good for me to try writing for Tina. So I signed up.

It didn't work out. Whenever Tina and I disagreed about an idea for a story, I was quick to revert to type—the stuffed-shirt old *New Yorker* type—forcing Tina to play the suit to my artist. Also, I hated the magazine. There was some good stuff in it, but it also published trash, and while the Tina people put this down to the "mix," I put it down to a basic lack of standards.

With my first year's contract coming to an end, I went to the *Vanity Fair* Christmas party, which was held at The Sky Club in the Pan Am Building that year. I had been slaving away on a piece that just wasn't working, for reasons that were more my fault than Tina's, but I was tortured and angry about my lack of communication with her, and when I saw her at the party that night she offered me her left hand, as if I was sup-

posed to kiss it or something. I tried to grab her wrist. It was awkward, which for some reason it usually was with Tina.

Feeling that everything was utterly fucked up, I had a couple of quick drinks and got a little buzz going, then ran into another staff writer and began telling him loudly, all reckless now, about what a shitty place *Vanity Fair* was. In the editing of my last piece all the interesting stuff had been taken out, I said, and the whole thing had been dumbed down for some theoretical reader whom I didn't even like. The older writer listened, sipping his drink, nodding boozily. He was a once-talented writer who had squandered his ability in hackwork for Tina. He was quite drunk, and the pleasant, serviceably witty face he presented to the world—the face that still got his subjects to trust him when they shouldn't—had cracked, like ice, showing the bitterness underneath. After I had finished my rant, he said, "Yes, I used to feel that way, too. I got over it. You will too."

That encounter with the ghost of Christmas future decided it: I quit. Maybe I'd end up being a lawyer, but I didn't want to do this anymore. That night, while I was walking home through the freezing cold in an effort to clear my head, I decided I'd go back to freelancing for *The New Yorker* again. I wouldn't be earning anything like the money I had at *Vanity Fair*, but I would be writing about serious things for an institution that respected quality, not trafficking in pop as I was now.

I informed my parents of my decision to quit during Christmas dinner, and it caused a huge fight, with me screaming empassioned defenses of my artistic integrity at my father and my mother going out to the kitchen to cry. The fight was not just about whether to quit—my father recognized that *Vanity Fair* was lower on the cultural totem pole than his writer son should shoot for. The fight was over whether I

should tell Tina why I was quitting: basically, because the magazine sucked. "Leave 'em smiling," my father kept saying, "leave 'em smiling," which enraged me at the time.

I left Tina smiling, more or less, and seven months afterward I was glad I did, when on the morning of June 30, 1992, a publicist I had dealt with on a *Vanity Fair* story called me at home to say she had heard Brown was going to replace Gottlieb as the editor of *The New Yorker*. I said this could not possibly be true. Tina engendered these rumors all the time, and they were always just rumors. Rumor was like an opportunistic infection that bloomed in the hot zone around her. Tina Brown could not be the editor of *The New Yorker*, because in the world of High-Low distinctions I still believed in, *The New Yorker* was everything *Vanity Fair* was not.

That afternoon was one of the first times I remember taking the concept of Buzz seriously. I could almost sense it in the air, like weather. My parents heard the news on National Public Radio, and my father was on the phone to me immediately.

"Well, so that turned out to be pretty good advice I gave you," he said. Score one for Dad.

On assuming control of the magazine, Tina went into a round of meetings with *New Yorker* people. If not exactly a honeymoon, it was a monthlong Renaissance Weekend, like the one the Clintons favored. I had to wait until the end of the month for my audience, which didn't seem like a very good sign. In the elevator on that day, riding up to seventeen, I was very nervous. One of the things that made Tina seem powerful was that her attention was so hard to get. This was another of her gifts as an editor, something close to her instinct. She personified the distracted, easily bored modern reader—the reader *The New Yorker* now had to compete for. When you were in

her presence, you felt like you had to make the most of your time. I tended not to do well in those circumstances.

I had spent the previous six months working on a long piece for Gottlieb that was tentatively titled "The Man Who Invented the Intermittent Windshield Wiper." It contained a lot of material on patent law, the charming eccentricities of inventors, and theories of invention, as well as some neat stuff about Thomas Jefferson and the history of patents in America. None of this, I suspected, was going to be Tina's cup of tea. (It wasn't: "Too much then, not enough now," was her verdict on that draft.) But at our meeting Tina was friendly, encouraging, willing to let bygones be bygones. And she said all the right things about *The New Yorker*. Someone had given her George Trow's 1978 profile of Ahmet Ertegun to read, and she cited that as a model of what she wanted—a piece that was, as she rightly guessed, also in my fiery pantheon. "Gosh," she exclaimed keenly, "I never knew how many wonderful writers *The New Yorker* had! Mark Singer! William Finnegan! Susan Orlean!"

I tried to pitch her my new idea, which was a process piece about giant bluefin tuna.

"A tuna?" said Tina. A look of distaste crossed her face. But after listening to me describe the story she said it sounded like something I should stay on. I knew she didn't want it, but I stayed on it and wrote the piece, and Tina never ran it, which taught me the cardinal rule about writing for Tina: Never do a piece Tina didn't want you to do.

She was drinking a can of Diet Coke, mouthing the straw musingly—then, abruptly, she looked up and caught my eye. These moments, when she trained her energy right on you, used to frighten me, but I would soon grow to love and need them once in a while. Tina made you feel like a pop star. It wasn't the parties and the flashbulbs in your face, or the people

wearing headsets coming up to Tina when you were talking to her at a party and whispering that some celebrity or powerful advertiser or more famous writer than you had been sighted in the northeast quadrant of the party tent. It was that quick look up from the Diet Coke that did it—lit you up. In that moment I knew that in spite of other writers' lofty examples I was not going to leave *The New Yorker* because of Tina Brown.

The New Yorker was where I wanted to write; it was the only job I had ever wanted, the only institution I had ever completely trusted; and I was not so high-minded that it did not occur to me that the older writers' quitting might create opportunities for younger writers like me. Besides, what would I be leaving for, exactly? For good taste, standards, decency? "Read the magazine today," wrote Joseph Epstein in *The American Scholar* of Brown's *New Yorker,* "with its unbuttoned, and often sloppy language, its edge of political meanness, the childish obviousness of its attempts to outrage, and one comes to yearn for the quiet good taste that could once be counted on in a magazine one has been reading for decades." Those were the kind of principles I was supposed to be in favor of. And yet that quiet yearning for good taste was beginning to sound like death to me.

My reflected image in the polished elevator doors cleaved neatly into two halves as the doors slid open on sixteen. I found the receptionist, C. S. Ledbetter III, at his post. As always, gathered around C. S.'s desk was a rat's nest of odds and ends that had no reason for being there other than that C. S. allowed them to remain. Someone's sister's graduation gown hung on the coat stand; there was a bust of the Bard, William Shakespeare, wearing a hat someone picked up at the Saint Patrick's Day Parade; and there was a bad art-school painting

of a bomb about to strike a hay wagon. To the writers who re-membered the old *New Yorker,* the style of C. S. Ledbetter III compared favorably to those grimy, grubby hallways: Here the old too-cultured-to-care attitude was still intact. The couches behind C. S.'s desk were a hotbed of old *New Yorker*ism.

C. S. was within earshot of the yelps and yodels of Maurie Perl, the high-energy P.R. person Tina brought with her from *Vanity Fair,* and he had been observed to flinch as Perl's voice, in full holler, came sweeping down the quiet hall—"Tell her I gotta call her back!!!"—as she and her helpers flung them-selves into another Buzzstorm, expertly stoking the machine with tidbits from *The New Yorker,* yes the muthafuckin' *New Yorker.* Under Shawn, *The New Yorker* had gone out of its way to avoid being associated with other, lesser magazines by avoiding the kind of subjects other magazines included. Now each week the P.R. department made batches of clippings from other magazines and newspapers in which *The New Yorker* was mentioned and spread them around the office.

Down the hall, in the writers' offices, all was quiet. Busy, maybe, but not Buzzy. Most of the writers didn't use their of-fices much. Having an office to write in was nice, but having an office and not using it was better still. I only occasionally frequented mine, which was in the back of the building in what was called Dead Man's Gulch, a few doors down from Joe Mitchell.

C. S. was writing. "Working on the memoiiiiiir," he said, giving me the slow nod.

On the way to my office, I passed the library, which, in its unadorned bookishness, had also retained the spirit of the old *New Yorker.* The library was the Fort Knox of the place. It held bound back issues, all *New Yorker* writers' books, and, the holiest of the holies, the big black folders full of the writers'

clippings, with the writers' names written on the spine in what looked like Wite-Out, three or four folders full for the most prolific authors like White, Thurber, Perlman, Ross, and McPhee. All type, no hype—just the work, straight up, a daunting if not haunting achievement.

The library had been the site of some memorable Nobrow moments. Once, I had gone to look up an old article and found Sharon Stone there, on the phone with Richard Avedon, whose studio was on the Upper East Side. Avedon, the *New Yorker*'s first staff photographer, hired by Tina on the day after William Shawn died, occupied a high place in the Versailles of artist-courtiers that Madame de Pompadour had gathered around her at the magazine. Apparently Avedon had offended Stone by asking her to remove too many of her clothes during a shoot, and Stone had unwisely sought refuge in Tina's scheming bosom. There was a phone she could use in the library, so C. S. had installed her in there.

On another occasion, Steven Spielberg came to the office. I happened to be up on seventeen, where Tina and her editors worked ("the killing floor" as one editor referred to it), when I looked up and saw Spielberg and Tina, looking fetching in one of her cream-colored suits, sweep past. George Trow said of Tina's editorship, "A great girl in the wrong dress," and I'll come back to that, but on this day Tina was the girl in the right dress as she and a small crowd drifted down toward the area outside her office. Tina tried to engage Spielberg in small talk. Was there anything at *The New Yorker* that the maitre wished to see? Spielberg, who seemed like an earnest middlebrow in the old *New Yorker* mode, admitted that he would be thrilled to see the famous library.

The library! exclaimed Tina. Wonderful! Then, turning to an aide, she was heard to whisper, "Where's the library?"

I said hello to the few people I passed in the hallway, reflexively assuming the slightly exaggerated civility with which people who worked at the magazine treated one another, a kind of Old World courtliness that seemed to derive from the ides of culture that the institution itself represented. This courtesy was extended not only to writers, who were treated like superior beings, but to the fact checkers, copy editors, and production staff—to everyone involved in putting out the magazine. Tina, who as editor of *Vanity Fair* had favored an imperious, who-is-this-wretched-person-get-him-out-of-my-face style of dealing with underlings, made little effort to mold her Condé Nast manners to suit *The New Yorker*'s, nor did she try to get to know many of the people who produced the magazine. Eleanor Gould Packard, the legendary copy editor who has worked at the magazine for fifty-five years (as of this writing), has said that during Tina's six years at the magazine she never exchanged a single word with her.

Sitting down in my office, I got some reporter's notebooks out of my briefcase and started typing up notes. I had spent the previous weekend in Texas, with a fifteen-year-old musician named Ben Kweller, who was supposed to be a rock-and-roll prodigy, and with his parents, Dr. Howie Kweller, an M.D., and Dee Kweller; Ben's drummer, John, who was sixteen; John's parents, the Kents; and a publicist from the kid's label who was sent from L.A. to keep an eye on me.

Ben had been described to Tina as "the next Kurt Cobain" by Danny Goldberg, the head of the kid's label, Mercury Records. Goldberg, who was practiced in the art of making distinctions where none existed, had worked, over the last two decades, with bands like Led Zeppelin, Sonic Youth, and Nirvana. Goldberg had told Tina about Ben during a lunch at

Michael's, a restaurant on Fifty-fifth Street, where the hat-check girl was the not-yet-discovered actress Gretchen Mol, and Tina thought it sounded like a good story for John Seabrook.

Tina and Goldberg, I knew, had certain mutual (synergistic) interests. Mercury, it was shortly to be announced, would be putting out a CD series of *New Yorker* writers reading their work. They also supported similar charities, such as the Literacy Volunteers and Hale House, and were loosely attached to the same social circle of tastemakers in New York City. For me, accepting the assignment would inevitably mean functioning not only as a reporter but also as a kind of broker in a negotiated relationship between Tina and Goldberg, who were themselves functioning as brokers in a negotiated relationship between Si Newhouse and Polygram. I knew I would be wading a little bit deeper in the vast, tepid swamp of Buzz, with its surrounding cedar bogs of compromise. On the other hand, the idea of a rock prodigy—a kid who had learned to be a rock star from watching rock stars like Kurt Cobain on MTV—did sound like a good story.

I'd hung around the Kwellers' house in Greenville, a small town about sixty miles outside of Dallas, going with the boys to clubs in the city where the band was playing gigs. Whether or not Ben was an artist, he was certainly a kid, and that had made him the subject of an intense bidding war among different record labels, and thus an appropriate story subject for the new *New Yorker*. He looked a little like a twelve-year-old version of Kurt Cobain; he moved like Cobain, and there was a Kurt-like sweetness to him. What I had heard in New York was true, apparently: Ben had internalized Cobain by watching him on MTV. For my part, I found Ben to be just as adorable as Danny Goldberg said he was. He was like the ideal version of the twelve-year-old me—no longer the mopey dick-

head listening to folk rock in the bedroom with the lights off, but a real live rock star.

I tried to work, but kept drifting off into reveries inspired by the Underworld CD—Mmmmskyscraper—until finally I decided to head home. The cold pavement of Forty-third Street was even colder, now that it was dark, and heels sounded even harder as they clicked over it, hurrying for the subway. The eye-watering cold made the lights of Times Square trickle in my eyes. Night hid the tawdry side of the Buzz; at night Times Square sharpened into something purer, an image of itself. The big screen was showing the news. At the souvenir place up Seventh they were selling Star Wars stuff in the window. Eight blocks down Seventh, the Knicks would be playing in a couple of hours, a game that would provide me with my evening's culture.

Pausing again to take it all in, I wondered what my own place in the Buzz would be, not knowing yet that the answer would soon be rising out of the immense crater at the corner of Broadway and Forty-third Street.

2

My Father's Closet

When a man of my father's age lies down on an operating table there's always a chance that he may never get up again. But there he was at the breakfast table, two weeks after bone chips were removed from his spine, not only out of bed but dressed in one of his beautiful bespoke British suits, which must have been painful to put on. My father looked pleased with himself. He had cheated mortality again, and now he felt frisky and ready for argument.

"What are you advertising today?" he asked.

He nodded across the breakfast table at my Chemical Brothers T-shirt. There was a slightly supercilious smile on his face, which was intended to annoy me. My father thought it was in poor taste to wear logos or brand names or words of any kind on the outside of clothing. (The T-shirt said DANÜCHT on the back, which means "da new shit" in hip-hop.) A word on a shirt was like a mayonnaise jar at the dining table: an unsightly intrusion of commerce into what should be un-commercial space. You'd never see so much as an alligator or a polo player on his chest, much less a word.

I said, "It's a Chemical Brothers T-shirt."

Silence. Click of a small silver knife on a butter plate, having spread marmalade (removed from its container and placed

45

in a glass jam server with a silver top) on toast (homemade, not store-bought bread).

"And who are the Chemical Brothers?" Slight emphasis on the "who."

"They're a techno group from England. I went to their show last month and bought this T-shirt."

No reply, just raised eyebrows and a slight, courtly bob of my father's head—mock thanks for passing this *terribly* interesting information along to him.

My father took this sort of thing seriously. You start wearing T-shirts with words on them at the breakfast table, and pretty soon you're amusing yourself by watching daytime TV, or smoking. When I was growing up, Seabrooks did not do such things. On a special occasion the Seabrook children might be allowed to watch television—*The Wonderful World of Disney* on Sunday night, say—but never during the week. "You'll thank me one day," my father would say when I would complain about not having anything to talk to the kids on the school bus about. But, in fact, I would not thank him. I missed a valuable opportunity to learn empathy from TV. Fortunately, when we were being minded by Mrs. Hiles, who came in to do the laundry, clean, cook, and look after us after school, the TV was on and I at least got to see *Gilligan's Island* and *Star Trek*.

It was not that my father thought the Seabrooks were really any different from Mrs. Hiles's family, who were our neighbors. He knew how little difference between the Hileses and the Seabrooks there really was—which was precisely why these cultural distinctions were so important. This was true all over America. No one wanted to talk about social class—it's in poor taste, even among the rich—so people used High-Low distinctions instead. As long as this system existed, it permitted considerable equality between the classes. Strip away that

old cultural hierarchy, and social relations between different socioeconomic levels were harsher, because they were only about money.

I could have tried to explain to my father that in my world, two hours up the New Jersey Turnpike, there was an important distinction between a T-shirt that says, say, BUDWEISER or MARLBORO and a Chemical Brothers T-shirt that says DANÜCHT. In a system of status that values authenticity over quality, a Chemical Brothers T-shirt will get me further in many places than my father's suit. (The danüchtians are doing very hip parties for Puffy right now.) But the cultural choices at my parents' house out of which I made an identity for myself in the city seemed so unreal. Anyway it was too early and I felt irritable and tired, and the house was too hot, and I would probably lose if I attempted to mount an argument like this against the Silver Fox (as Dad used to be known in his CEO days). So I said nothing and ended up feeling a little like a traitor for not trying harder to keep the commercialism of my city existence out of the quieter, genteeler spaces of life down here on the farm.

My father was a famously flashy dresser. When I think back over his long and eventful life my mind's eye fills up with his silhouette at different times over the years, as defined by his beautifully tailored suits. I see the closet where his suits hung. Viewed from his dressing room, my father's closet appeared to be the ordinary, well-appointed closet of a successful businessman. It wasn't until you stuck your head inside that you became aware of a much larger collection of suits, hanging on a motorized apparatus, the kind you'd see at a dry cleaner's, extending up through the ceiling of the second floor and looming into the attic, which was mostly filled with a lifetime of his

clothes. As with most bespoke suits, each jacket had the exact day, month, and year it was ordered marked on the inside pocket. You could stand in the doorway downstairs, press a button, and watch as the history of my father, in the form of suits from all the different eras of his life, moved slowly past you.

Next to this master closet were other closets. One held shirts made by Sulka or Lesserson or Turnbull & Asser, another a silken waterfall of neckties of every imaginable hue. Still another held the shoe racks, starting at the bottom with canvas-and-leather newmarket boots and then rising in layers of elegance, through brown ankle-high turf shoes, reversed calf-quarter brogues, medallion toe-capped shoes with thick crepe soles, and black wing tips with curved vamp borders to the patent-leather dancing pumps at the top.

This wardrobe was in some respect my father's inheritance from his father. Not the clothes themselves, but the lesson that a custom-made English suit, worn properly, was a powerful engine of advancement up the status hierarchy. Without his clothes, my grandfather was an uneducated man who had spent his early years working in dirt, more or less. (The expression "dirt farmer" was still used sardonically by farmers down here to describe their profession, as though the dirt itself were the product.) But dressed in his Savile Row suits, my grandfather was a man of substance, grace, and good taste.

My father was more of a fashion innovator. He was the Duke of Edinburgh as played by Douglas Fairbanks Jr. In his youth he experimented with elements of both the Brooks Brothers style, which he encountered as an undergraduate at Princeton, and his father's Edward, Prince of Wales, look, hitting upon his own synthesis around 1950: double-breasted, high-waisted suits with wide lapels, snug in the body but with deep vents in the back. The cut of the clothes was still that of

the sensible establishmentarian, but within those controlled contours you'd get flashes of purple and pink in the wide-spread-collared shirts, polka dots in the ties, and a bold green chalk stripe of imagination in the suits, signifying the American tycoon.

Out of these pinstripes and houndstooths and windowpane checks my father created a whole world. There were drape suits, lounge suits, and sack suits, in worsted, serge, and gabardine; white linen suits for Palm Beach and Jamaica before the invention of air-conditioning; glen plaids and knee-length loden coats for brisk Princeton-Harvard football games, and a raccoon coat for Princeton-Dartmouth, which was later in the season. Suits for a variety of business occasions, from wowing prospective underwriters with a new offering (flashy pin-stripes) to mollifying angry shareholders whose stock was diluted by the offering (humble sharkskin). Then, as the life-is-clothes approach succeeded at the office, suits for increasingly rarefied social events, from weddings at eleven and open-casket "viewings" at seven, to christenings, confirmations, and commencements, culminating in the outfits needed for my father's rarefied hobby, four-in-hand driving, in which four horses are harnessed to a carriage—a sport that presents one with a daunting range of wardrobe challenges, determined by what time of day the driving event is taking place, whether it's in the country or in town, whether one is a spectator or a participant, or a member or a guest of the club putting it on. Three-quarter-length cutaway coats, striped trousers, fancy waistcoats, top hats: This was the part of my father's closet that bordered on pure costume.

The '60s burst against his solid shoulders of English wool and receded, leaving only one very interesting trace behind: a blue velvet Nehru smoking jacket, decorated with light-blue-and-navy flower-and-ivy psychedelia, and matched with midnight-

blue velvet pants. The suit was made by Blades of London, and dated April 25, 1968, a period when the Nehru was enjoying a brief vogue in the popular culture, thanks mainly to Lord Snowdon's wearing a Nehru-style dinner jacket in a famous *Life* magazine photograph in the '60s.

When he wasn't dressed up, my father was either in pajamas (sensible cotton pajamas like the ones Jimmy Stewart wore in *Rear Window*) or naked. He was often naked. He embarrassed not a few of my friends by insisting on swimming naked in the pool when they were using it. But his nakedness was also a form of clothes, in the sense that it was a spectacle. Dressing without regard to clothes at all, occupying that great middle ground between dressed and undressed—dressing just to be warm or comfortable, which is the way most people wear clothes—did not make sense to him.

Where did the information necessary to create this haberdasherical embodiment of an Anglo-American aristocrat come from? Much of it came from popular culture—from magazines and books and movies about the British aristocracy, from Noël Coward plays, from the Cecil Beaton outfits in *My Fair Lady*, from Cary Grant in *The Philadelphia Story* and Grace Kelly in *High Society*, from *The New Yorker*. This was one of the secrets of the American aristocracy: the degree to which its idea of itself was based on fictions created by wanna-be elites themselves—the Jewish studio bosses, writers like Scott Fitzgerald and Preston Sturges, and editors like William Shawn, son of Jackknife Ben Chon, a Chicago knife salesman.

One day back in the mid-'80s, while I was visiting my parents, I found my father contemptuously tearing Ralph Lauren ads out of a magazine. This was around the time that Ralph was making his move from denim into sportswear and "com-

plete lifestyle marketing" (home furnishings, linens, interior design products). Magazines were carrying small ad portfolios printed with a message from Ralph himself, which said in part, "There is a way of living that has a certain grace and beauty. It is not a constant race for what is next, rather, an appreciation of what has come before. There is a depth and quality of experience of what is truly meaningful. . . . This is the quality of life that I believe in. . . ."

"Ralph Lauren *offends* me," my father said, with withering scorn, almost disgust, ripping out another page. The vehemence of his response surprised me. After all, Ralph Lauren's sentiments were not inconsistent with my father's own views on value in culture. Dad did not object to having some of his most elaborate four-in-hand outfits featured in the "Man and the Horse" show at the Met—a show partly underwritten by Ralph Lauren. But after I had thought about it for a while it made perfect sense. In making images of horsey, aristocratic-looking people like my father available to everyone, Ralph Lauren was a threat to my father's identity as an American aristocrat—an identity that he, like Ralph Lauren, had invented out of whole cloth, as it were. Of course, my father would never *ever* wear Ralph Lauren, because he had gone Ralph Lauren one better. This was his distinction in the sand.

As for me, being that much closer to Nobrow, I tended to see Ralph Lauren ads as a validation of my identity, not a threat to it. When I was in my second year at Princeton, for example, someone came down to the crew boathouse looking for models to participate in a Ralph Lauren fashion shoot. The idea was that preppy-looking rowers like us would be seen horsing around on the crew dock wearing Ralph Lauren clothes that suggested rowing (horizontal-striped jerseys, crew-neck sweaters, etc.). You might think that since we were all real preppy rowers we would not care about being in a Ralph Lau-

ren ad depicting preppies like us, but of course you would be dead wrong about that. Almost every member of the crew signed up. Being to the manor born couldn't compete with being chosen because you fit the commercial culture's image of you. When I wasn't chosen I tried to console myself with the thought that only fake preppies were picked, but it was hard to swallow.

Now I was home to help during what had been a difficult time in my parents' lives. Even more serious than my father's back was my mother's heart. My mother contracted rheumatic fever as a child and grew up with the knowledge that she had "a heart." Her mother told her she should avoid excitement—certainly having children would be too much of a strain. In recent years a leaky mitral valve had caused her some shortness of breath, and it got so bad that she was out of breath just walking up three or four steps. If she did not have an operation she would be forced to live as an invalid, the doctors said. But if she did have the operation, she was convinced she would die.

Finally, after talking it over with all of us, she decided to have a valve replaced at the Cleveland Clinic. Dr. Cosgrove, who was, my father assured us, the top valve man in the country, performed the operation. He had hoped to use the new minimally invasive operation that involved making only a three-inch incision, but it turned out he couldn't reach the valve with the smaller incision—there was too much scar tissue. So in the end he had to crack my mother's chest.

My mother survived the operation and seemed to be getting better, but it was like she'd lost her compass. Always so sure of herself, so quick to make decisions, so competent, she had become subject to these strange panic attacks in the night. She thought the panic came because we ate dinner too late, so

we ate earlier, but it still came. One afternoon I tried to talk to her about it, but it seemed to panic her more to talk to me.

At night I stayed up late reading in the library. I listened to the silence, quietly metered by the ticking ormolu clock. I got up and walked through the dark, quietly elegant rooms in my socks. My sense of the house of culture, that neoclassical upstairs-downstairs structure of distinctions I carried around in my head, had something to do with this house in which I grew up. There was a lot of dark mahogany, Regency-period furniture, heavy clocks, a couple of Aubusson carpets. The rooms looked elegant without looking too expensive, but it wasn't the too-cultured-to-care style either—my father was too close to real shabbiness to dabble in that. The house itself was an eighteenth-century Quaker farmhouse, and the stolid values of its architecture forbad too much in the way of orna-ment. The pictures on the walls were not particularly distin-guished but not bad; they took up space tastefully. Several were nineteenth-century family portraits of families that no one remembered anymore; my father bought most of them at an auction years ago. There was one weirdly Goyaesque paint-ing of a Spanish family. The dead-looking eyes of the baby, turned away from his Madonna-like mother's breast in the Renaissance convention, gave me nightmares when I was a little kid.

This was the style of hegemony: taste as power pretending to be common sense. The idea that taste is power first oc-curred to me in a seminar led by Raymond Williams, back when I was a student at Oxford University in 1983. The Williams seminar now seems like the real beginning of my ed-ucation in Nobrow—the real world of culture that I was work-ing in at Tina Brown's *New Yorker*. The seminar was one of a series organized by the Oxford English Union, a group of lit-erature grad students who opposed the traditional kind of lit-

erary criticism taught at Oxford, that Arnoldian business of se-
lecting the best that has been thought and known, practiced in
the twentieth century by critics like F. R. Leavis and T. S.
Eliot. The guiding lights of the Union were, rather, Derrida,
Althusser, and Gramsci, who was the Italian author of the con-
cept of hegemony.

For some months I had seen the Union's Bolshevik-
looking leaflets, announcing one or another discussion on the
crucial importance of race, gender, class, identity, or "other-
ness" in the formation of literary judgments. On seeing them
posted on the bulletin board near the mailbox of my college, I
would smile contemptuously. I dimly recognized that these
ideas were profoundly contrary to my own interests and plans
for the future, which would in one way or another involve
making my own selections of the best that had been thought
and known. The authority to make these judgments would
rest on my "cultural capital"—that is, on my study and knowl-
edge of the canon that Leavis, Eliot, and others had helped to
select. The Union, on the other hand, was promoting a differ-
ent kind of value altogether, a system of multicultural capital
that would inevitably devalue my cultural capital. Whereas the
old system valued unity and orthodoxy, the new system recog-
nized and assigned a value to difference. Marginal groups, who
possessed little in the way of cultural capital—uneducated
women, the poor, street rappers, and graffiti artists who were
one jump from the gangs—could be rich in multicultural cap-
ital, as a result of what Pierre Bourdieu had identified as "the
hierarchy of oppression."

Raymond Williams was one of the seminal figures in the
British school of cultural studies, a one-time disciple of
Leavis's who had broken with him, as he explained in his won-
derful essay "Culture Is Ordinary," over Leavis's dim view of
what he saw as the mechanized vulgarity of the modern mass

society, and what Williams saw as the only possible salvation for the uneducated poor. At any rate, Williams's use of the new ideology seemed more nuanced than that of many of his followers, and so when I saw he was scheduled to lecture, I decided it was finally time to see what the Union was about.

Williams began the seminar by talking about the nineteenth-century romance novels that were among the earliest and most durable forms of mass literary culture. What standards shall we use to judge these books, he wondered aloud. How can we comment on their quality? After listening to the discussion for a while, I put up my hand and suggested that one standard for judging these books might be "taste." In what I now think of as town-house taste (but then thought of as the only kind there was), an individual's taste was the point of view imparted by his study of the canon. Taste was my cultural capital, boiled down to a syrup. With the benefit of this kind of taste, one could with confidence judge these romance novels: their language was trite, their plots insipid, and the moralism banal—in short, they were bad books.

To my right was a graduate student whom I knew slightly from the Bodleian Library. Now I felt the full force of his intensity fall across me, as he sized me up: another stupid American with hegemony written all over him.

"How dare you talk about taste when there are people in the world who don't have enough to eat!" he cried.

Even fourteen years later, the acid drip of accusation in his voice brought me up short as I walked around my parents' dark, quietly gleaming house. I try yet again, with all the best *l'esprit de l'escalier*, to defend myself, arguing that there are two kinds of taste—the taste for the agreeable and the taste for the beautiful—and noting the importance that Kant placed on distinguishing between the two. According to Kant, the man of taste can't judge adequately *unless* he has a full belly ("Only when

men have got all they want can we tell who among the crowd
has taste or not"). But this argument lacks the force of the grad-
uate student's position, which is that no one has a right to judge
as long as other people are hungry. For after all, taste *was* based
on privilege. That the cultural arbiters of old were privileged
was not at all remarkable—it would have been remarkable if
they weren't. But to this student privilege was a reason to sus-
pect the tastemaker. Disinterest, which was the pledge of good
faith in the Kantian system, was neatly rendered into an act of
bad faith in the hegemonic system.

The other students in the room were hooting and laughing
at me before I was finished with my discourse on value. Glee-
fully, they exposed the hitherto sheltered hegemonoculous for
what he was: a supercilious ass, stuffy about these old hierar-
chical distinctions of value as only an American can be.

"How are things going at *The New Yorker?*" my mother asked
me the next day. This was one thing I had noticed about *The
New Yorker* under Tina Brown—she definitely put the maga-
zine on my parents' social map even as she marginalized their
way of life. The fact that my parents had a source of inside in-
formation on the goings-on at Tina's much-talked-about *New
Yorker* was a status advantage in their circles. The truth is,
everyone loves gossip, and Buzz, once you get used to it, is
usually more interesting than observing the formalities.

Still, my mother worried that I didn't get enough culture in
New York. When was the last time we went to the theater?
Maybe six months ago. The opera? A few years, maybe. We go
to the movies, I said. I didn't tell her about the late nights in
the clubs or the gangsta on the Discman—no point in upset-
ting the poor woman.

My mother was in charge of our cultural education when

we were children. She had, for example, arranged for me to attend the Saturday-matinee orchestra-for-kids series in Philadelphia. (My father had attained culture in the French sense, the sense of being cultivated, but the upper limits of the German sense of *Kultur*—the great artistic, intellectual, and religious accomplishments of the civilization—were not interesting or useful to him.) I griped about having my Saturday afternoons taken up with these excursions to the symphony, when I would rather be playing football with my friends, but nonetheless, as I sat in there in the dimness of the concert hall, on the red velvet chairs that made the undersides of my thighs prickle and perspire, listening to the young conductor, Seiji Ozawa, who had recently taken over the Boston Symphony, talk about the music the Philadelphia Orchestra had just played, a sense of what elite culture was stole over me; I felt its high seriousness and compelling mystery—open to all yet attainable by only a few, "an elite community, a rather snobbish one, but anyone could join who cared about such odd things," as Dwight MacDonald had said. It *was* different from, say, pop music on the radio. But what was the difference?

Alas, all my mother's efforts to raise my cultural horizons above the popular never quite took. The symphony was beautiful, but at home, given the choice, I listened only to pop music—Beatles, CSNY, Woodstock, *Hair.* The closest I got to opera were *Tommy, Quadraphenia,* and *Jesus Christ Superstar,* which I encountered for the first time at age eleven and which crossed the mopey personal angst and pseudo-authenticity of folk rock with the New Testament story.

I accepted without question that classical music was of a higher order of quality than pop music, and that it was, sooner or later, the music I would grow up to appreciate. Pop was goofy, fun, sweet, open, honest, but at the same time utterly

fake. Pop was a symbolic language with which to talk about feelings you couldn't talk about in real life—love, pain, happiness. If you had told me then I would still be listening to pop music at the age of thirty-seven, I would have said you were mistaken (I was no fool). But I did know that when I was in my room with all the lights out, listening to Neil Young sing "Sugar Moutain," the experience seemed important and life-transforming in a way that my parents' culture would never be for me.

My father used his clothes to pass along culture to me. I, in turn, used clothes to resist his efforts. When I was growing up, I had a lot of nice clothes, which my parents got for me, and I did almost everything I could to avoid wearing them. Without really intending to, I managed to rip the silk lining in the beautiful camel's-hair coat Dad bought me, lose buttons off the Brooks Brothers suit, tear the seams around the pockets of the evening clothes. "You're so hard on your clothes," my mother would say, and she was right. My boyhood closet was a riot of misplaced anger exhibited toward innocent garments. Inside the little lord's scrubbed and Etonian exterior there seemed to be a dirt farmer struggling to get out. My brother, on the other hand, seemed effortlessly to acquire my father's ability with clothes. His closet was like an Eagle Scout's version of my father's. Mine was the Anticloset.

When I was fully grown, and turned out to be more or less my father's shape and size, there was rejoicing in my parents' household. Naturally my father was pleased. He had never spent much time with me as a boy, being so busy providing all the advantages that we enjoyed. We never threw a ball together or went camping—even if he'd had the time, he didn't have the clothes for it. But in the art of dressing for success in the adult world he would gladly be my adviser and my friend.

My mother was also pleased. Having grown up without money, she could never reconcile herself to her husband's clothing purchases, to the point where my father had to smuggle new clothes into the house. Now, at least, his reckless extravagance would have a practical outcome: I would never have to buy any clothes of my own. I could just start wearing my father's, beginning with the earliest items in his wardrobe and working my way along the endless mechanical circle.

Not long after I moved to my first apartment in New York, my father took me to his New York tailor, Bernard Weatherhill, to have a couple of his old suits refitted on me. The shop was upstairs on a midtown street, nothing flashy, just a nameplate on a wall you'd pass every day in the city without giving it a second glance. The man who measured me up was an elderly white-haired Englishman, whose slightly stooped posture was like an unparsable synthesis of class-based deference and the physical toll of years of bending down to measure the bodies of young gentlemen like me. His tremendous discretion seemed to suck all the oxygen out of the air.

The jackets fitted almost perfectly. A little big in the body, but the length in the sleeves was beautiful. My father and the tailor beamed with pleasure. The pants, however, needed taking in; the tailor asked me to "stand naturally" as he marked them up. But for some strange reason I had suddenly forgotten how to stand naturally. It was as if I'd lost the concept of posture.

"Why are you standing like that?" my father said. "Knock it off."

Later he took me to A-Man Hing Cheong, his Hong Kong tailor, to be "measured up" for a few "country" suits (a glen plaid and a windowpane check) and, presumably, many others in the future. ("Big men can wear bolder plaids and more details without appearing to be fairies," Dad once advised me.)

"Which side?" the tailor asked; he spoke a bit of English. He was kneeling in front of me, pointing at my crotch and waggling his forefinger back and forth.

"He wants to know which side you wear your pecker on," my father said.

"Yeh yeh, ha ha ha, yar peck-ah!"

But all my father's efforts to clothe me in the style of the young gentleman he hoped I would become were almost entirely unsuccessful. Around the house I wore jeans and T-shirts with words of all kinds on them—TV shows, brand names, sports, *Star Wars*, MTV, Ralph Lauren, Calvin Klein, *Jesus Christ Superstar*. Insofar as I had a style it was bad '70s— lots of brown colors, bell-bottoms, cords, and polyester shirts. In some dim inchoate way I perceived that T-shirts with words were *my* culture, and that was the only way out of the larger cage of hegemony in which my father's houndstooth and windowpane checks had me trapped.

We ate dinner in the formal dining room, as we always had. I made an effort to get "cleaned up." In recent years a semblance of what might charitably be called a personal style had been struggling to emerge from the mix of brands I invested my identity in: the Helmut Lang jeans, soft-collar shirts from Katharine Hamnett, a lightweight wool navy-blue blazer with a twill finish by Hugo Boss, socks from Paul Smith. I was also grateful for the rise of "technical fabrics" like vinyl and Lycra spandex, which combine the wrinkle-less properties of wool with the lightness of cotton and give the garment that little bit of stretch the salesclerks made so much of in those days.

SoHo was where I first attempted to acquire a wardrobe of my own. Part of the reason I was first drawn to writing was that, unlike my father's way of life, writing was a career you

could pursue without ever putting on a necktie. But whenever I got paid for my writing, performed in T-shirts with words on them and jeans, something unexpected happened. On receiving a check I could think of nothing I wanted to do with it more than spend it on clothes. With my check in my pocket, I'd set out for the bank, and then to SoHo. I appeared calm, standing there in Agnès B. pensively fingering some fabric, but inside my head a fashion psychopath was at work. Two hundred dollars for a pair of pants! Then again, they're asking one hundred and thirty for a shirt. So in a way two hundred is cheap for pants. Gradually I reduced the price through irrational reasoning until I heard myself saying, "Okay, I'll take them." Signing the receipt felt like the moment after an accident, when you can't believe it's happened. Then, to prove that it wasn't that bad to spend $200 for a pair of pants, I'd spend another $200 for a merino wool turtleneck.

I was drawn to expensive brands. Only a famous high-fashion brand name had the power to ward off the hegemonic succubus that lived in my father's clothes. To my father, of course, the whole concept of designer labels in men's fashion was ridiculous, another triumph of the marketers over the makers. What did these swishy women's dressmakers know about making clothes for a man? The first time I wore an expensive Italian suit I had bought with my own money, an Ermenegildo Zegna, I was to meet him at "21" for lunch. He arrived at the restaurant first, and as I walked in I saw that his attention was instantly riveted on the boxy, ventless, close-to-the-hips silhouette of my jacket. P. G. Wodehouse, describing the reaction of Jeeves upon spotting his master wearing a scarlet cummerbund with his evening clothes, wrote that "Jeeves shied like a startled mustang." My father, watching this Italian garment coming toward him around the checked tablecloths, reacted similarly. He recovered in time to greet me cordially;

then, plucking the lapel of the Zegna between his thumb and forefinger, he looked at the label.

"Hmp," he said softly. That was all: "Hmp." It was the sound of a world ending.

But tonight, to cheer my parents up, I dressed myself in an old gabardine suit of my father's. It was a surprise. I had found the suit in the attic the day before, when I was taking a break from my work at the laptop. I slipped the jacket over my T-shirt—the cool silk lining felt creamy against my bare arms—and found it fit me almost perfectly. The date inside the pocket said April 2, 1958—my father was almost exactly my age when he had it made. It even had slanted pockets, a little like the New Modern suits at Paul Smith.

My father was delighted by how well the suit fit me. My mother seemed genuinely pleased, too, as up as I'd seen her since the operation. She said I must wear the suit the next day at the book reading and signing I was doing over in the Christiana Mall, in Delaware, to which they'd invited some of their tony Wilmington friends.

"An old suit calls for an old bottle of wine!" my father declared, and, moving slowly but purposefully, went down to his cellar to fetch a '75 Palmer, an amazing bottle. I offered to decant it. The ritual of decanting was wisely denied to me as a boy—it was the kind of thing I would make a mockery of, or at least not care about enough to perform properly, but on this evening I was grateful for the opportunity to show I knew how to do it right.

As I watched the beautiful burgundy-colored fluid, illuminated by the candlelight, for traces of sediment, I thought of a house in Los Angeles where my Buzz studies had taken me recently. It was in the Brentwood hills—in that rim of new money that fans out below the Getty Museum, which sits up there like the Cheops of Nobrow. There I had seen a $1,500

bottle of 1975 Petrus (Frank Sinatra's favorite wine), unde-canted and poured label down, so that the sediment dripped into it. There was a kind of joy in the pure consumption of the Petrus that was perhaps as pure as my father's pleasure, and without the boring part of the whole oenophile thing, but it was vulgar, witless, and empty. It made me feel lucky to have a father who cared about the ritual.

I came back to the table with the decanter of wine and poured a little in my father's glass for him to taste. The wine splashed quietly; the lip of the glass rang softly as I touched it with the decanter. I was careful to roll my wrist smoothly as I poured, so that the last drops slid along the rim on the de-canter, just as the sommeliers at "21" do it. My father nodded, lifted the wine noiselessly and carefully from the table, and gave it a swirl. "To your new suit," he said, and then, smiling across the table at my mother, who lifted her water glass and smiled back, he let the wine run into his mouth without any drawing suction, sighing through his nose as he tasted it. He swallowed, replaced the glass noiselessly, reflectively, on the table, and said, with quiet, absolute certainty, "That's good wine."

3

From Town House to Megastore

The challenge that *The New Yorker* faced in the '90s was one faced by many cultural institutions—museums, libraries, cultural foundations: How do you let the Buzz into the place, in order to keep it vibrant and solvent, without undermining the institution's moral authority, which was at least partly based on keeping the Buzz out?

At *The New Yorker,* this challenge was complicated by the fact that in making selections of what was worthy or not worthy of the readers' attention, the magazine was also selling status. This, after all, was what had allowed William Shawn to put out a very "successful" magazine without seeming to care about commercial success—because disinterest in the crass commercial culture was the aristocratic ideal, and that's what the advertisers were buying. But maintaining that Olympian distance from the Buzz eventually made William Shawn's *New Yorker* seem irrelevant. The buzzing confusion inside the readers' heads became too disconnected from the untroubled flow of thought in the magazine's pages. The *New Yorker* would need to find a new set of distinctions within the Buzz, which by its nature abhorred distinction and consumed all single points of view. The trick was to trade on the cachet of the old *New Yorker,* that integrity derived from never publishing "any-

thing in order to sell magazines, to cause a sensation, to be controversial, to be popular or fashionable, to be 'successful,'" while at the same time doing just that.

MTV was my initiation into the realm I would come to think of as Nobrow. The rough idea, which was Tina's, was for me to hang around MTV and do a profile of the place at work. Despite the historical and cultural distance between the two institutions, MTV was conveniently located at Forty-fourth and Broadway, a five-minute walk from *The New Yorker*, and I spent a month going back and forth along that street, in and out of Times Square.

My daily walks back and forth between *The New Yorker* and MTV were a transit between a town house and a megastore. In the town house was symmetry, in the megastore multiplicity. In the town house was quiet, in the megastore cacophony. In the town house was the carefully sequestered commercialism of my father's world, in the megastore the rampant commercialism of mine. In place of *New Yorker* distinctions between the elite and the commercial, there were MTV distinctions between the cult and the mainstream. In the town house, quality was the standard of value; in the megastore, the standard was authenticity. In the town house you got points for consistency in cultural preferences; in the megastore you got status for preferences that cut across the old hierarchical lines. In the town house there was content and there was advertising. In the megastore there were both at once. The music videos were art—music videos offered some of the best visual art on television—but videos were also, technically speaking, ads for the music, and the money to make them came from the music industry or the artist, not from MTV.

I tried to diagram the difference. The megastore looked something like this:

Nobrow

Identity
Subculture
Mainstream Culture

Whereas the town house looked like this:

High Culture
Middlebrow Culture
Mass Culture

But where the old hierarchy was vertical, the new hierarchy—Nobrow—seemed to exist in three or more dimensions. Subculture served in the role that high culture used to serve, as the trend giver to the culture at large. In Nobrow, subculture was the new high culture, and high culture had become just another subculture. But above both subculture and mainstream culture was identity—the only shared standard, the Kantian "subjective universality."

By starting from the megastore and working backward, one could learn something about the evolution of Nobrow. The town house of culture had been an upstairs-downstairs affair. Upstairs with the legitimate artists were the wealthy people whose money had built the museums and opera houses where the high art was enshrined; downstairs were the masses, watching shows like *Cops*, listening to gangsta rap, and reading the *New York Post*. Although the masses were not allowed upstairs, the elite could sometimes descend to the lower level, like Kate Winslet going belowdecks on *Titanic*, to be refreshed by the people's simpler pleasures and to reflect nostalgically on the time before the original sin of the commodification of culture made the town house necessary in the first place.

And why was it necessary? To protect the real artists and writers from the ravages of the commercial marketplace. The

town house was erected toward the end of the eighteenth century, when the relationship of artists to their sources of financial support began to change. Artistic patronage was declining, middle-class readers and commercial publishing were on the rise, and artists and writers, once subject to the dictates of their rich or titled or holy patrons, were thrown upon the untender mercies of the marketplace. Although this new master, the market, was in certain respects more permissive than the old patrons had been—for the first time the artist was free to choose his subject matter—in other respects the marketplace was even more tyrannical. It was uneducated, insensitive, easily bored, and unsympathetic to the high standards the patrons had enjoyed and upheld. Certain artists and writers were facile enough to please this new master, but only by compromising those standards.

So it became necessary to devise a way to distinguish the real artists from the hacks, and the legitimate art of the old aristocracy from the commercial art that the cultural capitalists produced for the newly urbanized masses. The Romantic notion of "culture" evolved to fill that need. The meaning of the word as Wordsworth and Coleridge used it derived from two sources: from the French word *civilisation*, which means the process of intellectual, spiritual, and aesthetic development, and from the German word *Kultur*, which describes any characteristic way of life. The French sense was orthodox and singular, and it included a moral dimension; the German sense was relativistic and was not explicitly concerned with morality. The English word *culture* was a hybrid of the two, although the nineteenth-century usage favored its outwardly strict French father over its more licentious German mother. As culture came to America from England and France, the French emphasis was ascendant.

The Romantic concept of culture held that what real artists

and writers produced was a superior reality—a kind of work that, being imaginative, transcended the workaday world of ordinary cultural production. The artists themselves were thought to be exceptional, gifted beings whose talents were extraordinary—impassioned geniuses who created not for the market but some higher ideal. "It is a fact," writes Raymond Williams in *Culture and Society*, "that in this same period in which the market and the idea of specialist production received increasing emphasis there grew up, also, a system of thinking about the arts of which the most important elements are, first, an emphasis on the special nature of art-activity as a means to 'imaginative truth,' and, second, an emphasis on the artist as a special kind of person. It is tempting to see these theories as a direct response to the actual change in the relation between artist and society. . . . At a time when the artist is being described as just one more producer of a commodity for the market, he is describing himself as a specially endowed person, the guiding light of the common life." In short, the idea of "culture" was always in part a clever marketing concept.

From Wordsworth to Rage Against the Machine, art created for idealistic reasons, in apparent disregard for the marketplace, was judged superior to art made to sell. For the artist, it was not enough to have a gift for giving the people what they wanted; to insure fame, the artist had to pretend not to care what the people wanted. This was difficult to do, for the artist, of every type, is as desperate for public approval as any human being. Oscar Wilde was a famous example of this paradox. In his essay "The Soul of Man Under Socialism" he wrote: "A work of art is the unique result of a unique temperament. Its beauty comes from the fact that the author is what he is. It has nothing to do with the fact that other people want what they want. The moment that an artist takes notice of what other

people want, and tries to supply the demand, he ceases to be an artist and becomes a dull or an amusing craftsman, an honest or dishonest tradesman." Of course, Wilde himself knew exactly what people wanted and how to give it to them; he used his essays to camouflage that facility.

During the second half of the twentieth century the town house of culture collapsed. It happened all at once, like an earthquake, when Andy Warhol showed his soup can and Coke bottle paintings at the Stable Gallery in 1962, and it happened very slowly, as over the course of the twentieth century the deep structural flaws in the town house were stressed by the sheer variety and ingeniousness of the commercial culture itself. Editors, curators, and critics fought courageously to preserve the separation of the high from the pop, the handmade from the machine-made, the unique from the reproduced. These cultural arbiters battled the pro wrestlers and soap-opera divas and the talk-show hosts, struggling to keep some sense of the original distinction between the old elite culture and the new commercial culture intact. As a last resort, intellectuals in New York sought to preserve the town house through camp. But camp was only a temporary measure. The camp arbiters were soon overrun and slaughtered by the pop-cult hordes as well.

With the waning of the distinction between elite culture and commercial culture, concepts like "going commercial" and "selling out" became empty phrases. Questions that the old arbiters had concerned themselves with, like "Is this good?" and "Is it art?" became questions like "Whose good?" "Whose art?" Selecting "the best that is known and thought in the world," in Matthew Arnold's phrase, which had been considered the duty, privilege, and moral enterprise of the arbiters elegantiae, became instead an immoral enterprise: an elitist attempt to ramrod a narrow set of interests onto the masses. A

whole generation of tastemakers, whose authority in one way or another rested on maintaining the distinction between elite and commercial culture, was gradually swept away, and in their place arose a new generation, whose skill was knowing how a certain piece of content could be tweaked to fit a demographic or "psychographic" niche. A subtle but all-significant shift in the tastemakers' authority had been made, away from the individual's taste and toward the authority of the market.

By the 1990s the notion that high culture constituted some sort of superior reality, and that the people who made it were superior beings, was pretty much in the toilet. The old meaning of the word *culture*—something orthodox, dominant, and singular, had yielded to the more anthropological, Lévi-Straussian sense of culture: the characteristic practices of any group. People at MTV talked about the culture of e-mail or the argument culture or bike-messenger culture. At MTV it was possible to have culture in the German sense without being the least bit "cultured" in the French sense. One could be deep into the culture of gangsta rap, for instance, and have nothing to do with civilized values.

But wouldn't Coleridge and Wordsworth have thrived on MTV? True, there was still a big bad market that could practice "censorship" on artists, but there was also an ever-multiplying grid of small niche markets for artists to support themselves—a condition that was good for the arts if not necessarily good for the artists. As the mainstream had become ever more homogenous, the fringe had become ever richer in cultural offerings. There were off-off-Broadway one-acts, cutting-edge zines, genre-busting bands, small films that fell between genres and cut across categories, rappers who had an original flava and a true story to tell. There were good small films playing next to the blockbusters at the megaplex, cable channels that showed edgy dramas from England, Web sites

where you could spend hours reading poetry that no publishing house would publish. When one could say with confidence that the marketplace choked the avant-garde artists, who were by definition beyond popular appreciation, then one could wholeheartedly give one's support to artists who seemed to be working outside the mainstream. But when, thanks to outlets like MTV, the mainstream broadened to the extent that formerly avant-garde artists could be a part of it, the situation changed. As the Web and related technology and media continued to shrink the distance between artists and potential audiences, the once-valid rationale for protecting the arts from the ravages of the mainstream marketplace lost ever more logic (quoth the raven). The mainstream market, once the enemy of the artist, even began to acquire a kind of integrity, insofar as it represented a genuinely populist expression of the audience's preferences. In a world of relative values, the popular hit had a kind of currency that ideals about quality lacked. You could argue about what was "good" (whose good?), but you couldn't argue with Soundscan and Amazon.com.

Technology had also changed the nature of authorship. The writer's ability to access rapidly many different ideas on a subject, with ever more refined searches, increased the chance that an author was using someone else's ideas, or at least blending original and borrowed thoughts. On the Web, where hypertext links to many other authors could be embedded in a single text, the decline of the physical separateness of texts had altered the traditional notion of authorship. In the music world, the art of sampling, the mingling of your sounds with appropriated or "quoted" bits of other people's music, had become as legitimate a way of composing pop tunes as the old method of making them up yourself. James Schamus, a screenwriter and independent-film producer, surveying the cultural landscape, told me he thought what was happening was not so much the

rise of corporate control over artistic freedom but a rethinking of who the artist is. To him there seemed to be a new kind of creator emerging, whose job was to execute the wishes of the marketers and the executives in a creative way—to synthesize various ribbons of creative input—rather than to be a solitary auteur. "Notions of authorship have been blown wide open," Schamus said. "The author is really the person who owns the activity, who is paying the artists for their time while they are doing that work—that's the author."

Finally, the belief that artists are unique beings had inevitably declined as the numbers of artists had grown. The business of America was art. There were far more painters, poets, musicians, actors, dancers, and writers than there had ever been before. Virtually everyone under twenty-five I met at MTV was an artist of one kind or another. Young people who once faced a boring job in an office could now make a go of it as a rock star, a performance artist, or a videomaker. It became difficult to believe in the superior reality of every kid with a guitar and an interesting haircut. The contemporary artist was the paradigm of a process of creative self-discovery which was thought to be the birthright of every citizen of the world.

A tall hip-hop impresario named Fab Five Freddy appeared out of the gloom of Radio City Music Hall one day, folded himself into a seat behind Judy McGrath, the president of MTV, and started pitching her an idea for an MTV special about the life of black men in prison. Fab Five Freddy had roots in old-school hip-hop, having been present at the birth of Bronx rappers like the Sugar Hill Gang; he had also, in the early '80s, helped to make uptown graffiti artists fashionable downtown, and so McGrath listened to him with interest. Sit-

ting around them in the huge, dim hall was a small circle of young MTV people. Production assistants were talking on walkie-talkies to other P.A.s who were somewhere in the bowels of Radio City. Everyone was bathed in the glow of TV monitors and laptop computers that were set up on a board in the middle of one of the rows of empty seats, about twelve rows back from the stage.

McGrath (pronounced "mick-graath") let her bangs hang down over her eyes and looked out from under them, which she sometimes did when she was thinking. She rubbed her face dreamily. She was very calm, her characteristic business mode.

"Is it a morality tale?" she asked Freddy.

"Well, you know, the black man has had a hard life—" Freddy began, but he was interrupted by the crushing funk of Snoop Dogg, a famous gangsta rapper. Snoop was scheduled to perform at the upcoming MTV Video Music Awards.

In the beginning, gangsta rap had been more explicitly political. When a young black man named Ice Cube of N.W.A. stood up to the police with his rap "Fuck tha Police," it was a powerful political statement that transcended mere style.

Fuck tha police, comin' straight from the underground
A young nigga wit it bad, 'cause I'm brown
And not the other color, so police think
They have the authority to kill a minority
Fuck that shit cause I ain't the one
Poor punk muthafucka with a bat and a gun
To be beaten on, and thrown in jail
We could go toe to toe in the middle of the cell
Fuckin with me cause I'm a teenager
With a little bit of gold and a pager
Searchin my car, lookin for product
Thinkin every nigga is selling narcotic

73

But the politics had been watered down by the record company executives who made gangsta mainstream. Gangsta had become merely a more real blues for jaded palates like mine that required fresh fixes of social reality in pop form. (And with the assassinations of Tupac Shakur and Biggie Smallz the conventions of authenticity within the pop song expanded to include the singer's actual death.) Successful gangsta rappers were often accused of being "studio gangstas," as opposed to original gangstas, or O.G.'s, who were once actual gang members, living the life of murder and robbery and pimping they rapped about. (Debates about who was the original original gangsta took on a Duns Scotus–like how-many-angels-can-fit-on-the-head-of-a-pin quality. According to L.A. journalist Bob Baker, the original original O.G. was a Black Panther–inspired Fremont High School student named Raymond Washington.) But every rapper was to some degree a studio gangsta, insofar as it was the inauthentic authenticity that the white boys like me who made the rappers so successful wanted.

By the mid-'90s, materialism, licentiousness, dumb misogyny, and black-on-black violence had become the main themes of the genre. The message was not hope or rage, but "Who really gives a fuck?" Snoop was the poet of that particular vibe. His album, *Doggystyle*, produced by Dr. Dre, had sold 4 million units and made Snoop's murderous styles and poetical techniques a part of the identities of white teenagers everywhere.

McGrath turned her attention to Snoop's rehearsal. Onstage, a huge crucifix hung over an open coffin and dancers dressed as mourners were filing past it in misery and despair. "You know how much shit I'm going to get for those crucifixes," McGrath said to no one in particular. Snoop was offstage, but his voice was heard as though he was rapping from inside the coffin. He sang the first verse of "Murder Was the

Case." In the song, Snoop is nearly killed in a drive-by shooting, but just before he goes to hell he manages to make a deal with the devil for eternal life, and proceeds to "smoke weed, never have a want, never have a need."

Freddy leaned forward and whispered to McGrath, "Guy charged with murder singing about getting murdered—*very* interesting." In Los Angeles in 1993, a twenty-year-old man Snoop knew had been shot and killed from a car driven by Snoop, and Snoop was tried and acquitted of murder. It wasn't clear whether the song was about Snoop's remorse over the incident or whether he was laughing at the moralists who thought he should be remorseful.

Snoop himself appeared on the stage, in a wheelchair, with a mike in his hand. His eyes flashed, and he turned his head coyly and drawled his rap out of the side of his mouth, in a silky smooth, North Carolina style. He got up from the wheelchair, and different parts of his slim, lithe body shifted cleanly in the little eddies in the funk. As he walked offstage at the end of the song, he ad-libbed, scat style, "I'm innocent, I'm innocent, or maybe I'm guilty."

McGrath nodded, saying nothing. Snoop presented an arbiter like McGrath with an interesting problem, at least when viewed from a town-house perspective. As a leading influence on youth, MTV had an important role to play as a teacher and communicator, and by and large it took that role seriously. Kids learned tolerance, justice, responsible sex, and fair play from MTV. Or at least they could if they wanted to. What Snoop was up there rapping about had nothing to do with these values. Snoop was advocating more or less constant smoking of bubonic chronic (strong pot), drinking dat gin and juice, stealing and pimping with the homeys, and getting pussy from the bitches whenever you could, and some pussy for the homeys, too, because as Snoop himself points out on *Doggy-*

style, "it ain't no fun if the homeys can't have none." If someone disses you while you're in the process of enjoying yourself in this manner, you pop a cap in that nigga's ass. In the old world of values—the world that McGrath, like me, was old enough to remember—sentiments like these tended to be discouraged by the arbiters elegantiae. Protecting kids from individuals like the Dee Oh Double Gee was what the old tastemakers' moral authority was for. But in the 1990s, in which culture producers like Time Warner, Polygram, and Viacom (MTV's parent) were making vast profits from gangsta rap—indeed, gangsta was the salvation of the record business—the tastemakers' values were more complicated. The occasional protests of Time Warner's shareholders notwithstanding, the values of gangsta fit perfectly into a corporate system that esteemed profits over everything else. Led by gangsta, hip-hop had rescued the music industry from stagnant sales in rock in the mid-'90s. By 1998, when hip-hop sold more than 81 million records, 70 percent to white fans, the genre had passed country as the most popular category in all pop music.

MTV had been in trouble in the mid- to late-'80s, when the big-hair bands and their boring girly-girl videos made some viewers (like me) lose interest. But then hip-hop came along. Like MTV, hip-hop wasn't hung up on the distinction between idealistic and commercial impulses in art. In hip-hop, as on MTV, the politics of identity were happily married to the poetics of consumption. The politics of the rock world still gave lip service to the old Romantic opposition of art and the marketplace, and therefore rock had never been quite such a seamless fit with the values of MTV. In rock a distinction was still made between music created for some idealistic reason and music created for money. A rock song could be a commercial jingle, but a certain decent interval had to pass, and in becoming the sound track to a pickup commercial, say, a rock

song inevitably lost some credibility as a work of art. But in hip-hop a song could be an ad and a pop hit at the same time. The clothes the rappers were wearing in the videos might or might not be supplied to them by marketers. The best rhymes often turned on product names, which was why hip-hop lent itself so seamlessly to merchandising. Puff Daddy's hit "It's All About the Benjamins" was merchandising, advertising, salary-boasting, and art all at once. In L.A. gangsta rap, part of the proof of your seriousness as a rapper was the extent to which you were in it for the money, not for the art. Hence, Eazy E, of N.W.A., could proudly boast, "We're not making records for the fun of it, we're in it to make money."

McGrath's boss, Tom Freston, the head of MTV Net-works, had questioned having Snoop on the Video Music Awards, because there was reason to suspect that Snoop was not a very good dog. But McGrath argued in favor of Snoop because, she told me, "Musically, Snoop is happening now, and we have a responsibility to our viewers to show that. It *is* sort of scary that this is the direction the music is taking us, but we're not really in control of that, and if we try to control it, MTV is going to lose its edge, which is the thing that makes us great. Plus, it's a lot more meaningful to show this stuff— it's real. I'm sure if this were 1968 and I had put Hendrix on, people would have given me a lot of shit, too. You know, this is the world we live in. . . . I don't want to hold Snoop to a higher standard.

"And you can't argue with the music," she added after the performance had ended. That was true. The musicianship transformed the brutality—almost. The inventors of gangsta had discovered in the mainstream pop culture, especially mod-ern gangster films like *The Godfather*, *GoodFellas*, and *Scarface*, a style with which to talk about the appalling degradation and violence of inner-city life in L.A., and yet somehow to marry

that brutality to the peaceful easy feeling that was the essence of pop. The gangsta rappers had brilliantly reworked mainstream motifs into a language for talking about what was happening in their subculture—matters that otherwise never got talked about.

I asked McGrath what she herself thought of Snoop.

"I'm a forty-one-year-old white lady," she said, smiling. "What do you expect me to think?"

She leaned forward and asked Doug Herzog, then the head of MTV's long-form programming. "Are we concerned that we are smooshing our image together with Snoop's image?"

"Image is everything," Herzog said ironically.

"I don't know," McGrath said, leaning back again. "Maybe I'm not religious enough about the image."

The director of Snoop's performance appeared on the edge of the MTV circle. He was intercepted by Traci Jordon, a producer who was McGrath's liaison to the rap music world. Traci said, "Now, Snoop's not going to say 'chronic' or 'nigger' or 'weed' in this song, like I just heard him say, right?"

"No, he's not going to say it," the director said. "Don't worry about that. It's just that it's hard for Snoop not to say it, know what I'm sayin', but Snoop knows that it's not in his interest to say it."

"For this I went to Catholic school," McGrath said.

After the last run-through was over, McGrath asked Traci whether it would be cool for her to go and meet Snoop. She assumed the languid attitude of people being taken to meet the talent, strolled down the aisle, and found Snoop hanging out backstage with members of his Dogg Pound. The cool inside the Snoop circle made a marked contrast with the cool inside the MTV circle. The MTV cool was the feeling of just hanging out—of watching and reacting to things that happened around you, taking the energy that was offered and not giv-

ing it back. The cool of Snoop's circle was generated from within.

Traci said, "Snoop, I'd like you to meet Judy McGrath, the president of MTV."

One of the Dogg Pound said, "Yo, check it out, the president of MTV. That all right."

Snoop stood up to a full six foot four, put on his most debonair smile, took McGrath's hand, and said, "Yo, I just want to thank you for playing my videos and supporting me and having me here at this show, and I want to thank you for your support of hip-hop, you know what I'm sayin'." He made a little settling motion with his hand. "And that's all," he said. "Boommmm," he added, softly.

As we were leaving the stage, McGrath spotted Carole Robinson, the head of MTV press relations, and said, "Hey, we met Snoop."

"What happened?" Robinson asked, somewhat breathlessly.

"He thanked me!" McGrath said with wonder. She turned to Traci. "You didn't tell me how cute he is."

The three top executives at MTV, Judy McGrath, Sara Levinson, and Tom Freston, were too old to trust their own instincts in doing their jobs as Nobrow tastemakers. In deciding what to show on MTV, they had to rely more on intuition and market research than on their own experience. The golden gut by which the tastemakers in the old house of culture had operated needed to be combined with, and in some ways replaced by, a numbers-and-spin construct (the media equivalent of twine and spit). Doug Herzog, a rising star who would go on to run Comedy Central and then become Fox's head of programming, told me he tried explicitly *not* to rely on his own taste in making his

programming decisions. "I may say, okay, I like it, but I'm not in the demo," which is the fifteen-to-twenty-four-year-old strike zone the programming was aimed at (and which, like the baseball strike zone, had been getting gradually wider). "If I'm in love with something," he said, "then an alarm bell should go off."

MTV employees who were in the demo therefore constituted a kind of in-house focus group for the tastemakers to observe. The demo kids who worked there were for the most part college interns and production assistants, who made little or no money (all the interns were unpaid, and Freston described their working conditions as "a couple of cuts above the industrial revolution") and who were crowded together in warrens and windowless offices on the twenty-fourth floor of 1515 Broadway, the Viacom Building, one of the commanding structures in Times Square. Many had recently moved to New York. In addition to helping to advance their own careers as filmmakers, MTV provided its interns an instant source of roommates, dates, cool friends, parties, and free concert tickets, which made them the envy of everyone else they knew. Although they were mostly gofers—they pulled videotapes from the wackily colored file cabinets in the central hallway, and might even be called upon to set up producers' lunches or take out the garbage—demo kids performed their chores with a joyous and ironic enthusiasm. "Absolutely, man, I definitely am going to letter those cue cards right now, that's an *excellent* idea," I heard one say, as if he were Dean Moriarty in Jack Kerouac's *On the Road.* The veejays—the on-camera personalities who introduced the videos—whom you might expect to be the stars of the demo scene, were in fact regarded as mildly uncool by the demo kids in production, and rarely showed up on the twenty-fourth floor.

The walls of the cubicles where the demo kids work were

covered with rock-and-roll posters. There was usually music playing somewhere, and employees who thought that a particular song ruled were encouraged to crank it. It was a breach of office etiquette to ask your co-workers to turn their music down. "First, you close your door," writer Geoff Whelan explained to me. "Then you ask them to close their door. But you never ask them to turn the music down." Sometimes, when two demo kids, each carrying an armload of tapes, approached each other, you'd see one of them break out of normal walking stride and slide into dance mode—head bobbing, shoulders twisting to the beat, lips pressing together—and the other person would respond by grooving to the tune a little too. As the two crossed paths, one of them would say, "I love this song," and they'd rock out together for a moment before continuing along the hall.

As an employee emerged from the demo, he or she could become an associate producer, or A.P., and then, while the feeling of being in the demo was still fresh, a full-fledged producer. This period, when you were in your middle twenties, was a heady time to be at MTV. Ted Demme, who started *Yo! MTV Raps*—a pivotal link in the station's successful marriage with hip-hop—had the classic MTV experience. He started as an intern, got a job as a P.A. after college, and was a producer by the time he was twenty-four. "As a producer, you do a little of everything," he told me. "Comedy, *Top Twenty Video Countdown*, promos, the Video Music Awards. I got the idea for *Yo! MTV Raps*, made a pilot, they put it on the air, the overnights were excellent, and in a couple weeks it went to an hour every day. It was like—left hand, right hand, left hand. MTV really opened up the whole world for me. Where else can you be on top of the world at twenty-five—have 'producer' on your business cards, talk to the head honchos at record companies, talk to talent, and do whatever you want?" Demme left MTV at

age twenty-eight to make movies, and his credits include *The Ref*, starring Denis Leary, *Who's the Man*, with Dr. Dre and Ed Lover, and *Beautiful Girls*. But he missed MTV, and, like a star high-school quarterback who keeps coming back after he's graduated to sit in the stands and watch the games, he often returned to the twenty-fourth floor.

When one hit one's late twenties at MTV, a weird career anxiety began to set in, which was the reverse of what happens in most careers. Just at the age when people in other companies were starting to get loaded down with real responsibilities, people at MTV felt the pressure to leave, so that others who were closer to the demo could be brought up to take their places. Tom Freston told me that the average age of MTV employees was now twenty-nine—four years older than the average age in 1981, when MTV started—and that the average was rising at a rate of six months a year. A producer said, "It's like *Logan's Run* around here—you know, everybody over thirty disappears." For people at MTV who had gone from intern to P.A. and on to A.P. and producer—people "who don't know that this isn't what the real world is like," as one writer put it to me—the prospect of taking a job at a television network or an advertising agency was not pleasant. Glenn Ribble, a senior producer who started as a P.A. and left MTV at twenty-five to work as a freelance director of commercials and music videos, said to me, "There I was just handed the storyboards—the idea had been worked out by other people—and told, 'Okay, here's the way we want it, go shoot it.' Whereas at MTV I could do the whole thing myself." Now he was back at MTV.

And so, at the age when most people start dressing and behaving more conservatively, people at MTV adopted more radical attire than ever, and filled their offices with ever greater amounts of rock-and-roll memorabilia, and started talking even more like the moronic characters in *Beavis & Butt-head*,

one of MTV's most popular shows. Nevertheless, I was told by one twenty-eight-year-old writer, "On some days, you'll see some kid coming down the hall and start rocking to the tune that's playing, and you realize you just don't feel like it. You know, you're busy, you're tired, you've got stuff to do—whatever. And the kid says, 'Come on!,' like it's uncool of you not to do it. That's when you know you're too old for MTV."

An MTV writer said to me one day, "Judy McGrath would be the heart of MTV, if MTV had a heart." McGrath grew up in Scranton, Pennsylvania, and her voice still had traces of her hometown in it, although it seemed to have slowed down and become more aware of itself, in a way that gave it a Manhattan flavor. When McGrath was very young, she used to stand on a chair and pretend she was Leonard Bernstein conducting an orchestra. She spent most of her demo years getting a B.A. in English from Cedar Crest, a women's college in Allentown, where her youthful ambition was to be a writer for *Rolling Stone*. She worked briefly as a copy chief for *Mademoiselle* and as a senior writer for *Glamour*, and joined MTV shortly after it went on the air, starting as a copywriter in the promotions department. The "Devo Goes Hawaii" and "Win a One-Night Stand with Pat Benatar" spots were two of her early ideas. She became director of on-air promotions in 1987 and the creative director of MTV in 1991. In 1994, she was made president of MTV, which brought both the financial and the creative sides under her authority.

I spent an afternoon with McGrath, accompanying her on her rounds. On the way back to her office from lunch, Judy shared an elevator with the senior producer Glenn Ribble, who was carrying a large old clockface that he had bought for a dollar from a guy down on Prince Street, because Glenn

thought it might make a good prop in a promo. Also in the elevator were two interns who were completely trashing Lisa Loeb, a Brown-educated singer-songwriter. One intern said mockingly that he was going to shoot a video of himself walking around his apartment and earnestly telling the camera about *his* romantic problems, the way Loeb did in her video "Stay." McGrath listened quietly, with some dismay, and when she got out of the elevator told me she hoped that a theory of hers—that Loeb was part of an emerging genre she was calling "dweeb rock"—wasn't wrong.

Returning to her office, she passed Nancy Clayton, the head of viewer services, who was listening to a few of the hundred-plus messages that MTV's viewers leave each day:

"Hello, MTV! When is your birthday?"

"MTV is part of our family cable service, and the other night we watched five minutes of *Beavis and Butt-head* and saw them deface a wall mural. *Beavis and Butt-head* is only encouraging kids to commit these acts of vandalism. I need to spend additional money, get additional equipment to keep MTV off our television."

"I think *120 Minutes* sucks."

"Hi, MTV, I'm sixteen and I have to stay home all summer, and it's really boring and I just wanted say it's not fair that you have to be eighteen to be an intern at MTV, especially since your audience is teenagers."

We went into McGrath's office and sat down in front of the television, as we always did when we talked. Virtually all

the people who worked for MTV, from the lordliest executive to the lowliest gofer, could see MTV from their desks during the day. It was difficult to find a sight line at MTV that didn't include a monitor showing MTV. The youngest employees often worked with the sound on, partly because their bosses wanted them to absorb as much of the language and the sensibility of MTV as possible. (A writer who was interviewed for a job on one of MTV's game shows told me that he was asked, "Okay, do you know what 'phat' means?" "Yes, 'phat' means cool." "Do you know what 'fly' means?" "Yes, 'fly' means cool." And so on.) The older executives tended to watch MTV with the sound off, which is the purest way to watch it, in the sense that you've stripped away the music, which MTV does not own, and are left with the images, or, rather, the process of blending the images, the promos, and the ads into precisely the right cocktail of programming, which is the thing that does belong to MTV.

To get work done at MTV, you somehow had to trick your eyes—which were naturally drawn to the lollipop colors and frantic movement on MTV—into not staring at the monitors all the time. You wanted your eyes to receive the images in the way that the ears experience sound—as ambience. MTV was visual radio; it's something you just had on. This was a fairly easy environment for kids who grew up in the '70s and '80s to adapt to, since the television was on pretty much all day while they were growing up, and the Bradys, the Fonz, and Mr. Kotter were like people they hung out with. But MTV ambience was surprisingly disorienting to people who grew up in the '50s and '60s, maybe because when Dick Van Dyke and Ed Sullivan were on the tube you sat down to watch them as though you were sitting in the audience.

I adapted to the environment at MTV with mixed results.

Although I was in the demo when MTV appeared, and I watched a fair amount of it, it was not internal to my identity, as it would have been had I been born ten years later. When I had started making my trips along West Forty-third, I found that although I was trying to observe MTV as a place that exists in the physical world, I often got distracted by MTV as it appears on TV. Walking back from the distraction factory to *The New Yorker*, I would find myself remembering things I had seen *on* MTV—the stylized gang signals the rappers make with their fingers, Janet Jackson's belly button, the Icelandic singer Björk dancing on a flatbed truck—more clearly than things I had seen *at* MTV. Sometimes, on leaving the building and walking into Times Square in the middle of an afternoon, after I had been inside MTV for three or four hours, I would experience a two- or three-second synapse breakdown, when I wasn't sure whether I was passing young bodies on the sidewalk or watching them on TV.

The new Trent Reznor/Nine Inch Nails video came on McGrath's TV, and we watched it together.

I want to fuck you like an animal
I want to feel you on the inside

The imagery was surreal, but instead of jarring this member of the bourgeoisie out of my placidly limited sense of reality, as the works of the great surrealist painters like Magritte, Dalí, and De Chirico did, the video had the effect of inducing the kind of placidly dumb amazement of the couch potato, familiar to anyone who has ever watched more than a half hour of MTV.

When the video ended, McGrath said, "You know, I sometimes feel that maybe a twenty-year-old person should be do-

ing the creative-director part of my job. Why am I doing it? What do I know about being twenty?" In her office, she had a picture of her with Bono, R.E.M. and Nirvana decals stuck to her door, a Melvins poster propped up in one corner, and in another a large cutout of Elvis holding a rhinestone guitar. From the windows there was an amazing view of lower Manhattan, the Hudson River, and northeastern New Jersey, but the Empire State view in McGrath's office was the television set, and when I was there I had to remember to sit so that Mc-Grath, the TV, and I were in the proper relationship to one another. At one of our early meetings, I made the mistake of choosing a seat across from McGrath at the round glass table that she uses as a desk, which gave me the best possible eye contact with her but put the TV behind me. What happened was that McGrath made eye contact with the TV, and I looked over her shoulder and out the window at two of the four faces of the huge clock atop the old Paramount Building, right across Forty-fourth Street. During the conversation, I found my body turning almost instinctively away from McGrath and toward the TV, until by the end of our conversation we were deployed in a triangle familiar to anyone who has sat around watching MTV with friends.

"I guess my job is to keep us focused on a vision," McGrath was saying, her eyes on the TV. "Is the global thing the MTV vision, is it that we're not like other TV networks, is it that we are a TV network for youth? What is the vision? Every now and then, I say we need to start stressing the global thing, or whatever, and the staff throws up all over it, which is the right thing to do. They're very truthful, and it's in my best interests to take their lead. Sometimes I take the lead by reminding them of the hidden principle in what they do, showing them how the music can be used for prosocial stuff—I think that's

what I do best. My job is to keep reminding them that their work is worth something—that it's more than just doing promos for *Top Twenty Video Countdown*. Because of the nature of MTV, there is a certain anarchy to the place, so people tend to push the edge of things, and sometimes I step in and say this is over the line, and they rail. But they know I came up through MTV and I love MTV, so I think they trust me."

Now we were watching gangsta videos. I was learning how to include the videos in the conversation. The TV screen was a relay through which the dialogue was passed, and a little booster for when it lagged. Switching back and forth between talking to each other and talking about the videos was as easy as hitting the "last channel" feature on a remote control. We watched a block of Snoop and Dre, and now Beck was singing "Loser" and cavorting around a fire with an animal mask on his head.

McGrath went on, "People who work at MTV will tell you that this place is like *The Little Prince*—you never want to grow up—and that's true," she said. "I still care about who the next Nirvana is. And I don't know why. I am still trying to understand what the feeling I get from this stuff means. What are young people saying? What are they thinking about? I just want to know." She thought for a while in silence. "It's the chance to be forever young, I guess. I think MTV keeps you stuck in that place. You know, I still pay bills, make mortgage payments, go out to adult dinner parties, but here I just get to be the person I was in college."

McGrath, Sara Levinson, who was the head of marketing for MTV, and Tom Freston all exuded a certain hip, youthful quality that could last at least until fifty. They were successful executives, with children and marriage and divorce, but at the

same time they were studiously ironic, fun-loving, and icono-clastic. They were "having fun." As Kurt Andersen pointed out in *The New Yorker*, the adults of this generation tended to describe their jobs as "fun," unlike their parents, who de-scribed their jobs as "work."

But one day while I was around, real adult life encroached on the tastemakers' life at MTV. Sara Levinson was leaving. After twelve years with Judy and ten with Tom, she was leav-ing Times Square and going over to Park Avenue, to run NFL Properties, the NFL's marketing and licensing arm. The NFL, alarmed by statistics that showed kids weren't playing or watching football in the numbers they used to, had recruited the marketing whiz from MTV to sell the game to the younger fans, especially to that all important, brand-sensitive, eight-to-twelve-year-old demo. Although the rhetoric of football—the way the institution talked about itself—was still invested in muscular Christian values of physical culture (strong mind in strong body, etc.), the spectacle of football was now ruled by the new hip-hop values: identity expressed through cultural preferences. At MTV Levinson had been selling exactly what my high-school football coach tried to drill out of his players, rebelliousness; indeed, MTV helped make rebelliousness and antiauthoritarianism a mainstream commodity. Football, at least when I played it in the mid-'70s, was defined as every-thing rock and roll was not: it was discipline rather than hedo-nism, showing team spirit instead of doing your own thing—a jock/stoner dichotomy memorably expressed in the movie *Dazed and Confused*.

But if football was going to maintain its position as the country's number-one sport, it needed to adapt to the chang-ing values. That was where Levinson came in. Levinson knew nothing about football, but that didn't matter. Paul Tagliabue, the commissioner of the NFL, thought Levinson could help

the league to become more "proactive" about marketing the sport (or "the product," as the newer owners were calling the game) to the kids. "It's really an attitude more than something you can quantify," he told me. "It's more youthful. More iconoclastic." Over the last two decades, the sports landscape in which the NFL competes had been profoundly altered by other forms of media and entertainment. Just as the devotion to all kinds of culture—fashion, movies, celebrities—had grown in intensity to resemble the old-time fan's devotion to his sports team, so sports fanship had been diluted and become more like other cultural preferences. The playing field of the contemporary urban kid's imagination was as likely to be a basketball court or a computer screen or an iron banister in the park that he slid down on his skateboard as a football field. Video games now provided kids with the same sense of action, speed, and power that pro football used to supply; on the modern media gridiron, it wasn't Johnny Unitas vs. Bart Starr anymore; it was Brett Favre vs. Batman. In the late 1990s, it could well be asked, as a letter writer asked *The New York Times Magazine*, "If it is true that sports is no game, but is rather 'a hot, global entertainment product,' then why should anyone root for a team in the first place?" The answer, of course, was that people rooted for teams *because* they were hot global products.

"Basketball is the MTV of sports," Levinson told me, when we were discussing her plans for the NFL. "The way TV covers basketball, with the quick cuts, the music overlaid—it's much more like MTV. So the NBA skews young. Going to a basketball game—it's like being inside a video. But we have to be careful not to be MTV, because it would turn off our viewers at the older end of the demo." Kids related to rebelliousness, and the NFL was "not a rebellious force. We need to get into kids' skins before the rebelliousness starts to get really loud." Her solution: make football into a hip-hop video. In-

deed, gangsta and football were made for each other, though it took a marketing genius from MTV to realize that.

The MTV triumvirate's final business meeting took place after lunch in Freston's office. McGrath was wearing vintage-cloth-ing-store, Grace Slick–like attire—a shimmery rayon skirt, a blue blouse with big horn buttons, and leather sandals. Fres-ton, a good-looking guy with a slightly suggestive gleam in the corner of his eye, was watching Stone Temple Pilots on MTV, muted, while listening to the new Bryan Ferry album. I noted that his Lego pile of CDs was much bigger than my Lego pile. "Have you heard this album?" Freston asked me. "It's great." There was a large cutout of Beavis and Butt-head to his left, and a large cutout of Ren and Stimpy to his right.

Reading from notes, Levinson said that a daily two-and-a-half-hour block of music programming made by MTV would start running, in Hindi and English, on DD2 Metro Channel, in India. A similar block, of Mandarin-language program-ming, would appear in China sometime soon. This new ex-pansion could eventually increase the number of households with MTV from 250 million (nearly twice as many as CNN) to more than 500 million.

"We've started auditioning Hindi and Chinese veejays," Levinson said, looking up from her notes. "I hear the Hindi veejay is hunky."

"He's adorable," McGrath said.

Levinson ran through the state of MTV Japan, MTV Eu-rope, MTV Latino, and MTV Brazil, where there were prob-lems getting satellite space.

"Well, Brazil represents ten million homes, and we want to get in there," Freston said. "You know, cable is going to be forever."

"Can we quote you on that?" McGrath asked.

"Hey, there's the Woodstock van," Freston said, pointing at MTV. "I'm going to spend a night in that." Everyone talked about Woodstock for a while. Then Freston turned to Levinson. "So that covers it?"

"Pretty much," Levinson said. "Oh, Australia."

She said that Australia might have to settle for American or European programming, and not original Aussie programming.

"I don't think we want to do that in Australia," Freston said. "Australia is a very media-savvy country, and we don't want to look ridiculous."

Getting up, Levinson said she had to get back to her office to call to check on her son, who had an ear infection.

"So you're leaving as of one-thirty on Friday," Freston said. "That's it?"

"That's it," Levinson said, looking down.

McGrath was fidgety, turning her body from side to side in a girlish way, her shimmery skirt billowing in front of her. "I can't believe it," she said.

"Well," Freston said ironically, "change is good."

"Change is good," McGrath repeated glumly.

The three of them stood somewhat awkwardly in the doorway of Freston's office. On Freston's secretary's desk was a small basket of flowers. Freston picked it up and looked at the card. "It's from Coolio," he said. Coolio, a softcore gangsta rapper, was a current MTV star.

Freston held the basket out to Levinson. "Sara, I want you to have these, as a sign of our appreciation."

The culture of marketing, the marketing of culture: What really was the difference? It used to be, or so it seemed to me,

one could say reliably that this was culture and that was marketing. Culture came first. Culture was the way you made the apple crumb cake because your grandmother made it that way. Then came marketing, which was Martha Stewart's recipe for your grandmother's apple crumb cake. Marketing attempted to exploit culture for commercial ends. Culture was a spontaneous enthusiasm, a genius of an individual or a people; marketing tried to manipulate that genius—to sell culture back to itself.

But this once solid-seeming distinction was in the process of being overthrown everywhere I looked. On the marketing shelves at my local Borders, for example, one could find books with titles like *Selling the Invisible: A Field Guide to Modern Marketing, Street Trends: How Today's Alternative Youth Cultures Are Creating Tomorrow's Mainstream Markets,* and *Predatory Marketing: What Everyone in Business Needs to Know to Win Today's Consumer,* on the cover of which a scared-looking rabbit (the consumer apparently) was depicted crouching fearfully on a dinner plate. This new marketing had *demographics* on its side. Once demographics meant merely the mathematical study of populations and the science of creating standards for measuring births, marriages, and deaths. With urbanization, demographics had been adapted to predict the future of populations, so that road builders, airport planners, and high-speed cable providers could predict future demand. These principles in turn had been adapted by marketers into a pseudoscience of "trends" and "psychographics" for the consumer society, which was supposed to help the culture industry to decide on clothing designs, movie endings, and what kinds of videos to show. Demographic information, market research, and the characteristic "click streams" of the Web surfer seemed on their way to replacing class, ethnicity, and geogra-

phy with patterns of consumption. To the extent to which you were "trending," in Faith Popcornese, you ceased to exist as a unique being and became a part of a demo.

The longer I spent around MTV, the more I began to suspect that where you drew the line between culture and the market was largely a matter of when you were born. This was the real source of the difference between the generations—the degree to which some ineffable sense of market culture had been made a part of your point of view, by exposure to that culture, in the form of TV, from an early age (or, actually, from the time you were still in the womb). MTV had dramatically closed the feedback loop between culture and marketing and made it much harder to tell one from the other, or which came first. And now MTV had produced a new audience for whom the distinction between the market and culture was almost nonexistent.

Even the highbrow pop culturists, the cineasts, like the writer and director Michael Tolkin, were taken aback by how little regard aspiring filmmakers had for the pop canon. He told me about a lecture he gave to film students in which he mentioned Jimmy Cagney and was shocked to discover that virtually none of them knew who Cagney was. "People in their twenties have for the most part no memory of history or art or anything else that's older than fifteen years," he said. "This generation, which grew up on cable TV, and on more recent movies, has been spoon-fed culture that was much more market-oriented than the culture of an earlier generation. Today the marketer is within." In other words, the younger artists made their art with an internal marketing barometer already in place. The auteur as marketer, the artist in a suit of his own: the ultimate in vertical integration.

* * *

Toward the end of my time at MTV, I rode out to the MTV Beach House in eastern Long Island with Andy Schuon. Schuon was the head of music and programming for both MTV and VH-1, a fledgling sister station that had not yet established a set of Nobrow distinctions for itself but soon would. Insofar as any one person was responsible for the video-to-video flow of images on MTV, it was Schuon, who was originally a radio guy. He was a boy-wonder deejay, who started working in Reno when he was fifteen and moved quickly to different radio stations around the country. He skipped college and ended up as the program director of KROQ, a big L.A. rock station, when he was twenty-five.

Schuon was a fast-food enthusiast—for his thirtieth-birthday party recently, his colleagues had feted him with Quarter Pounders, cold french fries, chocolate shakes, and pizza—and from time to time as we were sitting in traffic on the Long Island Expressway he would say he couldn't wait to stop at the 7-Eleven at Exit 70 for a Super Big Gulp, 7-Eleven's forty-four-ounce container of soda. "You got to love it—a Big Gulp," he said. I sensed that somewhere in Andy Schuon's exact relationship to a Big Gulp might lie an important Nobrow moment, but if so I never quite grasped it.

Big Gulps in our laps, I asked Schuon whether he worried about getting older.

"No way," he said. "Hang around MTV all day, go to concerts, listen to new music, go to Roseland—you'll never grow old. You *won't*."

The sun was going down when we arrived at the Beach House, a nice shingled house on the beach that MTV had rented for the season. A crew of about fifteen demo kids was busy setting up for an evening performance by Babyface, a well-known R&B singer-songwriter. They were supervised by a Brit named Lauren Levine, who said that the crew was all

completely "fagged" because they had been up until three in the morning the night before, "just raging." Earlier that afternoon, as on most afternoons, there had been a group of real-life demo kids hanging out around the pool, serving as extras in the veejay segments. Levine said, "Some of these kids we had this afternoon were so beautiful it took your breath away." She put her hand over her heart and looked at me wide-eyed.

Three young women were on phones upstairs recruiting an audience for this evening's Babyface performance. They were working with annotated lists ("cute guy," "sexy," etc.) of the names and numbers of kids who had been at the Beach House before. When I asked one of the women, Lisi Gottleib, how they had found the kids in the first place, she replied, "Well, we found a bunch of them right out here on Montauk Highway. There was a car accident, and a bunch of kids were standing around, so we went out and said, 'Hey, do you want to come to the Beach House?'"

From the upstairs terrace, I could see the demo kids massing out on the road. Security personnel led them, in batches, past the Beach House and down the steps to the beach. I was thinking of the scary fans in Nathanael West's novel *The Day of the Locust*, that strange race of autograph seekers and stage-door waiters who seemed not of this Earth. These kids were not like that. The kind of pop-cultural fanship that seemed so unnatural to West and Ray Bradbury is just everyday life in the '90s. Without pop culture to build your identity around, what have you got?

Two girls slipped out of the line and got into the Beach House itself, but Levine intercepted them.

"Bill Bellamy told me it would be cool if we just came over and hung out," one of the girls said.

"This is a television set!" Levine said, trying to look incredulous at such a boneheaded remark (difficult to pull off,

for this was, after all, the point of the Beach House—the ironic confusion of real life and TV life). "You can't just 'hang out' here."

Once all the kids were seated on the beach, the producers began walking back and forth, looking them over. The most attractive-looking kids were chosen for the prime seats, around Babyface, where the camera would most often take them in, and the less attractive kids were placed farther back.

Now Lisi Gottleib had a bullhorn and she was saying, "Okay, we're sorry if you get separated from your friends."

She explained that MTV was making a video out of Baby-face's performance, and that, to save money, they were shooting with only one camera. Therefore, they were going to film Babyface singing the same song five or six times, and, for the sake of continuity, the kids had to stay put.

"Once you're in your seats, please don't move," Gottleib went on. "You cannot go to the bathroom." The kids sat in a tense circle on the beach, obediently submitting to this directive, in the service of MTV's youthful ideals.

The famous veejay Kennedy came down the stairs and took a pratfall into the sand, then stood with her back to the kids. A shiver of "Kennedy!" ran over the huddled audience. Two teenage girls got up and came over to where Kennedy was talking to a crew member. Kennedy did not acknowledge them. One girl took a lock of Kennedy's long dark hair and just held it. Kennedy still didn't acknowledge them. Suddenly, she whipped around and gave the girls a huge, fake-ironic smile, said "Hi!" sarcastically, and turned her back on them again.

I retreated up the steps and found Levine, who was looking back at the Beach House, which would be in the background of some of the shots. "Isn't it lovely?" she said, pointing out the way the pool lights were playing off the side of the house. "I see that and I just think, *Deep Thoughts* by Jack Handey."

Andy Schuon came up the steps from the beach. I said that I was considering "heading out."

"You're not going to stay for the performance?" Levine looked crestfallen. I apologized. The culling of the cute kids from the noncute had brought back bad memories of what it's really like to be in the demo, and I was depressed.

"I'll watch it on MTV," I said.

4

The Next Kurt Cobain

George Trow, who foresaw the future so long before it arrived that he wrote about it in the past tense, described commercial culture as two grids in "Within the Context of No Context." There was the America of 200 million and there was the America of you and me. De Tocqueville had similarly observed in the United States in the1840s that in the absence of a definite sense of the reality of the social world, Americans tended to be pre-occupied with their own identities. "In democratic communities, each citizen is habitually engaged in the contemplation of a very puny object: himself. If he ever raises his looks higher, he perceives only the immense form of society at large or the still more imposing aspect of mankind. His ideas are all either extremely minute and clear or extremely general and vague; what lies between is a void. When he has been drawn out of his own sphere, therefore, he always expects that some amazing object will be offered to his attention; and it is on these terms alone that he consents to tear himself for a moment from the petty, complicated cares that form the charm and the excitement of his life."

Nobrow had progressed along Trovian or Tocquevillian lines. As the big grid grew ever more massive, with

the merchandising-driven, corporately compromised state of global culture—Star Wars, the Super Bowl, Michael Jordan, Las Vegas, the Stones' last stadium tour, the next Disney-Broadway spectacular—the small grid became tighter, more intimate, auguring in on itself. The blockbuster sequels to the blockbusters had proliferated. On the worst of them, the ones that had reached their end life as content, the public could smell death and stayed away—but it hardly mattered. One of the basic truths of the big grid was that a culture project that relied on artistic execution was riskier than a market-tested project that would make money even if it was bad, because it was well marketed, solidly targeted at the all-important under-twenty-five-year-old-male demo, and because Stallone was huge in India. And the content of these big-grid events was shape-changeable, and it kept coming back, in the form of books, videos, computer games, merchandise, and Happy Meals, so that even if, say, a movie bombed at the box office, the studio had a shot at making money. Besides, the global big-grid marketplace was so new, the distribution so vast, and the numbers involved so big that no one really knew if the big-grid projects were making money or not.

As capital became more tightly concentrated, the market-place became ever more decentralized. A vast array of cultural riches bloomed like algae across a swamp. As the big grid filled people with the revolting sense that everything in their lives is mediated, they turned to the little Scottish bands and the street rappers—artists who were "independent" and art that was "authentic." Then, as the small grids fragmented society into ever-smaller niches, each isolated from the others, people turned to the big grid for unity. Occasionally—and with greater frequency, over time—the global grid of 5 billion and the personal grid of one lurched into alignment. The death of a princess, the terrible last hours of an Everest victim, and the

warmth of an intern's mouth made intimacy and massiveness feel like the same thing.

MTV's business, in a sense, was to make small-grid art into big-grid art, expertly harvesting the Buzz thrown off by the changes in grid scale. This was the thing that MTV had changed most about the world: it broke down the old barrier between big grid and small grid, mainstream and under-ground, mass and cult, it and you. Before MTV, art made for the mass audience and the art made for a cult audience had been mostly detached and distinct from each other. There were local, folk-based enthusiasms for teams, bands, or au-thors, and there were mass audiences. Mass-culture products sometimes started as folk products, but they grew slowly over time, and once they were massive they tended to stay that way. But that all changed with the release of Nirvana's second al-bum, *Nevermind*, on the Geffen label, in 1991. Expected to sell two hundred thousand copies, it went on to sell ten million.

Prior to Nirvana there had been overnight pop sensations, of course, but never before had a cult band—a band that de-fined itself against the mainstream commercial culture—become part of the mainstream so quickly. After Nirvana, it became common for hip-hop acts who were on the street six months ago to sell millions of records, or for a band like Radish, which had no folk following other than the band's parents and friends—a band that had never even performed live before—to have millions of "fans" with one song and a good video. Thanks to MTV, the avant-garde could become the mainstream so quickly that it made meaningless the old antithesis—either avant garde or mainstream—on which so much critical theory, from Clement Greenburg through Dwight MacDonald, rested. Kurt Cobain was a martyr to the end of this antithesis: he wouldn't have killed himself if he hadn't sold so many records.

* * *

By eight forty-five in the evening, when Chris Luongo arrived at CBGB, the long, narrow bar was packed with rock-industry weasels. Some dressed in suits and sporting ponytails, they had come downtown to Bowery and Bleecker from their corporate towers in Times Square to hear "the next Kurt Cobain" perform the first of three Manhattan "showcases"—promotional events that a band's backers arrange in the hope of getting a record contract.

Chris Luongo, a thirty-year-old talent scout with Pure Records, got through the crowd and went to the front of the stage, where young Ben Kweller was checking a floor amp. Luongo had been following the band for months and had already listened to a three-song demo tape, but, he said afterward, "I couldn't believe that this fourteen-year-old boy was the same person who had made the music I'd heard." Ben looked around twelve, with smooth white skin, blond hair, and braces. He was purposefully setting up his equipment, in a way that reminded Luongo of "the introspective child you might see off by himself in a playground."

But as soon as Ben began to play, Luongo said, "It was clear that he belonged onstage." Not only could he sing like a grown-up rock star, with a big hoarse voice, but he seemed to know how to move like a grown-up rock star, to execute that simple opera of rock gestures that rivets your eyes to the performer. How did he know how to do all that?

Ben mostly played in the slacker-slouching-around-making-a-lot-of-noise, Cobain style, once in a while throwing in swooping ax chops with the guitar neck or guitar-as-extension-of-penis thrusts reminiscent of Slash. The music brought the guys in suits forward from the bar until they were pressing against the front of the stage. The band swung into "Bed-

time," which started out with Ben sounding like a little boy, singing, "I think it's past our bedtime, let's go to sleep," in an ethereal Peter Pan voice. Then at the chorus the rock-and-roll animal came out and roared, "I DON'T UNDERSTAND THE QUESTION!"

After the show was over, Luongo found Ben backstage, introduced himself, and said, "God, I'd give anything to do what you just did." But Ben seemed to have reverted to his little-kid self again. He was like a boy who had been temporarily possessed by a rock star. In his sincere, adorable way, he said, "Well hey, Chris, maybe you can live vicariously through me, man!"

The next day Luongo's boss, Arma Andon, called Dana Millman at Mercury Records and told her she should catch Radish's second showcase, which was taking place that night at Coney Island High, a club on St. Mark's Place. "I had heard about the age thing," she said. "But once Ben started playing, he was ageless." As Millman left the club, she took her cell phone out of her purse and called her boss, Danny Goldberg, at his town house in the Village. "Which I never do," Millman told me later, "because Danny's a family man. I said, 'Danny, you have to see this kid play tomorrow night.' "

Goldberg said, "Dana, I'm putting my kids to sleep!"

"I said, 'Danny, just promise me you'll see this band tomorrow.' "

So the next night Goldberg himself went to Don Hill's, which is on Greenwich Street at Spring, for Radish's final showcase. By now, the Buzz about the band had spread to other labels, and the crowd that night contained a substantial proportion of the middle-aged men who helped create the rock-and-roll industry: Seymour Stein of Elektra; Chris Blackwell of Island Records; the producer Don Was. The kid put on his rockingest show yet, performing a move that most

rock stars were too old to perform: a flying, mid-riff leap off the stage, which he capped by playing an electric serenade for a tableful of top music-industry lawyers.

"You can find songs that rock but don't have good melodies," Goldberg told me later. "And you can find songs with good melodies that don't rock, but it's rare that you find both. Ben was up there with braces and this angelic face, but the songs were finished adult compositions." He added, "There was a youthfulness, a joyousness, about Ben that was very exciting." At the same time, the music didn't challenge any assumptions about what rock and roll should be. It was safely "alternative" and would fit easily into the preexisting college-grunge and alternative-radio formats that dominated the radio. This was good, because, for all the rebellion that rock music suggests, the rock industry had become a very conservative business.

After the show at Don Hill's, Roger Greenawalt, the band's manager, took the boys down into the club's cruddy basement, in an attempt to shelter them, he said later, from the almost tangible waft of greed on the floor. But Mercury sent a scout down there anyway, and they were invited to come to Goldberg's office the following morning. There, on a high floor in Eighth Avenue and Fiftieth Street's Worldwide Plaza, with astounding views of Manhattan, Goldberg went into what he later described as "my selling mode."

Goldberg, lanky, forty-six years old, with modishly wavy hair and Buddy Holly glasses, was a prominent tastemaker in Nobrow. Like his friend Judy McGrath six blocks down Broadway at MTV, Goldberg could not afford to rely entirely on his own instincts as a tastemaker—he was too far out of the demo

for that—so he relied on a combination of instinct, market research, and logic to pick hits.

In courting young Ben, Goldberg was assuming that the fifteen-year-old kids who bought records would respond to a singer-songwriter their own age. This assumption—based in part on the recent success of young Alanis Morissette, the single megaselling rock act that the business had managed to produce in recent years (her album *Jagged Little Pill* sold more than 15 million copies)—had led to a rock industry boom for so-called baby bands like Silverchair, a group of Australian teenagers, or the Stinky Puffs, who were the project of Chris Novaselic, the former bassist of Nirvana. Who better to speak to the longings of the teenagers in the demo than a rock star who was just about to turn fifteen? Operating under this logic, Goldberg had already signed one baby band—an unknown group of three teenage brothers from Oklahoma called Hanson—and now was hoping to add Radish to Mercury's roster. Ben might or might not be a great artist, but he was definitely a kid, and in the demo-driven world of pop in the '90s, a kid was a surer bet.

Like all cultural capitalists, Goldberg had more misses than hits. Marx famously declared that production produced consumption, but while that was true in many industries, it was not (yet) the case in the culture business. Producers of automobiles had learned to advertise and market their products to create consumer demand, which could be predicted and planned for in advance. But similar attempts at rationalizing cultural production met with only limited success. Branding, the most successful way of distinguishing consumer goods from one another, did not work when applied to most culture products, with a few exceptions like Disney's animated movies, "name brand" authors of popular books, and *Star Wars*. Focus

groups and market testing didn't work very well either, as a way of attempting to predict consumer demand. The notion that you could ask people in a focus group what they wanted from a movie or a band, just as you could ask them what they wanted from a shaving cream, was fundamentally flawed, because people in focus groups responded as members of groups—as a market—but what they wanted from art was to be spoken to as individuals.

Nevertheless, as the town house became the megastore, the marketer-arbiters like Goldberg became very powerful. The old businessmen-arbiters, the moguls like Louis B. Mayer and Jack Warner who owned or controlled the means of production, had been replaced by marketers whose role was to make scrumptious little idea packages to wrap around the content. A subtle but all-important step away from the authority of the individual and toward the authority of the market had been made. The artists themselves, who had once taken orders from the producers, now took orders from the marketers. The proliferation of channels for creativity, from up-band cable-TV stations to the Internet to CD-ROMs to zines, had given writers, artists, filmmakers, and musicians new leverage in the struggle with the owners of capital. This had been predicted by the futurist George Gilder in his 1990 book, *Life After Television:* "The medium will change from a mass-produced and mass-consumed commodity to an endless feast of niches and specialties. . . . A new age of individualism is coming, and it will bring an eruption of culture unprecedented in human history. Every film will be able to reach cheaply a potential audience of hundreds of millions." But ironically, while the artists had won the means of production, in the resulting cultural deluge they'd lost the means of getting the audience to notice them. Yes, as the channels of distribution multiplied, what economists call "the barriers to entry" fell in the culture in-

dustry. Yes, technology had made publishing and recording on the small grids much cheaper than it used to be. Undiscovered pop stars no longer needed labels to front them the money to make records. You could literally make a CD in your bedroom with a computer and software to create a soundscape, a remixer to clean up the sound, and a wax machine to press the disk. "Twenty years ago," Goldberg told me, "Stevie Wonder, to make 'Songs in the Key of Life,' spent months in the studio getting all the sounds he wanted, and only Stevie Wonder could do that. Now anyone can. Ninety-nine percent of the sounds you can imagine are available to you digitally. It used to be you'd say, 'Can I have a violin player?' and the label would say, 'No, you can't have a violin player—it's too expensive.' 'Can I do another vocal?' 'No, there's no time to do another vocal.' Those constraints don't exist anymore."

But because more people could make art, more did. The market became flooded with art. There was too much art in Nobrow—too many artists, too many film festivals, too many books, too many new bands, too many "new voices" and "stunning debuts." The real and important artists had to compete for attention with the worthless time-wasting hacks. The artist had ended up as much, if not more, in the thrall of the marketers as he was in the thrall of the producers. One could make the independent film, sure—it was getting a distributor for it, when it didn't fit into any of the marketing categories, that was the problem. And while the marketers were always getting better at defining these categories—gathering more research, refining the demographic niches—the old methods of creative inspiration remained unimproved.

This was happening not just in the music industry but all over the megastore. In magazine publishing, my neck of the store, the editors who arbitrated the writers' works acted much more like marketers than they used to. Cathleen Black,

the president of Hearst Magazines, said in a speech in the spring of 1997, "Time was when it was enough for an editor to have a Rolodex full of writers' names . . . but today it's also necessary for them to steward their brands into other media, and outside the realm of media." In the magazine world in general, advertisers had become more a part of the editorial process than they used to be. IBM pulled all its advertising— $6 million a year—from *Fortune* and placed all its employees off limits to *Fortune* reporters as a result of a piece that the company thought was unfavorable to Louis V. Gerstner Jr., its CEO. At *Esquire*, the literary editor, Will Blythe, resigned when a David Leavitt short story involving homosexuality was pulled on the eve of its scheduled publication; the magazine's editors maintained that the story was pulled for "editorial reasons," but Blythe believed otherwise, having learned that the magazine was expected to notify Chrysler, an advertising client, of any "provocative" content that the conservative car manufacturer might not want appearing alongside its ads. He wrote in his resignation letter, "The balance is out of whack now. . . . We're taking marching orders (albeit, indirectly) from advertisers." Magazines fought against the erosion of their editorial independence, but the age of content was working against them. There were too many magazines—852 start-ups in 1997 alone—chasing too few ad dollars, and as a result advertisers could demand concessions that they never got before.

It was an age of one-hit wonders, an age more favorable to art than to artists. Because talent was rare, and because the big-grid marketers were always on the lookout for independent talent to feed the demand for authentic content, many small artists who were successful as real independents were hauled up to the big grid before they'd had time to mature. The lesson is that independence sells, and the price it sells for

is the end of independence. As the filmmaker James Schamus said to me, "You want to be independent? Sharpen your pencil and write a poem."

As true independence became a nostalgic memory, the idea of independence became ever more marketable still. "The new artist is expected to be the new messiah," the director of New York's Public Theater, George C. Wolfe, told me. "The whole concept of the journeyman artist has disappeared. You are not allowed to go on a journey. There is no journey. You're either extraordinarily brilliant or you're dead." Instead of the small grid improving the big grid, the big grid was sucking the life out of the small. In the theater world, Wolfe went on, "a corporate thought process is beginning to dictate what has always been a small, individual- or community-driven art form." The reason was that in response to rising costs Broadway producers had made alliances with corporations, and this had brought about a relentlessly box-office-driven approach to Broadway theater. "As the commercial landscape gets more and more bland in an attempt to appeal to everyone," Wolfe said, "the pressure's put on the not-for-profits to be what Broadway used to be once upon a time—to provide exciting and challenging theater for the commercial landscape. As opposed to being what the not-for-profit originally was, which was a breeding ground for maturing talent, and an alternative to the commercial landscape. We're instead expected to pick up the slack. So in the nonprofit world you have to be smarter about every single thing that you do. There are plays that I did two or three years ago at the Public which I would be very cautious about doing now, because I now understand that I'm not just letting a new artist be discovered, I'm introducing a new 'product,' which is a daunting task."

The tantalizing amoral twilight between the big grid and the small was lit with sparks of artists in transit between small-

grid success and big-grid failure—the small-grid prodigies like Ben arcing upward and feeling that wallop as their identities got bug-zapped by big-grid money and fame; the thirty-year-old big-grid has-beens drifting back onto the small grid like ashes, spent and forgotten. The midspace between the grids was Nobrow: an apocalyptic heath which the midlist authors, the good but not brilliant filmmakers, and the solid but not spectacular bands, who once comprised the middle of the culture, haunt like ghosts. Hey, there's Fiona Apple. Cool—Britney Spears.

Within a week of the showcase at Don Hill's, fourteen different labels were participating in a major bidding war for Radish. People in the industry were saying, "Don't you just love Ben?" to others who had met him. And Ben *was* lovable, in his sweetness and his boyish purity, in the way he said, "I love you, man," with such openness, in the way he was quick to hug you, the way he seemed to drink you in, and most of all the way he seemed like a golden version of your own youth. The mutually exploitative relationship between adults and children that characterized Nobrow as a whole was represented in the relationship between the innocent but knowing Ben Kweller and these jaded but needy record-industry honchos. Ben, marketed to the world as the next Kurt Cobain, was being made into a standard-bearer for the old guys' music, the guitar-playing singer-songwriter in the alternative format that the original Cobain had helped to create, and that was steadily losing new fans to hip-hop.

Roger Greenawalt: "When I met Ben, I said to myself, This is terribly interesting, because he's the strangest prodigy I've ever known. Most musical prodigies obsess about playing. It's all about you and your relationship with your instrument. Ben is obsessed not with playing but with songwriting, sing-

ing, and, above all, acting like a rock star." Paul Kolderie, who, with his partner, Sean Slade, remixed Ben's first album, rejected the notion that Ben was any kind of prodigy. "He's just a talented, bright kid who has watched a lot of MTV," Kolderie said. "When we were kids, you know, if you wanted to be a rock star you could watch *Don Kirshner's Rock Concert* on Friday night, or *In Concert*, and that was it. Today, rock stars are on TV twenty-four hours a day. There are constant cues on how to look and act like a rock star, and the kid is smart and he picked up on them. To some extent, he's aping them, but he's a quick learner."

Ben *was* authentic, in the sense that he really was a kid. Ross Elliot, a scout for Viacom's Famous Music, which ended up with the publishing rights to Ben's music, told me that what made Ben great was that his songs were about teenage experiences he was actually having himself as he wrote them. His teenage fans would be hearing the real thing, the feelings of a fifteen-year-old just like them, not some fat old geezer in grease paint and a wig. "All of us in the music business fucked up," Elliot said. "We kept throwing alternative bands at these kids, and they couldn't relate to it and started buying rap instead. But Ben is the audience. What's coming out of Ben is raw shit. 'Apparition of Purity'!" Elliot exclaimed, referring to one of Ben's songs. "That's not coming from a jaded place." He made a gesture toward his own chest. "That's coming from a pure place. Ben is honest. He's so young he can afford to be honest. All this stuff people write songs about, like why does love have to be so sad—that stuff is happening to Ben right now."

Elliot also thought that Ben, who couldn't read music very well, was an intuitive rock genius, and to illustrate this he told me the story of having Ben over to his house in Manhattan with six or seven older musicians. "These were serious musicians, right, guys in their twenties and thirties, and we were up

on my roof trying to figure out Beatles songs," he said. "Ben would say, 'Oh yeah, here it is, you invert that, and that's a G-sharp diminished fifth'—not taking the easy way out, you know, but getting the chord progressions exactly right, the passing chords and everything. And doing it all by ear! These other musicians were just staring at him, going, Who is this kid?" Elliot added that Ben displayed precocious gifts in an area that's at least as important to being a rock star as musical talent: attracting good-looking women. One night, Elliot took Ben and a band of adult guys to Freak Night at Don Hill's, where there was the usual complement of beautiful twenty-five-year-olds. "Those other guys didn't stand a chance," Elliot said. "This one girl came up to me and said, 'So, what's going on with Ben later?' By the end of the evening, it was just Ben sitting at the table with these six beautiful chicks, who were all totally into him."

For Ben, a shy, unathletic kid who had never been particularly popular in school, all this attention was "pretty surreal." Up until the time of the bidding war he had lived in a small grid of family, high school, and small-town life. His audience was his parents, his friends, and the girls who worked at the local diner—he had signed their menu. Now, thanks to the easy changes in grid scale made possible by MTV, he was about to be famous. That great beast, big-grid celebrity, swinging its Cyclops eye across the savanna of small grids, had suddenly trained all its attention on *him*.

At first, Ben's parents, the Kwellers—his father, Howie, was a G.P. at Presbyterian Hospital in Greenville, Texas, and his mother, Dee, had a degree in counseling—had been startled to find themselves with a rock star under their roof. The offers that were coming in for their son represented more money than either Howie or Dee would see in one place in

their lifetimes: $2.5 million for a kid no one had heard of, with a band that had played mostly at school dances and coffee shops. Dee told me, "We said to him, 'Now, Ben, you're sure you don't want to finish high school and college before you start this?' But Ben didn't want to wait. He feels like he's been waiting all his life. How can you tell a fourteen-year-old to wait six years? He said it's his destiny, and I truly believe that. The time is now. The songwriting is there, and it can't wait anymore." Yes, there were lots of girls and drugs and alcohol around the rock scene, "but we have tried to give Ben good values about that. Like with Kurt Cobain, who is one of Ben's heroes. We said, 'Now, Ben, it's okay to respect Kurt's music, but you can't respect what Kurt did with his life.' And Ben said, 'I know that.'"

In June, Howie, Roger, and Ben went to L.A. to meet with label people there. Madonna invited them to her house for lunch and nearly persuaded Howie and Ben to sign with her label, Maverick, on the spot. While they were hanging out, Anthony Kiedis, of the Chili Peppers, drove up on his motorcycle. The following day, a white limousine pulled up in front of the Kwellers' hotel and took them up the Pacific Coast Highway to Malibu, where they visited Jimmy Iovine, the head of Interscope Records, in his princely villa on the beach, which occupies a few acres along the Pacific, right next to Danny Goldberg's villa. Iovine had invited a few friends over to watch the middleweight-championship fight—Axl Rose, Tom Petty, Joe Strummer, and Dr. Dre. For Howie, it was as if he had died and gone to the Hard Rock Cafe in heaven. He grew up in the era when rock stars and their fans were connected only by a few hard-to-find fanzines—when the secret of how Jimmy Page fretted his guitar to make that sound in "Whole Lotta Love" was a kind of occult knowledge, pos-

sessed only by the true faithful. But Ben, as a child of modern media, knew exactly how to be cool around rock stars like these. It was just like watching MTV.

While everybody was chillin', someone brought out a guitar and passed it to Petty, who made up a song on the spot about "Jimmy Iovine and his football fields of green," which was an allusion to a regular touch-football game that various rock stars and label guys used to play together in L.A. (and also, of course, to the piles of money Iovine had made in the pop-music business), until their wives made them stop because they were getting too old and were coming home injured.

"Then he passes the guitar to Joe Strummer," Greenawalt told me, "and everybody goes, 'Joe! Play "London Calling," Joe!' And Joe says, 'Fuck you! I'm not playing "London Calling"!' And then he plays it. And then Joe says, 'Here, kid, catch!' and flings the guitar into the air in the direction of Ben, who is sitting like twenty-five feet across the room. The guitar floats in the air over Iovine's million-dollar glass coffee table and priceless tchotchkes, but Ben stands up and calmly catches it, sits down, and plays a couple of his songs. And when he was done those guys really gave it up for him."

In the end, Danny Goldberg's relationship with Kurt Cobain (Goldberg was Nirvana's manager and Cobain's friend) was what helped carry the day for Mercury. Goldberg even had Cobain's widow, Courtney Love, give Ben a call. "I pick up the phone and there's this chick on the other end, who doesn't say who she is, she just starts talking really fast," Ben told me. "Like really fast, saying that she heard my songs and really liked them and on and on, until finally I figure out that it's Courtney Love I'm listening to. Dude, like I don't even know how she breathes she talks so much. I guess it's like being a bagpipe player—you got to learn to breathe through your nose."

Under the terms of the deal they eventually worked out, Ben, who wouldn't have full access to his money until he turned eighteen, got $750,000 as a signing bonus, and a "three firm" record deal; that is, three records, whether or not the label releases them, plus a 13.3 percent royalty rate, of the kind that top bands like U2 get, and—unheard of for an unproved talent—creative control. Ben also signed a music-publishing contract worth $1.2 million.

Goldberg wanted Radish to build up a local following around Dallas prior to the release of the band's first album, *Restraining Bolt*. He felt that Radish should be from Texas—from somewhere real, and not just from the music industry, like a '90s version of the Monkees. (Already, the *Dallas Morning News* had done a story in which a reporter went to hear Radish in a local club and noticed all the middle-aged men with ponytails and Armani glasses sitting around at the back of the bar.) On a Saturday night in late January, Radish was to play two gigs in the Deep Ellum section of Dallas. Ben told me he was planning to take a nap between gigs, but that didn't seem likely. He was sitting on his bed in his bedroom. John, the drummer, was lying on the floor with his hands behind his head; Bryan, the bass player, whom the boys call Brain because he went to college and knows so much, was leaning against the wall. Ben's bedroom was maybe a bit neater than usual; his mother had made him clean it up for my arrival. Ben, a big *Star Wars* fan (*Restraining Bolt* was an allusion to the scene in which Luke fits R2-D2 with a restraining bolt, so that the little droid won't run away), had three *Star Wars* posters on his walls, along with a big poster of Kurt and an even bigger poster of the lead singer from Weezer, Rivers Cuomo.

I looked at the *Star Wars* posters, thinking that *Star Wars*

was what Ben Kweller and I had in common. It was something we could share, maybe even believe in, in a peaceful, prosperous time in which there were no historical events to unite us. Paul LeClerc, the president of the New York Public Library, once asked me during an interview if I thought it would be possible for a single work of art of any kind to have the cultural impact today that Goethe's *Faust* had in Europe in the early nineteenth century. "If not, then what we've seen is a huge shift in the relationship between consumption and cultural output," he said. "In our day, with so much information coming through the line, and with the constant necessity to shift between the trivial and the important, it's hard to imagine a single text having that kind of impact. In the late twentieth century, we are a society that values output, speed, and productivity, whereas art requires time, reflection, tranquillity, and space—all commodities that are in limited supply these days." My answer: *Star Wars*. *Star Wars* was our classic, although it also represented the marketing of the word *classic* to mean "noteworthy."

I was sitting at Ben's desk, where he supposedly did his schoolwork. Ben had ADD (attention deficit disorder), which made him a slow reader. He could barely spell and could not write, except in the most childish, cartoonlike scrawl. He also had difficulty conceptualizing in numbers. He had been home-schooled by his mother since sixth grade.

Ben had his mouth open a little bit, and his head tilted back, so that he could see out from under his bleached-blond hair, which still showed the effects of some green dye he had put into it when the band was parentless in New York, mixing *Restraining Bolt* at the Sony studios on West Fifty-fourth Street (John dyed his hair orange). Dee had told me earlier that it cost her almost a hundred dollars to get the green dye out when Ben got back to Greenville.

The phone rang, and Ben checked his Caller ID device. "Oh, it's my sister," he said, referring to his older sister, Heidi, who lived in an apartment in Dallas. He picked up the phone. "Cool. She says we're on Q102 right now." He turned on the radio. The early chords of "Dear Aunt Arctica," Ben's song about church burning and pornography, were heard. Ben crooned "duuude" softly.

The song sounded pretty good. But the ferocity of the sound coming out of the radio contrasted strangely with the frail-seeming boy standing next to it.

"It's weird not to have to press 'play,'" Ben said.

John, quiet as usual, smiled his dreamy smile.

When the song was over, Ben went downstairs and joined Howie in his study. Howie was surfing the Web, grabbing maps for the band's upcoming trip to Fayetteville, Arkansas. "What a great Web site! This stuff is dynamite!" he exclaimed. Ben sat in front of the TV and played the sixty-four-bit Nintendo Star Wars game, Shadows of the Empire, which he was very skilled at. After executing a series of death-defying runs along a deep canyon and wasting some Imperial Guards, he finally got to the jet pack that would take him to Boba Fett, but he missed the take-off ledge and fell to his death. Howie, without looking away from *his* screen, said, "When we go on tour, Ben, we're going to need Nintendo in the bus."

Howie played drums in a rock band when he was Ben's age, but his own dreams of being a rock star were put aside when he went to the University of Maryland and then to medical school at Mount Sinai. Now he was getting to live out his fantasies through his son. Howie was currently managing the band; however, in the process of gearing up for a national tour, which would follow the release of *Restraining Bolt*, and the big-grid fame that would likely come Ben's way, Howie was looking to hire some professionals. Tomorrow night, Warren

Entner, the manager of Nada Surf, Failure, and Rage Against
the Machine, was coming from L.A. to be vetted by the
Kwellers.

I could feel the enchantment that hovered over the Kweller
household, a magical feeling that, while everyone should of
course try to carry on with life as usual, everyone secretly knew
that life was going to change completely any day now. Howie
was planning to scale back his medical practice, and Dee
would be going on the road with the band as John and Ben's
tutor. This sense of life turned topsy-turvy was especially
strong in the Kwellers' living room, which doubled as Radish's
rehearsal space. It was conservatively decorated—standard
furniture, a baby grand, Judaica paintings on the walls—except
that the boys' instruments were sitting in the middle of it.
Sawdust from John's wild thrashing of the drums had collected
in a small pile on a Persian rug.

A tapping sound drew me into the kitchen—it was Ben's
ten-year-old sister, Abby, madly practicing her steps for tap
class. Dee, also in the kitchen, said that Ben's success had been
a little hard on Abby, who, as the baby of the family, was used
to getting all the attention. We went into the living room
and talked about Ben's brand-new song, "Panamanian Girl,"
which he had just finished the day before. Dee said that it was
about Ben's girlfriend, Emileigh, whose grandmother was
from Panama, and who was the first real girlfriend whom Ben
had had. When, after a few weeks, Emileigh dumped Ben for
her old boyfriend, a football player who was seventeen and
could drive, "Ben was really upset," Dee said. She made a sad
clown face and drew tear tracks on her cheeks with her fingers.
But when Ben got his record contract the Panamanian girl
dumped the jock and got back together with Ben. Now, Dee
said, Ben was bummed because John was going out with
Emileigh's nineteen-year-old sister. Dee was looking forward

to listening to Ben's new song tonight, and maybe gleaning some more information about the relationship.

Ben, who seemed to be keeping an eye on his mother to make sure she didn't say anything too embarrassing about him, came into the living room and sat at the drum set. I asked him how he felt about John dating his girlfriend's sister.

Ben groaned, "Duuude, it's weird, like I go over to her house and he's there. No wonder I'm so fucked up."

"You're not fucked up, Ben!" his mother said. "And don't say 'fuck.' "

Ben had been writing songs for as long as he could remember, he told me the next day as we were sitting around playing the Star Wars game again. "I'd write songs with 'I love you' and with a girl in them. I had no idea what love was. I just knew, from listening to the Beatles and Beach Boys songs my parents were always playing, that songs were supposed to have love and a girl in them." Among his earliest rock-and-roll memories was the time, in 1985, when Bruce Springsteen came to Dallas on the "Born in the USA" tour and played in the Cotton Bowl. Ben was four. The Boss's then guitarist, Nils Lofgren, who was an old friend of Howie's from Bethesda (Lofgren had once played the accordion in a band that Howie started), got the Kwellers tickets and backstage passes. They met the Boss, who was so charmed by Ben that he let him stay on the stage during the concert. Ben bounced around to the music for a while, then climbed up onto one of the huge speakers that the vocals were blasting out of and fell asleep. "The vibration was sort of soothing," he told me. "It was like being in the car." And when he woke up, he wasn't sure if he was a boy who had dreamed of being a rock star or a rock star who dreamed of being a boy.

After the concert, Ben started to imitate Bruce and Nils. Dee said, "He would jump around the house the way Nils did when he was playing rock and roll, saying, 'I'm Nils! Hey, I'm Nils!'" Like many ADD kids, Ben was an uncanny and relentless mimic. He would see the mailman; then he would be the mailman. "He could never role-play without acting out the whole part," Dee said. Ben told me, "I would be like ten different people in a day, like a different person every hour. I had all these costumes in my room, and I'd change my clothes constantly." When he was ten, Nirvana's album *Nevermind* appeared, and he saw Kurt Cobain for the first time, in the video of "Smells Like Teen Spirit." Suddenly, the Beatles made sense to him. "When Nirvana came out, it was like, Yes! This is the Beatles except with the guitars turned up." That was when Ben started to look like Kurt—like the too-sweet-for-this-world little boy Kurt once was.

He began taking piano lessons when he was six; his teachers criticized him for changing the chords around in songs like "Heart and Soul" and "Let It Snow," until finally one of them realized that this was actually a sign of creativity, not of disobedience, and informed the Kwellers that their son had some sort of unique talent. He started playing his dad's guitar when he was twelve, taught a neighbor kid to play the drums, and briefly formed a band called Green Eggs and Ham. Later, Ben hooked up with a bass player, and in January 1994, John joined as drummer. A few months after that, Ben got his own guitar, and in June the group debuted at Ben's bar mitzvah. They called themselves Radish. The boys had looked among the gnarly sounding diseases in Howie's medical dictionary for another band name, but in the end *Radish* came from a kid named Arosh, whom Ben met at a party. "He was like an Indian or something," Ben told me. "I said 'Whoa, DOODE! Your name

is Arosh? Hey, man, do you mind if I call you Radish?' He said, 'No, man, that's cool.'" Howie and David Kent, John's father, thought the band sounded pretty good. They made a tape, and Howie sent it to Lofgren, who saw to it that it got into the hands of his producer, Roger Greenawalt.

On Saturday night, we were driving from Greenville to the Deep Ellum section of Dallas, where the band had a gig. John the drummer was driving fast. Howie and John's father, David, were trying to follow in David's Suburban, which was pulling a U-Haul trailer full of instruments and sound equipment.

Ben asked the publicist from Mercury what bands she liked. She said, "Well, there's Morphine."

"Cool! Morphine," Ben said. "We love them, man."

"No, dude, that's Codeine we love," said John.

"Duuude, you're right."

John said, "This car back here is bugging me," and I saw a shard of his handsome face in the rearview mirror, looking backward.

Ben: "Give 'em the finger, dude."

John, intensely bored: "I don't have the energy." But his eyes lit up as an old Bad Company song came on—a song I was listening to on the radio with the same enthusiasm when I was seventeen. This seemed remarkable to me. In spite of the fact that I was old enough to be the boys' father, we were both on the same side of the real generational divide in the culture, the one the culture wars were fought over, between the people who had grown up in a world where identity was separate from pop culture (the world of my parents) and the people who grew up with Gilligan, Captain Kirk, and John, Paul, George, and Ringo in the house. To people on my parents' side of that

divide, pop culture was *mass* culture—someone else's culture, external to their identity—but for me and, to a much greater extent, for these boys, pop culture was *folk* culture: our culture.

John, station-surfing, stopped on Nirvana's "Come as You Are":

I don't have a gun.
No I don't have a gun.

The lines had a kind of Jesse Jamesian outlaw quality that was not unlike the Bad Company song, except that instead of robbing a bank with a gun the singer was going to blow his own head off.

I said that it was strange how many of Kurt Cobain's songs had guns in them. Ben said, "I think he was always planning to kill himself, and he was thinking about it, and trying to tell people, but no one around him stopped him."

I said, "Danny Goldberg was around him."

"Yeah, Danny was Kurt's manager," said Ben, nodding, thinking about it.

That day happened to be my birthday. I was thirty-eight, and I was kind of depressed about it. Christ, thirty-eight years old, and here I was, with a couple of kids young enough to be my children, writing down their bon mots, which mostly consisted of different variations on the word *dude*, from the expansive, come-with-me-my-comrade-to-the-ramparts "DOODE!" to the bluesy, empathetic "Duuude," to the bleak, fatalistic "dud." Pop culture was groovy and exciting and fresh and all, and it offered moments of transcendence like the one I had felt at the Chemical Brothers show, moments that old high culture was too bloodless to match. But maybe, after all, it was like getting a little bit pregnant. You could feed the Buzz, and it fed you, too. But the Buzz was never satisfied. Not

only did you have to keep feeding it, you had to keep feeding it more. Once you started writing about the would-be pop stars you became part of that same blaring aural superhighway of Buzz, no different from the voice of *Entertainment Tonight*, yammering away about how "our next story would read like a tale out of pulp fiction—*if it wasn't all too real.* . . ."

Pop songs did capture the zeitgeist in a way that longer, more complicated works like novels or plays or symphonies could not. But as a result, all culture came to be judged by the standards of a pop song. Listen to it, like it, then quickly tire of it, dispose of it, and find another song to delight you.

I was quiet in the back of the car, staring out at the low dome of neon on the horizon—the lights of Dallas, seen across thirty miles of prairie. Then I blurted out, "You know what the fuck today is? Today is my *fucking* birthday."

I did not specify which birthday it was, and was prepared to lie about it if the boys asked, which fortunately they did not.

"Duuddde!" crooned Ben uncertainly. "Happy birthday, dude!"

It was all-ages night at the Galaxy Club. The act before Radish, a hard-core punk band called Puke, was making lots of noise. Parents were sitting in the back of the club, as far away from the appalling sound as possible, their hands over their ears, while their kids moshed and slam-danced up front. The tattooed, buzz-cut front man of Puke finished a song, then screamed at the kids, "What the FUCK!!! Go ahead, say 'Fuck you!' You're allowed to say 'fuck,' aren't you?"

When Puke finished, Radish took the stage. Ben tried a little cultural rapport with the audience before starting. "How many people here have seen the movie *Beavis and Butt-head Do America*?" he asked. A couple of kids raised their hands. He

started to say something else, then stopped. Later, when I asked him what was going through his mind at that moment, he said, "It's hard for me to talk to the audience. I always feel sort of like someone's going to say, 'Hey, shut up, kid, we don't want to listen to you, you're just a kid.'"

The band started with "Simple Sincerity," which was a song Ben had written about the bidding war for Radish:

Take my simplicity
Take your sincerity
Take my simplicity
Away from me.

The audience got into it. The rock animal in Ben came out. He was good—for a kid.

During "Dear Aunt Arctica," the third song, Ben's vocal mike, which Howie had recently bought, shorted out, and Howie rushed forward to the stage. (At the gig the night before, when one of the bass amps blew, Dee had practically throttled the young slacker bartender, yelling, "My son's amp blew! Do something!") Ben remained calm; he simply walked back from the mike and let John finish the song. It was as though they had rehearsed it. Warren Entner, their prospective manager, who was standing beside me just out of range of a small but potentially hazardous mosh pit that was skirmishing in front of us, shouted, "His composure is amazing!"

The band played "Apparition of Purity," which featured Ben angrily screaming "Purity! Purity!" at the audience. Ben's little sister, Abby, went flying by, moshing with a nine-year-old friend of hers who had written Ben a fan letter that said, "Dear Radish. Check here if you love me. Check here if you like me. I love your musik."

They closed with "Panamanian Girl." The Panamanian girl herself, a sweet-looking sixteen-year-old, wearing hot-pink leggings under a modest skirt, was up there in front of the stage, looking up at Ben, who had his head bent over his instrument, and his legs akimbo, shaking the sound out of it. The girl stretched out her arms. The boy wailed on his guitar. It was the real thing, the moment that Danny Goldberg hoped soon to sell to the world in commodity form: the gesture (perhaps ironic) that the girl makes in the video. But at least for now it was a moment so innocent and joyous that Warren Entner and I looked at each other with big grins on our faces.

Back in New York, I went to see Roger Greenawalt in his apartment on the Upper West Side. It was still cold—the snap that had settled over the city the weekend before Inauguration Day was lingering. I rode the subway up to the Upper West Side. *Star Wars* was playing at the theater at Eighty-fourth. There was a long line of people outside, bundled up against the cold, waiting to warm themselves with a nostalgic experience of a movie that itself produced a feeling like nostalgia in the first place. So we beat off, boats against the current. . . .

Greenawalt's apartment was on the ground floor of a building on West Eighty-third Street. The wind was howling outside, but in here it was warm, the lights were low, candles were burning, music was playing, good Scotch being sipped, and Jill, Roger's pretty young model girlfriend, was sitting next to him on the couch. Greenawalt, making a gesture that took it all in, said, "The perfect career is like the perfect crime. I've got the beautiful girl on the couch next to me while I sit here sipping Macallan Scotch and telling my story to you, and *that's fine.*"

125

Roger was once the best fourteen-year-old rock-guitar player in *his* county, and he, too, wanted to be a rock star. He came close during the New Wave early '80s, when he was semi-famous for being in an Eno/Bowie–style band called the Dark, in Boston, and was recording and performing music with Ric Ocasek of the Cars. But ultimately he said, "I failed." He became a session guitarist and now was mostly a producer who made lush sonic backgrounds (soundscapes) for other bands. His current ambition was to get one of the big five music companies to front him the money to set up a label. Radish, "my baby band," was his ticket.

He liked the tape that Nils Lofgren brought him "within thirty seconds," he said. "You could tell the kid was good at music. I called Howie, and he was very excited, very solicitous—he and Dee treated me like a rock star. So I flew down there to see if they had the capacity to do the work at the professional level I would require." He ended up staying with the Kwellers off and on for two months, working with Ben and John for eight to ten hours a day on their music.

"We took apart every song, every lyric, every chorus, and I made Ben justify its existence," Roger said. He tried to make Ben more aware of his body, to teach him that rock is as much about image as it is about sound. "A rock star has to play with his whole body," he said. He taught Ben that for the rock star nothing exists outside the moment. Every aspect of his performance—how he plays, how he sings, how he stands—must communicate the feeling that this moment is the only possible moment, or at least the most totally satisfying moment imaginable. That's what rock stars are: the personification of moments.

"I would say, 'Ben, what's your favorite meal? Okay, let's have it right now. What's your favorite color? Okay, let's paint

it right now. What is the chord you're playing—why are you playing it? Does it feel good to lift your arms over your head?'" Roger jumped up from the couch, bowed his head, closed his eyes, and slowly raised his arms—expertly transforming himself into Roger Daltrey or Peter Frampton onstage with the light streaming past him.

I could imagine Howie and Dee sharing some parental concern over what exactly this slightly voluptuous, licentious-seeming character was doing in their house, with his cigarettes and his black jeans, having what Roger described to me as a "platonic love affair" with their son while instructing him in the spirit of rock and roll, which he traced back beyond Jagger and Chuck Berry and Robert Johnson to Oscar Wilde, Mahler and Liszt, and the Romantic poets.

"I taught Ben that he was not Kurt Cobain," Roger went on. "I said, 'Look, Kurt was a miracle. An absolute miracle. And this is not about being a child star, either. It's not a David Cassidy vibe, it's a Jodie Foster vibe. The culture may pay attention to us because we're young, okay, fine, but we can't *be* young. We have to compete with this' "—he gestured with his cigarette toward the stereo, which was playing U2's *Achtung Baby*— " 'and with Beck and Pavement.' " He took a drag on the cigarette and looked off into the visionary middle distance. "I don't know. Maybe Ben will be Shirley Temple." He focused on me again. "And that's cool. Shirley Temple is a good vibe."

Jill said she needed to get ready for her poetry class at the New School, but would we like cheeseburgers before she went? As she was fixing the food in the kitchen, Roger said, "Live large, but be small. The small reality—that was Ben's and my motto."

He got up from the couch and hit "replay" on the CD controls, and we listened again to Bono sing "One." Lots of people

could play at being rock stars, but very few had the genius to work within the rigid conventions of contemporary rock and yet manage to transcend them—actually say something.

Is it getting better?
Or do you feel the same?
Does it make it easier on you
To have someone to blame?

The electric guitar seemed to be pointing to a place somewhere inside the song where there was a possible escape from the blues in the music, to the place where there was only "One love, One life . . . One need in the night. . . ."

Ben had an uncanny sense for the basic elements of a pop song, and precocious skill at making little bits of joinery between those elements, but he did not have the soul of Bono. "One" was a song you had to listen to again if you heard it once. Compared to this, Ben was just writing about homework and crushes. Maybe some fifteen-year-olds would relate to it, but there wasn't much of a message that anyone older than fifteen could take from his songs. But that was the point, wasn't it: it didn't matter whether Ben was an artist; what mattered was that Ben was a kid. Kids were the artists of Nobrow.

Jill set the cheeseburgers in front of us. "I had already been feeding smart bombs about the band to people in the industry, so the anticipation was high," Greenawalt said of the Manhattan showcases where the bidding war for Ben began. A well-known music-industry lawyer, Jonathan Ehrlich, of Grubman, Indursky & Schindler, put his own network of connections at Ben's service in return for a piece of the action; Greenawalt had taken care of booking the showcases and bringing Radish

to New York. Ben and John crashed here in his apartment. Ehrlich represented the band in the record deal, for which he received a percentage. Howie, as the band's manager, got a flat fee, as did John. Greenawalt got a $60,000 finder's fee for his work with the band, and points on *Restraining Bolt*, which he recorded in July and mixed in August.

But when Ben listened to the tracks Roger had cut, he didn't like the way they sounded. The music had a too-finished, shiny, instrumental, studio-produced sound that was popular in the early '80s. (It was not unlike the album that Roger Greenawalt never quite got around to making himself.) "When we heard it, we were like, dude, that's New Wave," Ben told me. "I said, 'My friends are going to eat me up for this.'" He tried to discuss his reservations about the album with Greenawalt, but Roger acted like "an egomaniac," Ben said. "We would suggest something, and Roger would say, 'How many records have *you* made? You're just a kid.' He treated me like a kid."

Ben shared his misgivings with Danny Goldberg, and Goldberg agreed with him. "I thought it was two-thirds of a great album," Goldberg told me. The album was taken away from Greenawalt and given to two new producers in Boston, Paul Kolderie and Sean Slade, who recorded three new songs, rerecorded one, and remixed the others, adding the crushing guitar sound that was the grunge signature. In the process, Ben and Roger stopped talking.

Greenawalt spoke of Ben's rebellion with pride. "I think it's *charming* that Ben rebelled against me. Charming. He was my best student ever, and so of course his final act as my student had to be to rebel against me." He took another sip of Scotch. "I taught him well." Another silence. "You never know when you're going to meet the smartest person you've ever met, and you never know how old he's going to be." He sat up and be-

gan hunting around among the books at the base of the couch. Roger spent a lot of time on his couch, reading the arbiters elegantiae of old. Books were stacked high in front of it. After a while he came up with a large black folder. "This is something from Tacitus, which I wrote in my commonplace book yesterday: 'It is so much easier to repay injury than to reward kindness, for gratitude is regarded as a burden, revenge as a gain.'"

Restraining Bolt appeared in the stores that spring—and went nowhere. MTV didn't show the video more than a few times. Mercury could have helped matters by putting some of its marketing muscle behind the band, but as it turned out, the marketing department had its hands full. Mercury's other baby band, Hanson, was showing signs of going Big Grid. Those teenagers went on to sell 5 million copies of their album, *Hanson;* Ben went spinning back into the small-grid form of life in Greenville. The label sent the boys out on a European tour, and when that was over Radish set to work on their second album, an acoustic record that would hopefully highlight Ben's songwriting skills.

"In the end," Goldberg told me later, as we were sitting in his office taking stock of the company's investment in the baby-band boom, "it all worked out for Mercury. We got our Christmas bonuses."

5

The Empire Wins

When Tina asked me to write about the *Star Wars* phenomenon, I saw it as an opportunity to study a proto-Nobrow transaction. By staying true to his quirky vision and by daring to challenge the suits at the big studios, George Lucas had created something that was beyond Buzz, a movie that was also a real part of people's lives, and even their identities. When students in high school got killed and the papers ran their obituaries, that was who they were—*Star Wars* fans. But Lucas's success had the ironic result of taking him away from the thing that touched his audience in the first place. Now, with a new *Star Wars* movie, Lucas was going back to that primal material from which his inspiration had come. He was planning to direct a prequel to the *Star Wars* trilogy, *Episode I—The Phantom Menace*, which would be the first movie he had directed since the original *Star Wars*.

The early relationship brokering for the story was done by Caroline Graham, the *New Yorker*'s invaluable West Coast editor, whom Tina had brought from *Vanity Fair*. Caroline's skill was her instinctive sense for the blurry borderline between elite culture and commercial culture and her ability to cast what was in fact a Nobrow transaction—*The New Yorker* was trying to borrow Buzz from *Star Wars*—in old High-Low

131

terms: Being in *The New Yorker* would add a patina of class to *Star Wars*. Caroline extracted from Lynne Hale of Lucasfilm the commitment that I could come to Skywalker Ranch, the center of the *Star Wars* universe, but she could not promise an interview with George Lucas. However, it was Caroline's feeling that once I got onto the Ranch I might get an interview after all.

As it happened, my visit to northern California, where Skywalker Ranch is located, coincided with one of the biannual Star Wars Summits, which was taking place down in San Rafael. The meeting was an opportunity for the licensees who made the Darth Vader masks and the thirty-six-inch sculpted Yoda collectibles to trade strategy and say "May the Force be with you" to the retailers from Wal-Mart and Target who sell the stuff, and for everyone in the far-flung *Star Wars* universe to get a better sense of "how deeply the brand has penetrated into the culture," in the words of one licensee. Licensees come from as far away as Australia and Japan. People arriving by car at the Marin County Civic Center in San Rafael were ushered to parking places by attendants waving glowing and buzzing Luke Skywalker lightsabers; other arrivals, who were staying in the Embassy Suites next door, strolled across the parking lot in the sunshine.

Before *Star Wars*, brand-reinforcing merchandise was used only to promote movies; it had little value apart from the films. Disney had managed to brand its animated films and spin off merchandise, but no one before Lucas managed to brand a live-action movie. After *Star Wars*, movie merchandise became a business unto itself. People saw *Star Wars*, loved *Star Wars*, and then wanted to buy Star Wars, in the form of toys, games, and books, as well as movie tickets. In 1997, Star Wars action figures were the best-selling toy for boys and the sec-

ond over-all best-seller, after Barbie. The video games put out by LucasArts were the best-selling games for computers, while the novels were, book for book, the single most valuable active franchise in publishing. Most of the twenty-odd novels Bantam had published since 1991 had made the *New York Times* hardcover or paperback best-seller list. Lucas had succeeded in creating more than a movie—he had created a brand. "Great brands create a relationship between a company and a consumer that secures future earnings," John Grace, a branding executive, told the *New York Times.* "*Star Wars* has all the characteristics of a great brand of our time." A great brand, in this instance, was something to be that was also something to buy.

What was it that made the public crave this brand in so many different flavors? Was it culture or was it marketing? It seemed to me that somewhere between the dream and the stuff made from it—between the image of Luke gazing at the two setting suns on the planet Tatooine while he contemplated his destiny as a fighter pilot for the Rebel Alliance, and the twelve-inch Luke collectibles sold by Kenner—an interesting value shift was taking place, from the value of culture to the value of marketing. Here at the summit, you could feel this transformation drawing energy from marketing on the one hand, and from ordinary life—culture—on the other, until the distinction seemed to melt into another beautiful summer's day in northern California.

At five o'clock a squadron of Imperial Guards, accompanied by white-shelled Storm Troopers, took the stage, followed by Darth Vader himself, sporting a costume from Lucasfilm Archives. The Dark Lord of the Sith sternly upbraided the audience for not inviting him to the summit, but then said that it was actually a good thing he hadn't been invited, because he'd

been able to spend the day at "the Ranch" with someone far more important than "you mere merchandisers." With that, George Lucas strode onto the stage.

Lucas often received a standing ovation when he appeared in public, and he got two today—one on taking the stage and the other on leaving it. It wasn't simply Lucas's success as a filmmaker that people were applauding—the fact that, having begun his career right here at the Marin County Civic Center (he had used it as a location for his first film, the dark, dystopian *THX 1138*), Lucas had gone on to create in *Star Wars* and (with Steven Spielberg) *Indiana Jones* two of the most valuable movie properties ever, and, with John Milius, had also conceived *Apocalypse Now*, which Francis Ford Coppola ended up directing. Nor was it his success as a businessman: Industrial Light & Magic (ILM), which started as Lucas's model shop—a place to do the effects for the original *Star Wars*—had grown into the premier digital-imaging studio in the world, and was responsible for many of the milestones in computer graphics, including the cyborg in *Terminator 2*, the dinosaurs in *Jurassic Park*, and the Kennedy cameo in *Forrest Gump*.

People applauded Lucas for his unique Nobrow status: He was both a great artist and a billionaire businessman. He was the hero of the real *Star Wars*ian epic—the rebel artist-outsider who had conquered the evil empire of Hollywood and built an image-making empire of his own. For people deep into *Star Wars* culture, Lucas's story tended to mingle with Luke's, the real one becoming proof that the mythic one could come true, and the mythic one giving the real one a kind of larger-than-life significance. Just as Luke is a boy on the backwater planet of Tatooine—he is obedient to his uncle, who wants him to stay on the farm, but he dreams that there might be a place for him somewhere out there in the larger world of adventure—so Lucas was a boy in the backwater town

of Modesto, California, who dreamed of being a great race-car driver, but his liberal-bashing, moralizing father wanted him to stay at home and take over the family business. (His father liked to humiliate George every summer by chopping off his hair.) Just as a benevolent father figure (Obi-Wan) helps Luke in his struggle against his father, Francis Ford Coppola took young Lucas under his wing at U.S.C. film school and helped him get his first feature film made. And, just as Luke at the end of the first *Star Wars* film realizes his destiny and becomes a Jedi, so Lucas became the rich filmmaker, fulfilling a prophecy he'd made to his father in 1962, two years before he left Modesto for U.S.C., which was that he would be "a millionaire before I'm thirty."

During a break in the summit, marketing reps from Hasbro had given all the members of the audience their own Luke Skywalker lightsabers, and at Lucas's appearance onstage the faithful turned them on and waved them around. After they'd finished, Lucas said a few words. He looked strangely out of focus up there onstage, oddly blurry behind the looming shadow of his myth. (His lack of presence was also part of the myth: it's what made him Yoda-like.) He was slight, with a small, round belly, a short beard, black glasses, and a vulnerable-sounding voice.

After he finished talking, the president of Hasbro gave Lucas a twelve-inch sculpted Obi-Wan Kenobi body with a George Lucas head, and the crowd went wild. A George Lucas toy! As a summiteer said to me later, "What a collectible that would make!" George held up his George toy, and the licensees all cheered and waved their lightsabers.

Skywalker Ranch, the headquarters of Lucas's enterprises, is nestled into the Tuscon hills of West Marin. The Ranch is

a three-thousand-acre detailed evocation of a nineteenth-century ranch that never was. From the outside, the main house looked like the big house on the Ponderosa, but the inside was more like the Huntington Gallery in San Marino, which used to be the home of the nineteenth-century railroad magnate Henry Huntington. When Lucas was beginning to conceive the place, in the early '80s, he wrote a short story about an imaginary nineteenth-century robber baron who retired up here and built the homestead of his dreams. In this story, the tycoon's Victorian main house dates from 1869; the stable was built in 1870; a craftsman-style library was added in 1910; and the brook house in 1913. Lucas gave his story to the architects of the Ranch and told them to build it accordingly, a style he called "remodel" architecture.

At the Ranch, just as in *Star Wars*, Lucas created a new world and then layered it with successive coats of mythic anthropology to make it feel used. He made the future feel like the past, which was what George Lucas did best. *Star Wars* takes place in a futuristic, sci-fi world, but we're told at the beginning that it happens "a long time ago, in a galaxy far, far away." The movie has all the really cool parts of the future (interplanetary travel, flashy effects, excellent machines), but it also has the friendships, the heroism, and other reassuring conventions of the pop-cultural past (outlaw saloons, dashing flyboys, sinister nobles, brave knights, and narrow escapes). It makes you feel a longing for some unnameable thing that is always being lost (a feeling similar to the one you get from Lucas's second film, *American Graffiti*, which helped make nostalgia big business), but it's a longing sweetened by the promise that in the future we'll figure out a way of getting the unnameable thing back. C. S. Lewis describes a similar emotion in his book *Pilgrim's Regress:* "a particular recurrent experience which dominated my childhood," a kind of "intense

longing which . . . is acute and even painful . . . yet the mere wanting of it is somehow a delight." Unlike other desires, Lewis says, which "are felt as pleasures only if satisfaction is expected in the near future," this desire continues to be prized, "and even to be preferred to anything else in the world . . . even when there is no hope of possible satisfaction." What is so unusual about this kind of desire, says Lewis, is that "it cuts across our ordinary distinctions between longing and having." That sounds like the deliciously sad desire that I saw being forged into product at the summit down in San Rafael, but up here at the Ranch the desire seemed to exist in a purer form— as fake history, marketed to people who cannot remember their past and therefore are compelled to experience it again, not as farce but as nostalgia.

As in *Star Wars*, at the Ranch you got the sense that some all-controlling intelligence had rubbed itself over every part of the universe. The Technical Building, which was filled with the latest in sound-engineering and editing technology, including a full THX theater and a soundstage that could seat a hundred-piece orchestra, looked precisely like a nineteenth-century California winery. (According to Lucas's story, it was originally built in 1880, and the interior was remodeled in art deco style in 1934.) Trellises of Pinot Noir, Chardonnay, and Merlot grapes were growing outside; the grapes were shipped to Francis Coppola's real winery in Napa Valley. There were stables and a baseball field and people on bicycles with Skywalker license plates and an old hayrack and mower that looked as if they'd been sitting beside the road for a century or so. Lucas designed the place so that the visitor sees only one building at a time from any spot on the property. Although two hundred people came to the Ranch each day, you saw no cars—only bicycles, except for the occasional Skywalker Fire Brigade vehicle. There were three underground parking

garages at the Ranch, which could accommodate up to two hundred cars.

Inside the main house, the walls were covered with first-growth redwood that was salvaged from old bridges near Newport Beach and had been milled into paneling. Hanging on the redwood were selections from Lucas's collection of paintings by Norman Rockwell, another un-ironic American image-maker, with whom Lucas felt an affinity. The holiest of the fake relics were to be found in the two glass cases in the front hall, where the "real" lightsaber that Luke uses in *Star Wars* sat along with Indy's bullwhip and the diary that leads Indy to the Holy Grail. The Holy Grail itself was stored in the Archives Building.

Two days a week, Lucas came to the Ranch to conduct business. He spent most of the rest of his time at home, writing and looking after his three kids. The oldest, a teenage girl, he adopted with his ex-wife and collaborator Marcia Lucas (she won an Oscar for editing *Star Wars*); the younger ones— a girl and a boy—he adopted as a single parent, after he and Marcia split up.

Because my first visit to the Ranch fell on a Wednesday, which is not one of Lucas's regular days, I had been told there would be no meeting with him. But as we were touring the two-story circular redwood library with the stained-glass roof (a cat was on the windowsill, a fire burning in the fireplace, and a Maxfield Parrish painting hanging over the mantel), word came that Lucas was here today after all and would see me now. I was led down the back stairway into the dim recesses of the basement, which was sort of like going backstage at a high-tech theater, and into a small, windowless room filled with editing machines, lit chiefly by light coming from two screens—a television and a glowing PowerBook. There sat the great mythmaker himself, wearing his usual flannel shirt,

jeans, sneakers, and Swatch watch. He emerged from a dark corner of the couch to shake hands, then retreated into the dimness again.

Some of Lucas's friends thought Skywalker Ranch was Lucas's attempt to recapture not only America's legendary Western past but his own youth, especially his golden days at U.S.C. film school, in the '60s, when he was a young artist, a protégé of Coppola's (they met when he was a student observer on Coppola's film *Finian's Rainbow*), and a friend of other young would-be auteurs like Steven Spielberg, Martin Scorsese, and Brian De Palma. Then they weren't yet worried about topping one another's blockbusters. (*E.T.* and *Jurassic Park* both surpassed the *Star Wars* box-office record, but the new *Star Wars* movies got the record back.) Lucas's first film, *THX 1138*, was a work of startling visual originality that was too avant-garde to succeed at the box office.

Lucas conceived the Ranch as a complete filmmaking operation—his version of the ideal studio, one that would respect human values and creativity, as opposed to Hollywood studios, which were greedy and encouraging of mediocrity. Lucas's well-known disdain for Hollywood's morals and aesthetics was partly a result of his father's influence—George Lucas Sr. was a conservative small-town businessman who viewed all lawyers and film executives as sharpies and referred to Hollywood as Sin City—and partly a result of his own bitter experience with his first two films, *THX 1138* and *American Graffiti*. The dark lords at Universal thought *Graffiti* was so bad that they weren't going to release the film at all, and then they were going to release it just on TV; finally, when Coppola, who had just made *The Godfather,* offered to buy the movie, Universal relented and brought it out in the theaters, although not before Ned

Tanen, then the head of Universal, cut four and a half minutes from it—a move that caused Lucas terrific anguish but taught him a lesson in power. Made for $775,000, *Graffiti* went on to earn nearly $120 million.

"I've always had a basic dislike of authority figures, a fear and resentment of grown-ups," Lucas says in *Skywalking*, the 1983 biography by Dale Pollock. When the success of the first *Star Wars* film allowed Lucas to "control the means of production," as he liked to say, flashing his Marcusian credentials, he financed the second and third films himself, and built the Ranch. In the beginning, the films edited at the Ranch were Lucas's own: he was busy working on the *Star Wars* movies and overseeing the *Indiana Jones* series. But before long people at the Ranch were spending less time on Lucas's films and more time doing other people's. Lucas offered filmmakers a full-service digital studio, where directors could write, edit, and mix films, and Industrial Light & Magic, down in San Rafael, could do the special effects.

Lucas was the sole owner of his companies. He was an old-fashioned, paternalistic chairman of the board, who gave each of his twelve hundred employees a turkey at Thanksgiving, and who sat every month at the head of the redwood board-room table in the main house and listened to reports from the presidents of the various divisions of his enterprise.

"My father provided me with a lot of business principles—a small-town retail-business ethic, and I guess I learned it," Lucas said in his tired voice. "It's sort of ironic, because I swore when I was a kid I'd never do what he did. At eighteen, we had this big break, when he wanted me to go into the business"—George Sr. owned an office-supply store—"and I refused, and I told him, 'There are two things I know for sure. One is that I will end up doing something with cars, whether I'm a racer,

a mechanic, or whatever, and, two, that I will never be president of a company.' I guess I got outwitted."

Lucas's most significant business decision—one that seemed laughable to the Fox executives at the time—was to forgo his option to receive an additional $500,000 fee from Fox for directing *Star Wars* and to take the merchandising and sequel rights instead. The sequels did almost as well as the first movie, and the value of the brand, after going into hiatus in the late '80s, reemerged around 1991, when Bantam published *Heir to the Empire*, by Timothy Zahn, wherein Princess Leia and Han Solo have children. The book surprised the publishing world by going to No. 1 on the *New York Times* hardcover-fiction list, and marketers quickly discovered a new generation of kids who had never seen the movies in theaters but who had grown up with the story and characters as part of their folk culture.

Lucas stopped directing movies, he told me, because "when you're directing, you can't see the whole picture. You want to take a step back, be the overall force behind it—like a television executive producer. Once I started doing that, I drifted further and further away. Then I had a family, and that changed things—it's very hard to direct a movie and be a single parent at the same time." Then his company became a big business. "The company started as a filmmaking operation. I needed a screening room, then a place to do post, then mixing, then special effects—because, remember, I was in San Francisco. You can't just go down the street and find this stuff—you have to build it. Everything in the company has come out of my interests, and for a long time it was a struggle. But six years ago the company started coming into its own. The CD-ROM market, which we had been sitting on for fifteen years, suddenly took off, and digital-filmmaking techniques took off,

and suddenly I had a big company, and I had to pay attention to it." The great artist of Nobrow gave me an anal account of his daily existence: he said he spent 35 percent of his time on his family, 35 percent on movies, and 30 percent on the company.

Lucas's day-to-day activities in the main house included the management of the *Star Wars* story, which has probably the most carefully tended secular story on Earth. Unlike *Star Trek*, which is a series of episodes connected by no central narrative, *Star Wars* is a single story— "a finite, expanding universe," in the words of Tom Dupree, who edited Bantam's *Star Wars* novels in New York. Everyone in the content-creating galaxy of *Star Wars* had a copy of "The Bible," a burgeoning canonical document that was maintained by "continuity editors." It was a chronology of all the events that had ever occurred in the *Star Wars* universe, in all the films, books, CD-ROMs, Nintendo games, comic books, and role-playing guides. Each medium was seamlessly coordinated with the others. For example, the Lucas story called *Shadows of the Empire* was being told simultaneously in several media. A Bantam novel introduced a smuggling enterprise, led by the evil Prince Xizor; then the Prince began to appear in the new sixty-four-bit Nintendo games that I had played with Ben Kweller in Texas; meanwhile, Dark Horse comics was also featuring the Prince, along with related characters, like the bounty hunter Boba Fett, a Gen-X favorite.

New developments in even the remotest corners of the *Star Wars* universe were always approved by Lucas himself. The continuity editors sent him checklists of potential events, and Lucas checked yes or no. "When Bantam wanted to do the back story on Yoda," Dupree said, "George said that was off limits, because he wanted him to remain a mysterious character. But George has made available some time between the

start of Episode 4, and the end of the prequel, when Han Solo is a young pilot on the planet Corellia, so we're working with that now." Although Lucas had once imagined *Star Wars* as a nine-part saga, he had allowed licensees to build into the narrative space on the future side of *Jedi*—onto the later years of Han, Luke, Leia—which suggested to the Cassandras of *Star Wars* culture that Lucas wasn't planning to write any more of that part of the story himself.

"George creates the stories; we create the places," Jack Sorensen, the president of LucasArts, said, explaining how the interactive division fits into the Lucas multimedia empire. "Say you're watching the movie, and you see some planet that's just in the background of the movie, and you go, 'Hey, I wonder what that planet is like?' There's a lot going on on a planet, you know. So we'll make that planet the environment for a game. In a film, George would have to keep moving, but the games give you a chance to explore."

I asked Sorensen if he could explain the appeal of *Star Wars* as culture, and he said, "I'm as perplexed by this as anyone, and I'm right in the midst of it. I travel all the time for this job, and I meet people abroad, in Italy, or in France, who are totally obsessed with *Star Wars*. I met this Frenchman recently who told me he watches it every week. I don't really think this is caused by some evil master plan of merchandisers and marketers. The demand is already out there, and we're just meeting it—it would exist without us. I don't know if I want to say this in print, but I feel like *Star Wars* is the mythology of a nonsectarian world. It describes how people want to live. People all view politics as corrupt, much more so in Europe than here, and yet people are not cynical underneath—they want to believe in something pure, noble. That's *Star Wars*."

* * *

It's a little ironic, then, that one of Lucas's motives in writing *Star Wars* was to create a popular success. The failure of *THX 1138*, together with the treatment that the young artist had received in the Sithian dungeons of Universal, had convinced Lucas that he needed to make a movie that would earn so much money that he would never have to take orders from the studio bosses again. The Force means this: power, not for its own sake but for the creative independence it buys the artist working in Nobrow, where artists can no longer count on the town-house notion of "superior reality" to protect them from the marketplace. Lawrence Kasdan, who co-wrote the scripts for *Empire* and *Jedi* and also wrote the script for the first *Indiana Jones* movie, told me he thought Lucas's antagonistic relationship with Hollywood was what *Star Wars* was really about. "The Jedi Knight is the filmmaker, who can come in and use the Force to impose his will on the studio," he said. "You know that scene when Alec Guinness uses the Force to say to the Storm Trooper outside the Mos Eisley cantina, 'These aren't the droids you're looking for,' and the guy answers, 'These aren't the droids we're looking for'? Well, when the studio executive says, 'You won't make this movie,' you say, 'I will make this movie,' and then the exec agrees, 'You will make this movie.' I once asked him, 'George, where did you get the confidence to argue with Ned Tanen?' He said, 'Your power comes from the fact that you are the creator.' And that had an enormous influence on me."

To make *Star Wars*, Lucas began by studying the mythology of other cultures, noting recurring plot twists and cruxes and moments-of-no-return that reappeared in the stories humans told themselves. He took elements from myths found in *The Golden Bough*, Sufi legends, *Beowulf*, and the Bible and tried to combine them into one epic story. He ransacked Joseph Campbell's books on mythology, among other sources.

It was a kind of get-'em-by-the-archetypes-and-their-hearts-and-minds-will-follow approach to screenwriting. One could go through *Star Wars* and almost pick out the chapter headings from Campbell's *The Hero with a Thousand Faces:* the hero's call to adventure, the refusal of the call, the arrival of supernatural aid, the crossing of the first threshold, the belly of the whale, and the series of ordeals culminating in a showdown with the angry father, when, at last, as Campbell writes, "the hero . . . beholds the face of the father, understands—and the two are atoned"—which is precisely what happens at the end of *Jedi.*

"When I was in college, for two years I studied anthropology—that was basically all I did," Lucas said. I sat on a folding chair about five feet away. The glow of the blank TV screen illuminated his face. "Myths, stories from other cultures. It seemed to me that there was no longer a lot of mythology in our society—the kind of stories we tell ourselves and our children, which is the way our heritage is passed down. Westerns used to provide that, but there weren't Westerns anymore. I wanted to find a new form. So I looked around and tried to figure out where myth comes from. It comes from the borders of society, from out there, from places of mystery—the wide Sargasso Sea. And I thought, space. Because back then space was a source of great mystery. So I thought, Okay, let's see what we can do with all those elements. I put them all into a bag, along with a little bit of *Flash Gordon* and a few other things, and out fell *Star Wars.*"

You could see Lucas as the first of the great content robber barons—the first wholesale appropriater of world culture, which he sold back to the world as *Star Wars.* Or you could see Lucas as an early sampler, a groundbreaker in what would become the essential Nobrow aesthetic: making art out of pop culture. Like Snoop and Ben Kweller, Lucas somehow tran-

scended the old hierarchy. In *Star Wars,* visual quotes from cliffhangers like *Dam Busters* and the *Flash Gordon* series mix easily with references to the film-school canon. The light-sabers and Jedi Knights were inspired by Kurosawa's *Hidden Fortress,* C-3PO's look by Fritz Lang's *Metropolis,* the ceremony at the end by Leni Riefenstahl's *Triumph of the Will.* Alec Guinness does a sort of optimistic reprise of his Prince Feisal character from *Lawrence of Arabia,* while Harrison Ford plays Butch Cassidy.

Lucas also wanted his film to have an old-fashioned middle-brow morality. He told me that his intention in writing *Star Wars* was explicitly didactic: He wanted it to be a good lesson as well as good fun. "I wanted it to be a traditional moral study, to have some sort of palpable precepts in it that children could understand. There is always a lesson to be learned. Where do these lessons come from? Traditionally, we get them from church, the family, art, and in the modern world we get them from media—from movies." He added, "Everyone teaches in every work of art. In almost everything you do, you teach, whether you are aware of it or not. Some people aren't aware of what they are teaching. They should be wiser. Everybody teaches all the time."

It took Lucas a year to write the thirteen-page treatment of "The Star Wars" (as it was then called). *American Graffiti* had been a montage of radio sounds; this treatment was a montage of narrative fragments. When Lucas would get down on the carpet with his toy airplanes and his talk of the Empire and the dark and light sides of the Force and the anthropology of Wookiees, even Lucas's friends thought he had lost it, according to the screenwriter Gloria Katz. "He always had this tunnel vision when it came to his projects, but it seemed like this time he was really out there. 'What's this thing called a Wookiee? What's a Jedi, George? You want to make a space opera?'"

"I'm a visual filmmaker," Lucas said. "I do films that are kinetic, and I tend to focus on character as it is created through editing and light, not stories. I started out as a harsh enemy of story and character, in my film-school days, but then I fell under Francis's mentorship, and his challenge to me after *THX 1138* was to make a more conventional movie. So I did *American Graffiti*, but they said that was just a montage of sounds, and then I did *Star Wars*. I was always coming from pure cinema—I was using the grammar of film to create content. I think graphically, not linearly."

Star Wars was rejected by Universal, who had an option on it, and by United Artists; only Alan Ladd, who was then at Fox, would gamble on it, over the heated objections of the Fox board. Ladd paid Lucas $15,000 to develop the treatment into a script. Lucas spent another year writing a first draft. He composed *Star Wars* with No. 2 pencils, in tiny, compulsively neat-looking script, on green-and-blue-lined paper, with atrocious spelling and grammar. Realizing that he had too much stuff for one movie, he cut the original screenplay in half; the second half became the original trilogy.

Neither Ladd nor Lucas's friends could make much sense of his first draft. "It only made sense when George would put it in context with past movies," Ladd told me in his office on the Paramount lot. "Like he'd say, 'It's like that scene in *Dam Busters*.'" The only characters that Lucas seemed to have a natural affinity for were the droids, C-3PO and R2-D2. In early drafts, the first thirty pages focused almost entirely on the droids; the feeling was closer to the Orwellian mood of *THX 1138*. Based on his friends' reactions, Lucas realized he would need to put the humans on the screen earlier, in order to get the audience involved. But his dialogue was wooden and labored. "When I left you, I was but the learner," Darth says to Obi-Wan, before dispatching the old gentleman with his

saber. "I am the master now!" Harrison Ford's remark about Lucas's dialogue, which he repeated for me, was, "George, you can type this shit, but you sure can't say it."

When a rough cut of *Star Wars* had been edited together, George arranged a screening of the film at his house. The party traveling up from Los Angeles included Spielberg, Ladd, De Palma, a few other friends of George's, and some Fox executives. "Marty was supposed to come, too," the screenwriter Willard Huyck told me, referring to Martin Scorsese, "but the weather was bad and the plane was delayed and finally Marty just went home.

"So we watch the movie," Huyck recalled, "and the crawl went on forever, there was tons of back story, and then we're in this spaceship, and then here's Darth Vader. Part of the problem was that almost none of the effects were finished, and in their place George had inserted World War Two dogfight footage, so one second you're with the Wookiee in the spaceship and the next you're in *The Bridges at Toko-Ri*. It was like, George, what is going on?"

Finally the lights came up. Polite applause was scattered through the screening room. No cheers. It was a "real sweaty-palm time," said the critic and screenwriter Jay Cocks, who was also there.

"When the film ended, people were aghast," said Gloria Katz, Huyck's wife and writing partner. "Marcia was really upset—she was saying, 'Oh my God, it's *At Long Last Love*,' which was the Bogdanovich picture that was such a disaster the year before. We said, 'Marcia, fake it, fake it. Laddie is watching.'"

Here, at this first screening of *Star Wars*, a group of writers, directors, and executives, all with ambitions to make more or less artistically accomplished Hollywood films, were confronting the template of the future—the film that would in

one way or another end everyone's career as an auteur. Not surprisingly, almost every one of them hated it. Even Spielberg's *Jaws*, the first of the modern blockbusters, which had appeared two years earlier, was a work of social realism compared to *Star Wars*. In this Nobrow moment, before the tsunami of big-grid megatude closed over *Star Wars* forever, these people were seeing the movie for what it really was—a film with comic-book characters, an unbelievable story, no political or social commentary, lousy acting, preposterous dialogue, and a ridiculously simplistic morality. In other words, not a very good movie.

Huyck: "Then we all got into these cars to go someplace for lunch, and in our car everyone is saying, 'My God, what a disaster!' All except Steven, who said, 'No, that movie is going to make a hundred million dollars, and I'll tell you why—it has a marvelous innocence and naïveté in it, which is George, and people will love it.' And that impressed us, that he would think that, but of course no one believed him."

Katz: "We sat down to eat, and Brian started making fun of the movie. He was very acerbic and funny."

"Which is the way Brian is," Huyck said. "You know, 'Hey George, what were those Danish rolls doing in the princess's ears?' We all sat there very nervously while Brian let George have it, and George just sort of sank deeper into his chair. Brian was pretty rough. I don't know if Marcia ever forgave Brian for that."

When the movie opened, Huyck and Katz went with George and Marcia to hide out in Hawaii. On their second day there, Huyck told me, "Laddie called on the phone and said, 'Turn on the evening news.' Why? 'Just watch the evening news,' he said. So we turned it on, and Walter Cronkite was on, saying, 'There's something extraordinary happening out there, and it's all the result of a new movie called *Star Wars*.'

Cut to lines around the block in Manhattan. It was absolutely amazing. We were all stunned. Now, of course, the studios can tell you what a movie is going to do—they have it down to a science, and they can literally predict how a movie is going to open. But in those days they didn't know."

But the irony of *Star Wars* was that as a result of its success, a movie as fresh and unknowing as *Star Wars* couldn't get made twenty years later. *Star Wars* proved to the suits once and for all that movies are too potentially valuable to leave the artists in charge of them. As Huyck put it, "Truffaut had the idea that filmmaking entered a period of decadence with the James Bond movies, and I'm not sure you couldn't say the same thing about *Star Wars*, though you can't blame George for it. *Star Wars* made movies big business, which got the studio executives involved in every step of the development, to the point of being on the set and criticizing what the director is doing. Now they all take these screenwriting courses in film school and they think they know about movies—their notes are always the same. Both *American Graffiti* and *Star Wars* would have a very difficult time getting through the current system. *Star Wars* would get pounded today. Some executive would get to the point where Darth Vader is revealed to be Luke's father and he would say, 'Give me a break.'"

The first *Star Wars* movie is a portrait of raw speed. If you saw it when you were young, this tends to be what you remember—the feeling of going really fast. Perhaps the most memorable single image in *Star Wars* is the shot of the *Millennium Falcon* going into hyperspace for the first time, when the stars blur past the cockpit. Like all the effects in the movie, this works not because it is a cool effect (it's actually pretty low-tech—merely motion-blur photography) but because it's a powerful graphic distillation of the feeling the whole movie

gives you: an image of pure kinetic energy that has become a permanent part of the world's visual imagination.

But these days, Lawrence Kasdan said, "the word *character* might come up at a development meeting with the executives, but if you asked them, they couldn't tell you what character is." He went on, "Narrative structure doesn't exist—all that matters is what's going to happen in the next ten minutes to keep the audience interested. There's no faith in the audience. They can't have the story happen fast enough." Every time a studio executive tells a writer that his piercing and true story needs an "action beat" every ten minutes, the writer has George Lucas to thank.

One of the lessons that *Star Wars* teaches is that friends who stick together and act courageously can overcome any amount of technology, money, and imperial power. At the end of the first movie, Luke, down to his last chance to put a missile in the Death Star's weak spot (which will blow up the reactor and save the Rebel Alliance from destruction), hears Obi-Wan telling him to turn off the targeting computer in his X-Wing fighter and rely on the Force instead: "Use the Force, Luke."

At the very least, the situation at LucasArts was a lot more complex than *Star Wars* makes it out to be. The gleeful embrace of the latest thing was also a force. The technology to create never-before-seen images also created the desire to see even more amazing images, which made the technology more and more powerful, and the people who used it correspondingly less important. And the power of business was not in the service of human values or of making good films. Lucas had benevolently followed his business instincts into the new world of dazzling, digitally produced effects, but his success was a blow to the fantasy that men are more powerful than machines.

Like the other journalists sent into the Death Star that is *Star Wars*, I was beginning to feel like I was part of the machine, too. My independence as a writer, here in this room with George Lucas for a quick interview, was limited in a way it had never been limited before, and the only consolation I could take was that George Lucas's own independence seemed to be limited by the same thing. Even a voice of old *New Yorker* values such as Orville Schell, dean of the Berkeley School of Journalism (and father of Jonathan Schell, once the conscience of *The New Yorker*), said apropos of his puff piece on George Lucas that ran on the front of the *New York Times* Sunday Arts and Leisure section, "They're not going to let you in the door unless they find the person that's going to do the piece agreeable. That seems to be the state of the art now."

In writing about *Star Wars* I had become a part of the Buzz industry in a way I never had been before. Of course, since I was from *The New Yorker*, the highest standards of integrity were upheld, but once Lucasfilm let me inside my range of options had shrunk. Jamaica Kincaid, in one of her regular Tina salvos, had said, "She enlists the help of people who think they are writers, but they are writing advertising copy." That was overstating it (I hoped), but there was no denying that a transaction was involved somewhere along the line. A relationship between *The New Yorker*'s brand and Star Wars' brand had developed, and it was in *The New Yorker*'s advantage to cultivate it. This is the real quest: understanding that I was a part of that relationship now.

It was said of the movie *Godzilla* that the marketing campaign was better than the movie. But in the prerelease hype surrounding *The Phantom Menace*, the marketing and the movie have become the same thing. I go to the supermarket to buy

milk, and I see Star Wars has taken over aisle 5, the dairy section. There are figurine mugs of Han Solo and Princess Leia, nine-inch collectibles featuring Emperor Palpatine, an R2-D2 dispenser filled with *Phantom Menace* Pepsi, and, down from that, another big display case filled with Star Wars–themed Frito-Lay potato chips. Pepsi has sunk over $2 billion into promoting the new trilogy. Each of Pepsi's three fast-food franchises—KFC, Taco Bell, and Pizza Hut—has licensed a different planet and festooned their containers with its characters.

The marketing is the culture and the culture the marketing. The space that the marketing of Star Wars takes up in the culture, in terms of Buzz, is validation for the fans of the movie—a kind of return on their investment—just as, in a smaller way, the marketing of the WASP lifestyle by Ralph Lauren is a validation of my preppy culture. Star Wars is both something to buy (marketing) and something to be (culture), through the buying: a *Star Wars* fan.

One day, while piloting my rental car around the extended universe of *Star Wars*, I met a guy named Lance, in El Cajun, a small town in the desert about a half hour east of San Diego. Lance was behind the counter of his shop, StarForce Collectibles, an all–Star Wars merchandise store, which was located in a strip mall across from the movie theater where *Star Wars* was playing. Like other people I had met whose identities were deeply invested in *Star Wars*, Lance's first memories of the movie involved his family. He was eleven when he noticed his dad wearing a *Star Wars* T-shirt. Then his dad made him a lightsaber, which meant the world to him. Soon he became a collector. "I was this anal, somewhat obsessive compulsive kid. Like I'd wash my hands a lot. Or my room would either be real clean or real messy. And with this *Star Wars* stuff I was on a mission." He remembers his parents split up be-

tween the first movie and *Empire*, and that he lost his virginity between *Empire* and *Jedi*. After high school, he decided to leave the family farm in Nebraska and seek the wider world in California, so he packed up all his *Star Wars* stuff—it filled a van—and drove to California in seach of his destiny. He got married, found a job in a toy store, but kept getting fired, until all he had left was his *Star Wars* stuff. His mother-in-law suggested he might as well start a Star Wars store, so he did.

As we spoke, *Empire* was on the VCR. The film was coming up to the famous scene on the Cloud City catwalk when Darth reveals that he is Luke's father and tries to turn him to the dark side. From the TV came the buzzing sound as Darth and Luke fire up their sabers. In James Earl Jones's basso profundo, Luke's father said, "If you only knew the power of the dark side" (for the many-thousandth time, Lance spoke the line along with him). The small grid (Lance and his family) and the big grid (Darth and Luke) seemed to be arcing together here in the store.

Lance told me he screened the trilogy every day in his store. He had watched *Star Wars* about two thousand times. On his only day out of the store last year, which was Christmas Day, the USA network happened to be showing the trilogy, and so he sat down and watched the whole thing with his family.

Some of the most devoted *Star Wars* fans I met were Lucasfilm employees. This tended to make them excellent workers for Lucasfilm, because feeling successful in their jobs for *Star Wars* helped prove that the lessons of *Stars Wars* do come true. Clint Young, one of the programmers I met at LucasArts in San Rafael, who was working on the new version of the LucasArts game Jedi Knight, told me that he had been a devout *Star Wars* believer since he was six. "I grew up on a farm and so the story of Luke, who was born with the dream of do-

ing something bigger than was going on around him—I could really relate to that." After Clint saw *Star Wars* for the first time, on video, he started painting *Star Wars* images—that was how he became a painter. He watched the video more than one hundred times. "My grandfather would ask me, What are you doing, watching those movies? And I would say—It's respect." Last year when LucasArts came out to his college in Texas on a recruiting trip, they saw his *Star Wars* images and hired him. "I see a lot of parallels between *Star Wars* and my life," Clint went on. "I was the first of my family to get out of Dallas, just like Luke got out of Tatooine, and I feel like it was sort of my destiny to be here." His destiny so far had lain in building "low polys," the polygonal structures that are the basic elements of computer graphics. He was enjoying his work on Jedi Knight, which granted those who knew how to use the Force access to more levels in the game. "If you use the dark side of the Force you'll have more power, but you'll lose the ability to later on in the game use the light-side powers like enhanced jumping ability, or the certain healing powers."

In the basement at LucasArts, the young *Star Wars* geeks stared into computer screens, building polys, doing "beta testing" (checking software for bugs), and other routine, labor-intensive activities. There was dirty low-pile carpet covering concrete floors, no natural light, cubicles, kids, glom (giveaway brand-reinforcing merchandise), and big computers. Down there I met a young female victim of carpal tunnel syndrome, her left hand and wrist wrapped in Ace bandages, with just enough of her fingers poking out of the top for typing, pecking away at the beta version of a new LucasArts CD-ROM game called Herc's Adventures. She told me this was her first day "on the game," which she would be playing all day, every day, for the next two months, to see if any particular series of keystrokes and mouse clicks might cause it to crash.

"Unless I go into burnout first," she said clinically, playing the game, not looking at me.

"What's burnout?" I asked, watching Herc, who was making those not-quite-full-motion-video-yet-herky-jerky jumps over various obstacles in his way.

"Burnout is when you're no longer able to understand what's going on on the screen, or you get sloppy. It's like, you lose it."

Up at Skywalker Ranch it was possible to imagine that the future was somehow going to end up saving the past after all, and that we would find on a new frontier what we lost a long time ago in another galaxy, far, far away. But in the model shop at Industrial Light & Magic in San Rafael, this was harder to believe. All the monsters, ships, weapons, and other effects in the original *Star Wars* were made in the model shop—by hand, more or less—by the team of carpenter-engineer-tinkerer-inventors assembled by Lucas. They used clay, rubber, foam, latex, wire, and seven-foot-two, hairy Wookiee suits to create their illusions. (The only computers used in making the original *Star Wars* were used to control the motion of the cameras.) The model-makers were so good at what they did that they unleashed a desire for better and better special effects in movies, which ended up putting a number of the people in the model shop out of work.

The model shop survived mostly because the TV crews from *Entertainment Tonight* wanted something more visual to shoot than the computer geeks who actually made the effects. The model shop, with its creatures, ghosts, and crazy vehicles that were used in movies like *Ghostbusters* and *Back to the Future*, made an eye-catching set. While I was visiting, I saw two carpenters working on a C-3PO, whose head, arms, and legs were spread all over the workbenches—he looked the way he

did after the Sand People got done with him in the movie—
and I asked, naïvely, if I would see him in one of the new
movies. No, he was just another prototype, who would prob-
ably wind up in some supermarket aisle, selling Pepsi.

Paul Huston, a model-shop old-timer, did oil-on-canvas
matte paintings for the original *Star Wars;* he did digital matte
paintings for the *Special Edition.* He showed me a tape of some
of his digital additions to the *Special Edition,* which occur be-
fore and after the Mos Eisley cantina scene. ILM had inserted
a "C.G." (computer graphic) Jabba the Hutt into the scene,
where he now confronts Han Solo in the docking bay where
the *Millennium Falcon* was waiting. (Ford did his half of the
scene with a human actor inside a Jabba suit in 1976, but the
footage was never used, because it didn't look good enough.)
In order to create a crashed spaceship that was part of the
background of the Mos Eisley spaceport, Huston built a real
model, out of various bits scavenged from airplane and heli-
copter kits, and took it outside and photographed it in natural
light. Then he scanned that image into his computer and
worked on it with Photoshop. Clint Young would build the
crashed spaceship from scratch right on the computer.

"To me," said Huston, "it comes down to whether you look
to the computer for your reality or whether you look out there
in the world." He pointed outside the darkened C.G. room
where we were standing to the bright sunlight and the distant
Marin hills. "I still think it's not in the computer, it's out there.
It's much more interesting out there." He turned back to the
spaceport image on the screen. "Look at the way the light
bounces off the top of this tower, and how these shadows ac-
tually deepen here, when you'd expect them to get lighter—
you would never think to do that on a computer."

Huston seemed like kind of a melancholy guy, with sad eyes
behind small wire-rimmed glasses. He said he had accepted the

fact that creations like the C.G. *T. rex* in *Jurassic Park* were the way of the future, and that in many cases C.G. makes effects better. The model shop could never get lava to glow properly, for example, but with C.G. it's easy. Also, C.G. is more efficient—you can get more work done. "The skills that you needed ten years ago to do modeling and matte painting were hard to attain," he said. "Making models was a process of trial and error. There were no books to tell you how to do it. It was catch as catch can. Today, with the computer, you can get modeling software, which has a manual, and follow the instructions."

He gestured around at the monitors, scanners, and other machinery all over the place. "Our company has taken the position that the computer is the future, and we have moved aggressively toward that," he said. "I can see that's what everyone wants. In model-making there aren't many shortcuts. And this is a business of turnover and scheduling and getting as much work through the pipeline as you can. If there is a shortcut to doing something on a computer, and it's going to cost a hundred and fifty thousand dollars, the client will say, 'Oh sure, let's do it.' But if you offer them a model-building project for a third of that there are no takers. Because that's not what clients are interested in. So we're trying to do everything synthetically, with computers, to see how far we can go with that."

Star Wars, taken as a whole story and viewed in chronological order, is not really the story of Luke at all but the story of Luke's father, Anakin Skywalker, and how he, a Jedi Knight, was corrupted by the dark side of the Force and became Darth Vader. When I asked Lucas what *Star Wars* was ultimately about, he said, "Redemption." He added, "The scripts to the films that I'm finishing now are a lot darker than the second

three, because they are about a fall from grace. The first movie is pretty innocent, but it goes downhill from there, because it's more of a tragic story—that's built into it."

Innocence was what many people found so compelling about the first *Star Wars* movie. But had Lucas himself ever been that innocent? Because it really is appalling, when you think of it: George Lucas, in the process of restoring old-fashioned values to the kids, following his naïve, childlike muse, and staying true to his countercultural '60s roots, has made more money than anyone has ever made from a movie franchise before.

I felt that somewhere in this dark room was the real Force: the will-o'-the-wisp of financial independence, the thing that ends up controlling you. That was the note of loss in the voice in the dimness. It was a melancholy, a feeling that the *Star Wars* trilogy didn't allow very often onto the screen, but that was there in the background, like the remnants of blue screens you could see in *Empire*, in the thin outlines surrounding the Imperial Walkers on the ice planet Hoth.

Did Lucas worry about being turned to the dark side himself—the marketing side? Maybe it happened slowly and subtly, with the temptation to stop being a filmmaker and become a kind of master toymaker instead, which is fun until you wake up one day and realize you have become one of your own toys. You could see that starting to occur in *Jedi:* the Ewoks, those lovable furry creatures, seemed destined for the toy store even before they helped Luke defeat the Empire. *The Phantom Menace*, which was Lucas's attempt to recapture his own innocence as a filmmaker, would seem to many critics like a disastrous triumph for Lucas the toymaker.

"Of course your perspective changes when you get older and as you get battered by life," Lucas said.

"Have you been battered by life?" I asked.

"Anyone who lives is going to get battered. Nothing comes easy."

I believed him. He was Luke, after all, and like Luke he had had to reckon with his patrimony. (Darth: "Join me, Luke, and together we can rule the galaxy as father and son!") Just as Luke has to contend with the qualities he may have inherited from Darth Vader, so Lucas, in his career after *Star Wars*, had become the successful, fiscally conservative businessman that his father always wanted him to be. Instead of gaining his independence with the success of *Star Wars*, Lucas had lost it. That was the real lesson of *Star Wars:* In the end, the empire wins.

6

Sunday in SoHo

I live in downtown Manhattan. I lived in the East Village in the early '80s and the West Village in the late '80s. But SoHo was always the axis around which my idea of downtown revolved. SoHo: spilling out onto the sidewalk after the Basquiat-Warhol show at the Tony Shafrazi Gallery, someone saying let's get something to eat at Odeon, and then heading off into that BrightLightsBigCity night.

But by the time I was ready to buy an apartment, SoHo was too gross, too ruined by commercialism. Spending my weekends among the hordes who came to SoHo in search of some downtown status of their own was not my idea of home. I ended up buying in Tribeca, where in my own way I try to make the present feel like the past. To me, Tribeca is like SoHo before money took over.

Still I walk around in SoHo two or three times a week. I usually have a destination in mind—to shop for food at Gourmet Garage, to look at clothes at Helmut Lang or Agnès B, or to see a show at a gallery, though I don't do much of that anymore. It's almost always something to buy. There's a lot to buy in SoHo: fancy sunglasses and "authentic" Indonesian furniture, edible flowers, high-design soap dishes and hundred-dollar Kliss Touch scissors, plastics, fashion, and cell phones

cell phones cell phones. One walks in and out of shoe shops, jewelry stores, and a David Zwirner show (wait, that's not the same guy who's on *Friends*, right?), and the shoes, the jewelry, and the paintings don't seem any different from one another as objects. This too is Nobrow—the space between the familiar categories of high and low culture. In Nobrow, paintings by van Gogh and Monet are the headliners at the Bellagio Hotel while the Cirque du Soleil borrows freely from performance art in creating the Las Vegan spectacle inside. In Nobrow, artists show at Kmart, museums are filled with TV screens, and the soundtrack of *Titanic* is not only a best-selling classical album but one that supports the dying classical enterprises of old-style highbrow musicians.

Today is Sunday, a lovely September day, and the nominal purpose of my SoHo excursion is to get some good tomatoes at Dean & DeLuca, at Broadway and Prince Street. I walk across Franklin Street, which still has lots of old, ungentrified loft buildings that look like they belong to Original Tribecans—people who passed on SoHo in the '70s when the commercialization started to get bad and moved into lofts down here: cast-iron buildings with big grimy windows.

At Broadway I turn left and start heading uptown. Below Canal are the Chinese fabric places, where the cloth is one step up the production chain from the textile factories below them, in bolt form, available only to the trade. Across Canal the fabric emerges from the bolts, rendered into T-shirts and shorts and jeans and khakis, hastily stitched together in a local sweatshop and selling for *tendollahtendollah* and *eightdollaheightdollah* out on the street. Then, across Grand, you come to the hip-hop emporia that have sprung up around Canal Jeans. These stores, like Yellow Rat Bastard and Pulse and Active Warehouse, are also selling T-shirts and shorts and jeans and khakis, but something more has been added to the garments—the

brand. In buying the shirt you're buying the label, which will become a part of your identity in the mosh pit of identities out on Broadway. The branding is done by combining a commercial trademark with one or another subcultural motif, a subculture the buyer belongs to or wants to join—surfing, skateboarding, and all-around hip-hop bro-dom are the main motifs in these stores. The brand is the price of your admission to this subculture. The brand is neither quite marketing nor culture; it's like the catalyst, the filament of platinum that makes culture and marketing combine.

Young brands like Porn Star, Triple Five Soul, and Exsto jockey for attention within the thirteen-year-old demographic. Yellow Rat Bastard has created urban scenes for the different grouping of brands to be displayed—a bodega, a flop house—so that it feels like you're slipping into something more than clothes, a whole street identity. The Wu-Tang Clan's vaguely sinister appropriation of imagery from '70s kung fu movies has filtered into a lot of logo design. By the time I have reached Active Warehouse, where young salespeople wear futuristic headsets, it feels like I'm in a Puff Daddy video.

This lower third of the brand hierarchy ends just south of Spring, with Old Navy, which mainstreams the more out-there subcultural styles in the hip-hop stores into a single brandable big-grid look. Around Spring the welter of low brands resolves itself into the middle-brand stores. Guess, Banana Republic, Club Monaco; there's even a Victoria's Secret up at Prince. These stores are selling pretty much the same stuff that they sell down below Spring—T-shirts, khakis, jeans—but the quality and tailoring are better, and the price is steeper.

A cluster of fashion boutiques has recently taken up residence just west of here, on Greene and Wooster Streets: Louis Vuitton, Helmut Lang, Costume National, and Prada. The clothes here are more expensive still, and the fabrics and the

tailoring are even better. But what's noteworthy to the student of Nobrow is that the hierarchy of price is not a hierarchy of style. The lower-end styles down Broadway have more influence on the styles up here than the elite have on the masses. There was a time when mass merchants like the Gap knocked off the high styles of the elite designers like Helmut Lang, selling inferior versions of designer clothes for much less. But now in the Helmut Lang store you find knockoffs of the T-shirts and jeans they sell in both the midbrand and the low-brand stores, except that Lang's clothes are made with better fabrics and with tailoring expensive enough to warrant charging four times as much for them as they charge in Old Navy. But they are the same style as the clothes in Old Navy—cotton tees, cargo pants, cords—and the fact that they are the same as Old Navy is exactly what makes them distinctive.

Taking a detour from my destination, I stop in the Helmut Lang store, where the T-shirts and faded jeans hang next to $1,700 suits. The only sure way to tell the women's clothes from the men's is by the color of the hanger. In some pieces Helmut seems to be outlowbrowing the Gap—going for the thrift store look. All the impulses toward casual dress that I struggled with so ungracefully in my own boyhood closet have here been resolved into my ideal Anticloset.

As I walk in they're playing that Olivia Newton-John song from the '70s, "Have You Never Been Mellow?" It sounded bad to me when it was new, but now, played here in Helmut Lang, it sounds sweet. I hear a girl near me say to her boyfriend, "I *love* this song."

Just as the country rock I was listening to in the '70s has come back as an interesting vibe in the sound of '90s alternative country bands like Wilco and Elf Power, where it seems

more like art than pop, so the casual clothes I wore in the '70s as an escape from my father's closet have come back as high fashion—in the cords and T-shirts here in Helmut Lang. I stop before a navy-blue T-shirt, made out of lightweight jersey fabric, which makes it feel very smooth inside. I look at the price—$200.

Olivia Newton-John is followed by a song from the Smiths, one of the great ones, "Reel Around the Fountain."

Fifteen minutes with you
Oh, I wouldn't say no

"Excuse me. How will I wash this?" I ask the salesperson.

"Well, actually it's better if you don't wash it," she says. "I know that sounds terrible, but the color fades easily."

Hmm. No washing. That is a consideration. But still. What does that mean? I guess you dry-clean it.

I go into one of the changing rooms, which look a bit like Richard Serra sculptures: they're massive and brutally elegant. The fashion psychopath who used to bedevil me regularly in the '80s reappears. Buy it, he whispers. Go ahead. Buy it. You know you want it. Then you can be part of that whole hip-hop thing happening down Broadway, while at the same time being secretly above it all. You'd spend $200 for a dress shirt, so why not a $200 T-shirt that you'll wear a lot more? And, unlike the dress shirt, no one will know it cost $200 except you— so you don't have to feel guilty about being a conspicuous consumer. You can be an inconspicuous consumer, which is even better. It's antistatus as status, another important principle in Nobrow.

I try the T-shirt on. It feels great. And fits beautifully. A high-fashion T-shirt that looks utterly ordinary. I take it off and leave the dressing room. As I walk up to the beautiful,

lanky Australian girl behind the counter, I don't know what I'm going to do. The fashion psycho likes to make a Zen thing out of it.

I hear myself saying, "Thanks, but I think I'm not ready to spend two hundred dollars on a T-shirt." I give her a smile, and I'm on my way, feeling victorious.

In 1980 Barbara Tuchman published in *The New York Times Magazine* an essay entitled "The Decline of Quality," in which she explained in the gentlest and most disinterested way possible why it was necessary to be an elitist. "A question that puzzles me is why inexpensive things must be ugly; why walking through the aisles in a discount chain store causes acute discomfort in the esthetic nerve cells," Tuchman wrote. The question, of course, wasn't puzzling at all: as the old standards of craftsmanship and quality are replaced by market-oriented standards of popular appeal, the inevitable result is poor workmanship, homogenization, and general ugliness. *Of course* handmade goods, made by a craftsman who cares about his work (whose impulse in making the thing is not merely utilitarian) will have a kind of quality that machine-made goods don't have. After she had pondered the matter for a while Tuchman concluded that "quality is undeniably, though not necessarily, related to class, not in its nature but in circumstances." Elitists everywhere breathed a sigh of relief.

Twenty years after this essay was published, there is reason to suspect that Tuchman's "circumstances" have changed. What has happened in all the arts, broadly defined—in the decorative as well as the fine arts—is that quality, once the exclusive property of the few, has slowly and inexorably become available to the many. The old reasons for deploring the mass manufacturing of clothes and home furnishings—workmanship

and design—have become the very reasons for applauding mass marketers like Old Navy, Banana Republic, Crate and Barrel, and Pottery Barn. Why buy furniture from Herman Miller and Knoll when you can get that clean modernist line and sturdy workmanship at IKEA and Hold Everything for a fraction of the price, *and* you can drive off with it in the trunk of your car? Quality is no longer very closely related to price, at least in fashion and furnishings. Manufacturing has improved; good design has spread to the lower prices of consumer goods; the craftmanship and style of the goods sold at Nine West, as well as in Banana Republic or Pottery Barn, are so much better than the goods from a Korvette's or a Pier 1 or a Kmart, or some other discount wholesaler in which Tuchman might have experienced aesthetic discomfort in the late '70s, that they hardly bear comparison. It is true that these chain stores cause standardization of style, but it is also true that the good design of the products promotes an interest in good design generally, and that sends better-educated consumers off to the smaller, more independent stores.

But if the old totem of elite culture—quality—which at one time could be acquired only through that magic triumvirate of status indicators—knowledge, time, and money—is made into a commodity that can be purchased by almost anyone, then the elite can no longer rely on conspicious consumption as a means of distinguishing themselves from the masses. If everything is knocked off and made for a lot less, like the imitation Prada and Louis Vuitton bags you can buy on Canal Street, the owners of genuine Prada and Louis Vuitton are forced to become, in effect, inconspicuous consumers—to take inner pride in the fact that their bag is the real thing, even if only a few cognoscenti know that.

Thorstein Veblen wittily skewered the rich for their obsession with handmade goods, arguing that such objects, being

imperfect, were actually *inferior* to machine-made goods, but the rich had managed to make those imperfections into virtues such as uniqueness. But by the late 1990s that trick was nearly up. As the middle class got better and better at appropriating the distinctive styles of the rich, imperfections and all, the rich were forced to go to ever-greater extremes of imperfection to distinguish themselves, making high fashion out of clothes and furniture so imperfect and ugly, in such poor taste (in the old High-Low sense) that no self-respecting middle-class person would want to knock them off, like the $3,800 ripped and beaded Gucci jeans that were all the rage last fall.

As usual this part of SoHo is shoulder to shoulder with pedestrians in hot pursuit of status in Nobrow. When you do away with the old High-Low hierarchy, people become more obsessed than ever with status. The action seems like it's more out on the streets than in the galleries. Standing in the Sonnabend Gallery, at a group show, I turn and for a moment my eyes stop in an interesting rectangle of space. Then in the next moment I realize it is an open window and I am looking out onto West Broadway.

A lot of these people aren't actually affluent: They have no savings, their credit cards are maxed out, and they're carrying thousands of dollars of debt at 18 percent interest. But their lack of means does not make them ease off the pursuit of status—indeed, it spurs them on.

The downtown Guggenheim is displaying the six finalists for the Hugo Boss Prize, a competition for groundbreaking artists, and I want to catch the show before it closes. I pay my $8 and go upstairs, where the works are on display. All six of the finalists are multimedia or installation artists; there isn't a painter or sculptor in the show.

After walking around the exhibit, I sit on the floor in front of a video installation by a Swiss artist named Pipilotti Rist. Entitled *Sip My Ocean*, Rist's piece is a music video based on a Chris Isaak pop song called "Wicked Game." In the video Rist herself sings the Isaak song in a goofy, slightly hysterical-sounding voice, while the camera catches glimpses of the artist's body underwater, in a tropical ocean, wiggling semi-erotically to the music. (Rist is a former rock drummer, a fact that helps to distinguish her as a fine artist in Nobrow.) The video (actually two videos, joined at right angles on the large L-shaped projection surface) is shot in the familiar MTV-surrealist style.

I ask myself the usual questions, strain to make the usual judgments. I slip out my once-trusty slide rule of status and measure *Sip My Ocean* with it. Avant-garde or kitsch? Art or advertising? Good or bad? The old categories and hierarchies aren't very useful here. This isn't quite art and it isn't quite advertising—it's art that has been made out of the discourse of advertising. A video, which is neither art nor advertising but a hybrid of both, is repurposed and used to market . . . the artist herself. And yet you couldn't really accuse Rist of "selling out." Her installation isn't really a commodity, though it's made out of a commodity. Rist probably couldn't sell this piece. (Why bother to buy it when you could watch it on TV?) Like many installation artists, Rist lives more on the patronage of museums and marketers like Hugo Boss than on the sale of her works.

The audience is at least as interesting to look at as the art is, and it seems to be aware of that. A few people carry into the Guggenheim the air of town-house seriousness that I still instinctively carry into a museum—that earnestness with which one goes to "get" high culture at the Met. But most people are here just to chill out and watch one another, secure in the knowledge that they *are* the culture.

As I sit here I see hip-hugging cargo pants, with turned up and straight cuffs, established brands (Polo, Guess), and newer labels like Muss and LEI. "X Large" brand T-shirts, rave-style acid-house logos and cloche hats, gangsta-style high-slung drawers, "Tims" (Timberland boots), and "Tommy Hill." Tommy Hilfiger, like Ralph Lauren before him, had tried at first to market to the upwardly striving white middle class by imbuing his advertising with images of WASPs at play. But it wasn't until the black hip-hop kids in the cities started wearing Tommy that the white kids decided it was cool to wear him, too. Hilfiger has a $3.2 billion company, largely because he was the first designer to realize, with the help of Russell Simmons, that white kids would buy what black kids bought, not the other way around.

Sip My Ocean is like a paradigm of a transaction that is going on everywhere in the room—the art of representing identity through culture. In using a music video and a well-known pop song to sell herself to this audience, Rist is doing in a more dramatic way exactly what the audience is doing when they choose their clothing or buy a CD. When you say about a painting, a music video, or a pair of jeans, "I like this," you make some sort of judgment, but it's not a judgment of quality. In Nobrow, judgments about which brand of jeans to wear are more like judgments of identity than quality. These judgments do not depend on knowledge of the canon, tradition, history, or some shared set-up standards about what constitutes "good taste" to give them weight; this kind of taste is more like appetite than disinterested judgment. Taste is the act of making the thing part of your identity. Stripped of the legitimacy that the old cultural hierarchy gave to them, acts of taste are acts of appetite, whether applied to art, furniture, or food.

Fanship, brandship, and relationships are all a part of what the statement "I like this" really means. Your judgment joins a

pool of other judgments, a small relationship economy, one of millions that continually coalesce and dissolve and reform around culture products—movies, sneakers, jeans, pop songs. Your identity is your investment in these relationship economies. Investments in certain big-grid properties are virtually risk-free but offer little return (saying you like the Rolling Stones is like buying thirty-year Treasury bonds), while investments in the small grids are riskier but potentially more lucrative (such as saying you like Liz Phair: are you investing in her image as a strong rock chick, which is cool, or are you standing up for an indie sellout and CK jeans model, which would be un-cool?). The reward is attention and self-expression (your iden-tity is in some way enhanced by the culture product you invest in), while the risk is that your identity will be overmediated by your investment, and you will become like everyone else.

These cultural equities rise and fall in the stock market of popular opinion, and therefore one has to manage one's portfolio of investments with care. No value endures; every-thing shifts in the marketplace of opinion. The seeker of iden-tity through culture has to take care to surf ahead to the next subculture, before he is mediated out of existence. You make choices about what's "good" and "bad" in culture as though your life depended on it, which it does to some extent. What you taste becomes a temporary part of your identity, and you in turn become a member of the subculture of other people who are also invested in that pop equity. In the cultural mar-ketplace of Nobrow any number of possible identities are on offer. You construct an identity out of a collective of these in-vestments, mixed up in such a way that it makes you seem unique (this is *your* art). You want to be perceived as original, but not so original that you are outside of the marketplace of popular opinion. You're a snowboarder who listens to classical music, drinks Coke, and loves Quentin Tarantino; you're a

preppy who likes rap; you're a chop-socky B-movie fan who prefers Frusen Glädjè to Häagen-Dazs, or a World Cup soccer fan who wears FUBU and likes opera.

Chris Isaak, a slightly schmaltzy country crossover crooner, whose own video for "Wicked Game" features him in erotic clinches with a topless model, is a risky investment for Rist to make, but Rist's risk is hedged somewhat, since Isaak has a lot of his own identity as a pop singer invested in the blue-chip equity of one of the white fathers of wiggling, Elvis Presley. In her video Rist's body wiggles suggestively underwater in a way that seems to sample the collective image of Elvis's wiggling on-stage, which is part of the common language that everyone in here shares. But at the same time the art is all very much about Rist. Just as MTV videos are ads for the music, so Rist's video is an ad for the artist—and in Nobrow that's what makes it art.

Back out on Broadway, I walk up the street and get pulled into the Pottery Barn. There's also an Eddie Bauer, a Nine West, and a Sunglass Hut. (And soon there will be a new Prada, right inside the Guggenheim's lobby.) This part of Broadway feels just like the stretch of Fifty-seventh Street from Madison to Sixth, and rather like any other up-market mall in Brand USA, including the new Times Square. As I walk by these stores, I can feel this new, upscale mass culture pressing in on me, trying to make me and the rest of the people in the street exactly like one another—each of us a demographically desirable Banana Republican, out for a little Sunday consumption.

The Pottery Barn feels like a museum, too. Seeing in the physical world furniture you are already familiar with from its reproduced image in a catalog gives it a kind of aura it wouldn't ordinarily have. There's also a sense of connoisseurship in the store. Some tastemaker has been at work in here, working in a

method not unlike George Lucas's approach to writing *Star Wars*—selecting traces of designs from different cultures (French, Indian, and southeast Asian colonial, of different periods), lifting styles out of their cultural and historical contexts and recontextualizing them with other styles (a Montana cowboy goes on safari in the Raffles Hotel in Singapore), in such a way that no one style is obvious. It's similar to the game being played over in the Guggenheim—an identity is constructed out of the shards and scraps of any number of subcultural references—but here the purpose is to create a dominant, mainstream identity that's too bland to be really unique, but is enough to make these mass-produced objects feel special.

Toward the back of the store I see a coffee table. It's called the Cairo Chest. There's not much that's Egyptian about it, although it does make stylistic reference to a chest that a sea captain might have, and Cairo is on the Nile. The price is $299—cheap. I lift a corner of the table: it has a pleasing heaviness. I have confidence in its workmanship. But do I really want to buy a table that eight million other people might have in their homes? Not according to the old High-Low system of status I don't, but maybe there is a Nobrow currency in owning the Cairo Chest that I don't understand.

I have been looking for a coffee table on and off for the last twenty years. I realized not long ago I would probably never find one I liked, because what I was really doing was trying to recover the simple cartography of status mapped out on my parents' coffee table, where cocktails and coffee were served, each at the appropriate hour, and where certain magazines, like *The New Yorker*, made it clear exactly what place in the cultural hierarchy we belonged to. Once again, I take out my slide rule of status. I make an earnest attempt to find the Cairo Chest in poor taste, by town-house standards: mass-produced objects are low, and mass-produced furniture is particularly

tacky. And, once again, my sense of taste is oddly frustrated. The ingenious blend of approximate identities out of which the Cairo Chest is constructed has made it oddly impervious to an individual act of judgment. Taste, formerly in the eye of the beholder, has been built into the object itself.

Without making a decision about the Cairo Chest, I walk back out onto the street and down Broadway to Dean & DeLuca, across Prince Street, to accomplish my errand—to get the tomatoes I need for tonight. Dean & DeLuca looks like an atelier, with its high ceilings and its big clean windows in front. The food here is, in my judgment, inferior to the food in Balducci's on Sixth Avenue, but the vast open space at D&D inspires the mind to higher contemplation of artworks like the morel mushrooms ($35 a pound) than the low and souklike Balducci's does.

I become absorbed in testing the Belgian tomatoes against the late-season Jersey tomatoes, neither of which are cheap ($3 a pound). I take refuge in this act: here, within this circumscribed space, my judgment can still operate. I cannot say whether *Sip My Ocean* is high art, nor can I say whether the Cairo Chest is in good taste, but I can at least pick a good tomato. Tomatoes are my folk culture—a part of the cultural inheritance that has come to me unmediated from the place where I grew up. South Jersey doesn't have much going for it in the way of culture except for the tomato.

I carry my tomatoes and two beautiful lamb shanks, wrapped in thick wax paper, away from the Valley of the Shadow of Nobrow and get home in time for the six-thirty news. I take out the olive oil, pour it into the pan, and begin to chop celery.

Then I cut into a Jersey tomato and discover I've been fooled. The tomato, which looked perfect on the outside, and which should be fresh, since it came from just fifty miles away, has the gluey, frosted-looking interior of a common, lowbrow supermarket tomato. I should have gone with the Belgians.

7

High Nobrow

Tina sprang the idea of doing a Geffen profile on me when I was in her office for a meeting about the California Issue. She gave me that quick, thrilling, high-octave glance up from the Diet Coke and said, "What about Geffen?"

Geffen was one of those ideas that had been kicking around the office ever since Tina arrived. Other writers had been offered it and prudently refused, because taking the assignment would obviously mean acting as a relationship broker between Tina and Geffen. I could have said no, too. I had said no to Tina before, and while the experience was unpleasant—she gave you a dead cold look that was just as intense as the hot glance up from the Diet Coke—it was necessary once in a while. Otherwise you burned out or got known for one thing only, and then were expected to do that thing over and over again.

But I said that Geffen sounded interesting and that I'd look into it. Why? I was curious about how an antimogul like Geffen (his life story was also a proto-Nobrow tale) conducted his affairs. Also, I think I wanted to please Tina, to impress her as someone who could write about the kind of people she was really interested in, to be included among the inner circle of writers who went to her house for dinner and got faxed in the

middle of the night. What I found inspiring about Tina was the way she flung herself into this quixotic project that Newhouse had hired her for, which was to remake *The New Yorker* as a magazine for the new commercial culture while somehow hanging on to the literary quality of old. Even if the objects of her fascination, like Geffen, couldn't always live up to the heroic energy she invested in them, the energy itself was very attractive.

"You know, it's hard for me to explain to you what I've done, even in the past, let alone today," Geffen was saying. He gazed at the orange late-afternoon sun on the venetian blinds of his office in L.A., which was the same shade of orange as the sun setting over the Mos Eisley cantina in the ILM computers, and the same millennial orange that lit the side of the *Titanic* as it sailed into its last sunset.

"You have an idea of the way you think it is," Geffen went on, "and it's not that way at all, it's something else."

Geffen peeled a Post-it from a pad that was sitting on the coffee table in front of him and folded it into a square. He performed this meaningless action carefully. The boredom in his eyes, which seemed on the verge of spilling over into other parts of his face, was held in check by the lively eyebrows. It was as though all the enthusiasm that the eyebrows had been forced to express over the years for all the artists whom Geffen had absolutely adored had left run-off deposits of residual boredom in the lower eyelids—the slag of the star-making machinery.

It was a beautiful November day in Los Angeles, a day with a sort of at-the-end-of-the-day feeling to it. Geffen's thirty-five years of pop dreamers and telephone screamers seemed but the distant sound of lyres and flutes. Unmoored from all

institutional responsibilities, he was on the verge of floating away into a fanship or brandship or relationship economy so pure that it was almost evanescent.

The phone rang. Geffen turned his head very slightly and took in the little green Caller ID screen. On the phone were twenty speed-dial buttons, next to which were the names of Jeffrey Katzenberg, Steven Spielberg, Edgar Bronfman Jr., Ron Meyer, Calvin Klein, Paul Allen, Allen Grubman, and Barry Diller, among others (like Tina Brown? I wondered)—a big-grid relationship economy of tastemakers whom Geffen talked to every day.

Before I got to L.A., I sent Geffen a fax in which I told him that I imagined him going to nightclubs in pursuit of the next Guns n' Roses or Nirvana, walking into glamorous parties, flying to Cannes, trading wits, etc. Geffen called me to say that he didn't live anything like that. Who cared about all that crap, the wine, the clothes, the parties? He lived very quietly, saw friends, enjoyed his paintings, and worked. He didn't keep up with new music—hadn't for years. "I have to tell you honestly," he said, "when I heard 'Smells Like Teen Spirit,' I couldn't make out the lyrics. It never occurred to me that it would turn out to be this hit that would be a number-one record in every country in the world. I couldn't make out the lyrics in English, how are they going to like this in Greece?"

Geffen sat upright in his chair, back straight, head up. He wore Reebok Classics sneakers, jeans, a Puma T-shirt under a flannel shirt that actually looked nicer than something you'd find at the Gap—a relative sartorial flourish. ("Wear a nice suit," my mother had croaked from her sickbed on hearing I was off to California to interview the billionaire David Geffen. I wore a nice T-shirt, made by the Haitian band RAM, which I got in Port au Prince, and Geffen immediately admired it. "Where'd you get that T-shirt?")

The office here in Beverly Hills, like Geffen's beach house in Malibu, was white, a vaguely spiritual, Buddhist white, but also sort of a who-really-gives-a-shit white. "David doesn't respond to his environment the way most people do," Fran Lebowitz, a Geffen friend, had told me. "Like, he lives on the beach, but he never swims in the ocean. And yet when he goes on vacation it's almost always on boats, and we'll go, like, eight million miles just to get to a beach that looks like the one he just left. And he still doesn't swim in the ocean."

Voices came from the outer office. Geffen raised his head. The boredom in the eyelids seemed to drain back into his skull.

"Does somebody want me?" he called out.

"David, we want you as badly as anything we've ever wanted in our lives," said Terry Press, the head of marketing for DreamWorks, striding into the room ahead of her boss, Jeffrey Katzenberg, and the music-industry legend Mo Ostin, who ran the music division of DreamWorks.

Geffen got up from his armchair, one of four identical white chairs around a low table. He had not worked behind a desk since his early days at the William Morris Agency, in the mid-'60s. In the presence of Katzenberg, a cheerful man dressed in preppy clothes, he became playful and affectionate. Although the founding of DreamWorks SKG, which involved $2 billion of other people's money (and $33.3 million each from the three partners, Geffen, Katzenberg, and Steven Spielberg), was, to be sure, an adult undertaking, there was a boyish spirit in the enterprise that seemed to be important to its self-image.

Katzenberg and Geffen chatted about Bill Clinton, who had been in L.A. over the weekend and had departed that morning. On an earlier visit to L.A., the president had eaten dinner at Geffen's house in Malibu, an unpretentious series of

small buildings on the beach, and on this occasion he had wanted to stay there. Geffen, for his part, had stayed at the White House more than once. The three-way relationship that is DreamWorks was consummated in the Lincoln Bedroom, after a state dinner for Boris Yeltsin in 1994, when G was awakened at one-thirty in the morning by a call from K and S—they had been relegated to the Hay-Adams Hotel for the night—who said to G, "Let's do this." More recently, Geffen had attended the state dinner for the president of China, and his had been one of two names without affiliation on the *Times'* list of guests: not David Geffen, DreamWorks, or David Geffen, art collector, or David Geffen, philanthropist, or David Geffen, prominent homosexual; just David Geffen, the only man in the history of cultural capitalism who has succeeded in three different industries—popular music, Broadway, and Hollywood—but whose only long-term investment through the years had been himself.

Geffen hadn't been able to put the president up. "So I called Jeffrey and I said, 'Jeff-rey, I think the president should stay in your house.'" Katzenberg, whose house was a short stroll down the beach from Geffen's, agreed, and on Saturday night Geffen had gone over to Katzenberg's for dinner and a movie with the president (*The Peacemaker*, made by Dream-Works). Clinton had loved his house, Katzenberg now told Geffen, and the president wanted to know whether Hillary could stay there next week, and he also wanted to talk to Charles Gwathmey (who built Katzenberg's house) about designing the Clinton Library (there were also rumors in the papers that SKG had offered C a place on the DreamWorks board of directors after he left the presidency).

Was proximity to the most powerful man in the world exciting? Geffen demurred, blinked. Perhaps it had been—once. It was old hat now. Boring. "Let me put it this way," Geffen

said, resting his hand on his heart, raising his eyes and giving me his sincere look. "I am delighted to have a *relationship* with the president of the United States. I can't tell you I don't val-ue that greatly. But, I mean, you know, I'm not blown away by anybody."

Geffen recounted his morning phone call with the president for Katzenberg. "He said to me, 'How come Jeffrey's house is so much nicer than yours? I thought he was the one who doesn't have any money.' That's what he said to me. 'I thought he was broke.' I said, 'Well, "broke" is a Hollywood term!'"

Katzenberg chortled. Geffen cried, "Ohhh!" in a pained way, as though the small pleasure of this joke was just too much happiness, and the feeling had exhausted him. He sank back into his chair, spent.

Then Terry Press turned to Geffen and, with an air of getting down to business, asked, mock coquettishly, "Are you going to be my date in Washington?"

The DreamWorks movie *Amistad*, a Spielberg movie about the slave trade, was set to have its premiere in the nation's capital in early December, a few weeks away, befitting what Spielberg had described as "an extraordinarily important film, perhaps my most important film ever." Geffen seemed to be keeping his distance from the movie—perhaps because news that *Amistad* might have been plagiarized from a book by Barbara Chase-Riboud, a black writer, seemed to be on TV every half hour that day. Or maybe it was simply his old strategy of remaining in the background of the talent. Or maybe he smelled flop.

"I'm not going," Geffen said testily.

"What do you mean, you're not going?" Press's smile brightened ironically.

"I don't want to go. I'm going to Acapulco for a vacation.

What the hell do I have to be in Washington for? You don't need me. Let Jeffrey be there with Steven. I was there with Jeffrey last time."

Press looked over at Katzenberg and gave him a whaddaya-want-me-to-do? look. Katzenberg gave her a whaddaya-want-me-to-tell-ya? shrug back.

Press turned to Geffen again. "So, basically, what you're saying," she went on, "is that you'll go to Washington for the Chinese dinner but you won't go for the company."

"Yes!" Geffen yelled. "There's a big fucking difference between going to the premiere of a movie and—"

"The premier of China?" Katzenberg put in in his bright, facile way, putting his hand on his cheek and smiling, Jack Benny style. "They're both premiers. What's the big deal?"

Entertainment moguls usually come from the film business, sometimes from TV, almost never from the record industry. Never before Geffen had a man emerged from the ruck of cigar-chomping fatties with shoe polish on their heads to become one of the elite of the American mogulocracy. The skills required of the pop-music man tend to be local, fungible, and untransferable. You might be temporarily blessed with a golden gut, but then you got older, the fashions changed, and the gut betrayed you. Only Geffen had combined an exquisite sensitivity to pop-cultural fads with the cast-iron stomach of the perfect capitalist. Danny Goldberg, who had molded himself in Geffen's image, told me, "There have been great A&R men in the record business, and great businessmen, and some great investment-banker types, but there has never been anyone except David who could do it all. He is the only person like that which the record business has ever produced."

In the late '50s and the early '60s, record companies had

much more control over the way pop music sounded than they have today. The label generally chose the music, the producer, the arranger, and the band. The "artist"—the person who wrote and/or sang the song—had relatively little to do with the process. As the rock revolution swept aside these institutional controls, the singer-songwriters replaced the producers and arrangers as power centers in the industry. The artists' advocates, who were the agents and managers, got more powerful, while the labels' advocates, the lawyers, declined in influence. It was during this unsettled period that David Geffen first came to power as an agent and manager.

Geffen's sympathy with the prerock world of Broadway divas drew him to intense women like Laura Nyro and Joni Mitchell. Mitchell shared a house with Geffen, in accordance with his genius: total absorption of his identity into the pop identity of his star. (Later, when Geffen moved to L.A., he had a romance with Cher. "David wanted to marry me," she told me. "He proposed to me in Hawaii—he had a ring and everything.") Nyro became his client after a disastrous performance at the Monterey Pop Festival in 1967, when her then manager dropped her, and Geffen proved a fierce champion of her unconventional talent. David Crosby, who, along with the other members of what became Crosby, Stills, Nash, and Young, was also a client of Geffen's, told me, "David was always very ambitious for himself, but there was one interesting, unprotected place in him—he really loved Laura Nyro. That was a window into something in him that was not primarily about money." However, Geffen was not so besotted that he neglected to arrange for himself a half share of Nyro's publishing company, Tuna Fish Music, a deal that netted him more than $2 million in 1971, the first big score of his career.

Geffen differed from other agent-managers in that he never lived the rock life. Unlike Albert Grossman, who was

Bob Dylan's manager, Geffen did not become a hippie; he almost never used drugs. At crucial moments in the careers of rock stars, when millions of dollars in royalties hung in the balance, Geffen was the only person in the room who wasn't high.

Jackson Browne was Geffen's first discovery. Geffen had thrown Browne's demo tape away, but his secretary saw the boy's picture in the trash, thought he was cute, listened to the tape, and then made Geffen listen to it. Geffen invited Browne to his office. To Browne, Geffen was like a new kind of being: a businessman who really liked artists. "He seemed to be one of us, in a way," Browne told me. "That was the sort of word about him. He was like one of us, but he was sort of superior, because he was a very savvy businessman. Guys who had record companies would say, 'Shit, he's just so damn fast. He can make the computations so fast.' David takes a very direct route to the bottom line."

In 1971, Geffen established Asylum, the record company that produced most of the gallery of folk rock archetypes I carried around in my eleven-year-old brain. Jackson Browne, Jo Jo Gunne, Linda Ronstadt, Joni Mitchell of the *Court and Spark* period, and the Eagles—that "peaceful, easy feeling" sound that, one could argue, became mainstream modern country.

"I had no desire to start a record company," Geffen told me. "But I was challenged by Ahmet Ertegun when nobody wanted Jackson Browne. I said to him, 'You could make millions with this kid,' and he said, 'I already have millions.' It was like, 'Oh, thank you very much, I already have money.'"

The rock critic Robert Christgau, reviewing the Eagles' first album, in 1972, wrote that the Eagles were "brilliant but false." Brilliant *and* false was more like it. The peaceful, easy feeling, which was identified with California, was produced and packaged by a guy from Detroit (Frey), a guy from Texas

(Don Henley), and a guy from Brooklyn (Geffen). The music that the Eagles played did not draw on the historical reality of black music, or on the political legitimacy of folk, or on the social energy of the class struggle. Folk rock worked as style alone. Punk rock, which is often seen as an antidote to the empty virtuosity of the Eagles and a return of anticommercialism and social significance to rock, seems to me more like the logical evolution of the commercial L.A. sound. Punk rock was even more about style than folk rock was. And after the mid-'70s wave of punk, writes Gary Clarke in his 1981 essay, "Defending Ski-Jumpers: A Critique of Theories of Youth Subcultures," "virtually any combination of styles became possible. To name but a few examples: the revival of skins, mods, and teds; rude boys; suedeheads; a psychedelic revival; rockers—both the traditional type and the younger, denim-clad heavy metalists; Rastafarians; soulheads (short-haired blacks); disco; Ant-people; Northern soul; jazz-funkateers; Bowie freaks; punk (subdivided into Oi, 'hardcore,' or 'real' punk, plus the avant-garde wing); futurists; new romantics; glam revivalists; beats, zoots, and so on."

In 1999, thirty-five years after Geffen entered it, the pop-music world had returned to a period like the early '60s, when the commercial interests held the upper hand over the artists. Rap was like the pop of the early '60s in that the producers and the label's A&R people often had more control over the sound than the rappers had. Singles were back; the importance of album-oriented rock (AOR) had declined. No one thought of Hanson, Aqua, and the Spice Girls as singer-songwriters. The difference was that labels were not forcing the artists to make pop. The artists did it themselves. The instinct for how to get paid was now innate.

* * *

In his *New Yorker* profile of Ahmet Ertegun, George Trow had written that "there was a brief vogue for David Geffen." Geffen, then a rising star in the pop-music business, was bright and brash, but he didn't have the connoisseurship, or the style, or the sophistication, that Ertegun possessed. Ertegun was an adept. He was hip. His authority as a tastemaker was derived from the specialized knowledge that you could only get by going out night after night to Harlem to smoke some tea with bebop musicians or by going down to New Orleans to hear the swamp music. In those unimaginable days before MTV, the only way to make a judgment about a band or a singer was to do that kind of primary research.

Geffen, on the other hand, was a mere . . . fan. He had enthusiasms and powerful allegiances to the pop stars he loved, like Laura Nyro, Joni Mitchell, and Cher, but Geffen did not have anything like Ertegun's knowledge of history and music, to say nothing of his personal style. (Geffen had gone through his Cher period, when he wore a stylish leather vest, but in the '80s he settled on the who-really-gives-a-shit jeans and T-shirt look that had become part of his personal iconography.) Geffen did not know where the music came from, or why it sounded the way it sounded, or what its social value was. His taste was mere . . . appetite. Geffen knew nothing, really—except what he liked and how to identify completely with his enthusiasms. And that, it turned out, was *way* more important.

The Ertegun profile was published when Geffen was in retirement. Geffen was found to have bladder cancer in 1976, and at the same time he was fired from his job of running Warner Pictures. Bound by a noncompetition contract, he "retired" to New York, frequented Studio 54, and lectured at Yale. After a brilliant arc across the pop industry, his influence on the popular culture seemed to wane. But in 1980, Geffen came out of retirement by founding Geffen Records. (His

bladder ailment turned out to have been misdiagnosed; he never had cancer at all.) After twenty consecutive unprofitable quarters, Geffen caught a vibe from the hard-rock bands of the mid-'80s—Whitesnake, the second incarnation of Aerosmith, and, above all, Guns n' Roses. His company also produced successful movies—*After Hours, Lost in America, Beetlejuice, Interview with the Vampire*—and Geffen himself invested in two enormously successful Broadway musicals, *Dreamgirls* and *Cats*. Perhaps his most self-revealing project was *Risky Business*, which introduced Tom Cruise to the world. Geffen came up with the famous poster image of Cruise in sunglasses, dressed in the who-really-gives-a-shit T-shirt and jeans style that was Geffen's trademark. Geffen also insisted on changing the screenwriters' ending for the movie, in which Tom Cruise was punished for turning his parents' home into a brothel by not getting into Princeton. In the version that the world now knows, Cruise gets the good life and Princeton.

By the '90s Ertegun, though he still traveled around the world and showed up in the Sunday *Times* social pages, and was still chairman of Atlantic Records, had almost no influence over why things looked the way they looked or sounded the way they sounded. Meanwhile, Geffen, sitting very quietly beside the ocean in his T-shirt and jeans, with his cell phone and his trashy novel, gazing off into the sunset, was the Nobrow tastemaker par excellence.

Geffen was Joshua to Warhol's Moses: the man who sounded the trumpet that brought the walls of the town house of culture crashing down. It was Geffen who had stayed home with Joni Mitchell from Woodstock and was with her the night she wrote the song "Woodstock," a landmark in the evolution of inauthentic authenticity, that essential Nobrow commodity. It was Geffen who turned California folk rock into a big-grid style that is now eighteen iterations old and still go-

ing strong. It was Geffen who was there on the cover of the *New York Post*, at Yoko's side, coming out of the hospital where John Lennon died—emerging into the harsh morning sunlight of that day at the end of the '70s when the music really died. It was Geffen who demanded of Tom Freston at MTV that he play a video by an unknown L.A. band called Guns n' Roses, who would become one of the first small-grid–big-grid crossover acts. It was Geffen's label who signed an underground Seattle band, Nirvana—and that band became the template for the easy crossovers between the grids today enjoyed by such phenoms as Hanson, Juvenile, and Kid Rock. And in the '90s Geffen, the greatest of all pop-cultural arbiters, had become one of the greatest collectors of high art.

As Ertegun had presided over the transformation of black culture into hip white culture, so Geffen presided over the transformation of hip culture into the new consumerist culture of cool. Cool required no specialized knowledge. Cool could be bought (but hopefully not cheaply). Cool was hip plus demographics. Intimate knowledge of black-roots music, such as Ertegun brought to rock and roll, actually made it harder to grasp the fundamental evolution in the meaning of pop music, in the '70s, from an enterprise that was primarily about music and history to an enterprise that was primarily about image and style. Geffen, easily bored, petulant, unburdened by history, and blessed with the plastic enthusiasms of a teenager, was attuned to the spirit of the demo in a way Ertegun could never be.

With a personal fortune of more than \$2 billion, much of which came from the sale of Geffen Records to MCA in 1990 and the subsequent sale of MCA to Matsushita, Geffen was certainly the richest and probably the most powerful business-

man the pop-music business had ever produced. In the corporate world of global entertainment, Geffen was cited by many tastemakers I spoke to as a throwback to a more individualistic era. He alone was truly independent, because he was the richest and most powerful. He was the only free man in Paris, in the words of the song Joni Mitchell wrote about him. George Lucas, for all his rebel fantasies, seemed like a conventional businessman, a suit, while Geffen really was as free as any tastemaker I met in Nobrow.

"David's not afraid," Jimmy Iovine told me when I went to see him in Interscope's hip-hop fortress on Wilshire. Iovine was another guy from Brooklyn who was living large thanks to pop music. "We all know that David's really smart and really talented, but he's also not afraid, or if he is he doesn't show it. He's more than willing to put all the chips on something he really believes in. And that doesn't exist in the record business anymore. Because most people are afraid for their jobs, of the impact someone else can have on them."

People in Hollywood made a collective fetish out of fear. Fear was their own private voodoo. All that *Godfather* stuff, with the bear hugs and the men kissing men. That was the Hollywood gangsta vibe, and it clung to Geffen. It was all about the money, but it was also about fear. Geffen was the Godfather for people like Puffy Combs and Master P.

"Some people in Hollywood have no fear," the producer Linda Obst told me over tea at the Peninsula Hotel, "because they have no understanding of the meaning of fear. They're sociopaths. You know, all balls. David knows what fear is."

Geffen himself told me, "I'm not saying that I am incapable of *being* afraid. You know. But I would say, for the most part, that fear does not play a big part in my life. In Hollywood people lie to each other and cheat each other and then go and play tennis. You know. But I don't want to *be* a tennis player. I

don't want to *be* that. I'm not going to go *play* tennis with people who lie to me or fuck me over in some way—I'm not *interested* in that."

But because Geffen was not afraid, he was greatly feared. Geffen was believed to be willing to pursue personal grievances to a level most moguls would consider to be a waste of time. The fact that Geffen had no long-term relationships himself—no partner, no kids, no family except for a brother he didn't talk to—gave him plenty of time. "You know, the guy has a lot of time," one well-known record industry person told me. "And if you make him unhappy, you'll hear from him." The idea that Geffen crushed people who displeased him was felt so broadly and deeply in L.A. that it was almost an article of faith, irrespective of the facts. It was like voodoo: it was easier to believe that there was a sinister force behind your reversals than to believe that they were your fault.

In his book on the rock business, *Mansion on the Hill*, Fred Goodman wrote, "If rock and roll is all about money, then David Geffen is the most important man in rock." The author makes it clear from the context that he means this sardonically. Like many of the rock writers of his generation, Goodman takes it for granted that the greedy businessmen sold out the noble artists, and in his book he paints Geffen as a principal devil in this larger cultural transaction. Goodman quotes Paul Rothchild, a producer whom Geffen outfoxed in a deal involving Crosby, Stills, and Nash. "When David Geffen enters the California waters as a manager, sharks have entered the lagoon. And the entire vibe changes. It used to be, 'Let's make music, money is a by-product.' Then it becomes, 'Let's make money, music is a by-product.'"

The trouble with the Geffen-as-Mcphisto argument— Geffen as the personification of the collective greed to which

rock sold out—is that it doesn't give the artists themselves enough responsibility for being corrupted. Geffen, after all, was only getting the artists what the artists wanted: money and power in the legitimate business world. "Most people don't know how to get paid," Iovine said. "That's an art. To know how to get paid is an art. David taught people that."

"Money does corrupt," Jackson Browne told me. "God, as soon as you have a lot of money, you've got to figure out how to stay in touch with what you write and why you write. And if you always had the idea that money was going to make a difference in your life, now you have to contend with the idea that it doesn't. But David Geffen didn't do that. I mean, come on. Why not say the Beatles did it."

Geffen was bored by my attempts to discuss money and art in rock. When I asked him if he thought there ever was any social or political meaning to rock—whether the artists were ever motivated by ideals, rather than by money—he said, "That was all a lot of bullshit then, and it is now. It isn't that different. Most of the artists were trying to make a living, trying to get laid, trying to figure out who they were. They weren't trying to change the world. That's what other people put on them. I knew all those people. I knew them all intimately and well. Bob Dylan. I would say that Bob Dylan is as interested in money as any person I've known in my life. That's just the truth."

In the early 1990s, following his payout from MCA, Geffen assembled one of the world's greatest collections of postwar American art, from abstract expressionism through pop. While he was building this collection of high art, Geffen did not lose his instinct for pop fads and trends. It was Geffen who per-

suaded Calvin Klein to use a disreputable white kid from Boston named Mark Walhberg (who had gotten himself a hip-hop name, Marky Mark, early on) in his underwear ads. Geffen also immediately grasped the appeal of *Beavis and Butt-head*. "We aired *Beavis and Butt-head* on a Friday night late in 1992," Tom Freston recalled, "and David calls me at home the next morning, ten o'clock Saturday morning New York time, so it's seven a.m. in L.A. He had seen it on MTV the night before. It's not as if someone said, David, you got to watch this. He had just seen it. And he called me and said, 'Tom, this is going to be a huge hit, unbelievable. I want to make a movie and a record with you.'" The same instinct that allowed Geffen to cherry pick some of the world's greatest art collections also allowed him to grasp immediately that *Beavis and Butt-head* was going to be huge. That was what made him Geffen. He had a mind so fine that no idea of cultural hierarchy could penetrate it.

In 1990 Geffen bought the Warner estate, which was built by Jack Warner at the top of Beverly Hills in the '30s. At first Geffen had planned the Warner house as a place to hang his collection—a sort of Nobrowish bookend to the new Getty, which sat atop its own hill in Brentwood, across the valley. But at some point in the intervening eight years, during which Geffen had been intimately involved in the taking apart and rearranging of virtually everything in and around the Warner house, including the tennis court and the swimming pool, he had decided that he would make the Warner house his home, when it was finally finished. This move, his friends thought, had an obscure significance in the growth of Geffen's identity, which was the great project of his life. The Malibu beach house, comfortable though it was, had no real style except as another neutral, white environment for Geffen to operate within. The Warner house, on the other hand, seemed to be Geffen's attempt to commit to something or at least to get be-

yond the who-really-gives-a-shit mode that was his usual response to matters of taste.

A certain amount of relationship brokering preceded Geffen's letting me see the house. I had no idea what Tina may or may not have said to him—she was far too clever to tell me. I had persuaded myself that my power as the storyteller was equal to the power Brown and Geffen held in the transaction, but by now I was realizing that in some larger sense this could not possibly be true.

Finally Geffen agreed to pick me up at the hotel. Coming down the steps, I saw his face leaning against the car window as he was talking on the phone. The eyebrows were not lively, and boredom was completely in the ascendant on his face. "I want you to know I really didn't want to do this," Geffen said as I got in, his voice gravelly with displeasure. This established, his mood seemed to brighten a little.

The canyon roads wound upward into the windswept heights of Beverly Hills, where the Warner house occupied ten rolling acres.

"Steven was in *tears* this morning," Geffen said. The film *Amistad* had had its L.A. premiere the night before, and the reviews were not very good. "You know what *Time* called him? 'Steven Stcalberg.' It's awful. Disgusting. *Amistad* is forever tainted by this lawsuit."

After passing through a big copper gate, the driveway wound among overhanging sycamores. Jack Warner had had a four-hole pitch-and-putt golf course here. Geffen had eliminated it and regraded the area extensively, enhancing the long vistas of the rolling hills. He had planted full-grown sycamores; they were brought through Beverly Hills one at a time at night, after streets were closed off for that purpose.

The house was big and white, Hollywood Georgian in style, with columns in front. Geffen flung open the front door

for me and made a submissive, you-first gesture. Inside was a circular entryway with a parquetry floor and a curving staircase. To the right was a long, narrow Jackson Pollock and to the left was a de Kooning; beyond them were a Gorky and a Rauschenberg. In the foyer outside the bathroom was a Warhol. Downstairs was a Jasper Johns target painting on one wall which made the hair on the back of my neck stand up, not so much because of the object itself as the aura of money and fame that clung to it.

Robert Rauschenberg used to walk around SoHo in the early '60s looking for objects to make his collages, or "combines," as he called them. In those years the detritus of utilitarian consumer culture (fan blades, place mats, shirts, aluminum, mannequins, children's toys) spilled out onto SoHo's streets, and that junk was transformed by Rauschenberg and others into high art, which now hangs in the world's greatest museums and private collections, like this one. Pop art wasn't the end of art, but it was the death of the town-house notion that art is superior to other commodities.

Here in the airy verdant silences at the top of Beverly Hills, the radical attack on cultural hierarchy that the pop artists had launched in the '60s seemed to reach its apotheosis. The town house had been built inside the megastore of Geffen's interests. High Nobrow.

The style of the house was one of distinction without difference. It was the same as everything else—Geffen had in no way betrayed the basic Warholian principle in his aesthetic. And yet it was different. There was pine paneling, of a width that you can't get anymore; Geffen informed me he had bought a nineteenth-century school in North Carolina just for the pine. Rococo moldings throughout the house had been cleared away, except in the living room, which also contained other touches of its original aspect. Downstairs was the art deco screening

room, where the screen came up through the floor. There was a deco bar, and around the corner was a billiard room.

The house had the same brilliantly reworked feel of Sky-walker Ranch, that sense of a design intelligence everywhere but nowhere. Geffen's taste was a collective of all the wrong moves he might have made, cleverly avoided. It was not so much good taste as the total absence of taste. This was the same kind of taste that Tina Brown had, it seemed to me, and perhaps this was the essence of taste in Nobrow: an exquisite instinct for what you don't like. Rose Tarlow, the decorator of the house, had told me earlier, "David knows what he wants. Or, rather, he knows what he doesn't want. David has a very definite sense of right and wrong. But he couldn't tell you how to do something—what style, what period to use. He just knows. He can walk into the room and see one little piece down in the corner, just one spot, and say, 'That's not right.' It's simply amazing. Almost unbelievable."

Upstairs in the master bedroom the only painting was a Jasper Johns flag. Down the hall, in what had been the chil-dren's wing, was a guest bedroom and a gym full of gleaming Cybex machines. The gym was the only room in the house where one could easily imagine Geffen hanging out. He seemed a little sheepish in the other rooms.

One room from the original house had been preserved in-tact: Jack Warner's cracked-leather office and dressing room. This seemed to be the greatest act of appropriation of all—Geffen's final triumphant eating of the heart of the old mogul. Masculine hairbrushes and tonics were lying out on the table as though Warner had left them lying there earlier in the day. Geffen mentioned that the windows in the bathroom had been moved, and that some of the cracked leather had needed to be redone, but it was impossible to find anyone who knew how to do the work.

"So we— See."

He pointed out his solution: painted panels that looked exactly like the original leather.

The place did not seem to have any appreciably different effect on Geffen than his other environments. Part of the trick in being David Geffen seemed to mean remaining untouched by anything that might make the exquisite instincts less pure. Even Jack Warner's cracked-leather sanctum was just another room for talking on the phone.

8

No Place in the Buzz

I attended a *New Yorker* "Book Publishing: Dead or Alive" discussion at the New York Public Library. About 150 members of the publishing community gathered in the Celeste Bartos Forum, a rococo temple of old town-house culture, on a chilly October night to hear from a Ken Auletta–led panel representing different interests within the publishing community. (There was, of course, a special publishing supplement in the magazine that week.)

About halfway through the evening, Cynthia Ozick, an author of books with literary value but limited commercial appeal, voiced an oft-heard complaint among writers, which is the need to preserve the midlist author, those writers who produced the books on the shelves of the old town house of culture, books with history, tradition, wit, and intellect— "good" books. Unfortunately and unfairly, these worthy authors did not sell many books in the megastore, where authors like Cynthia Ozick had to compete with authors like Mark Fuhrman and Andrew Morton. Ozick concluded with an eloquent argument for the value of good books, which drew applause from the sympathetic audience.

After Ozick had finished talking, another panelist, Leonard Riggio, the head of the Barnes & Noble chain of megastores,

said, "Well, Cynthia, I happen to have your sales figures right here," and, reading from a computer printout, proceeded to inform the audience that the recently published *Cynthia Ozick Reader*, a collection of the author's favorite writings, had sold only a few hundred copies. He then asked, "So why should the publishing industry support a midlist book that readers clearly don't want?"

In the quick, shocked intake of crowd breath that followed this revelation, I thought of my own "numbers"—that low literary sperm count that marked the sales of my first book, *Deeper: My Two-Year Odyssey in Cyberspace*. Because the book was about the Net, a pop-culture subject, the publisher had been persuaded that *Deeper* would be a popular megastore commodity, maybe even a best-seller, and I had been paid a large advance to write the book. I, in turn, took the advance as confirmation that I was, in fact, writing a best-seller— presumably the publisher wouldn't pay me this kind of money if they weren't reasonably sure of getting it back; also, the advance would mean the publisher would have an incentive to market the book that much harder.

But instead the book tanked. I had brought my cultural capital to bear on the Internet, as I was trained to do—had considered such modern phenomena as e-mail, chat rooms, cybersex, and home pages in light of the values of Western Civ, in an effort to judge what was good and what was bad—to select the best that had been thought and known about the young medium so far. And in doing so I had produced a book that was neither a highbrow literary work nor lowbrow guide to the Net, but some unmarketable combination of categories: the dreaded tweener.

As I stood there in the premillennial chill that followed Leonard Riggio's remarks, I knew that somewhere inside that same computer where Ozick's sales figures had come from

were my own pathetic numbers, like bad credit passed on my cultural capital, and I was not so Romantically disinterested in the marketplace that the yawning minus sign in the royalty statements did not sit on my literary prospects like the mark of doom. (Why, yes, John, I happen to have your sales figures right here. . . .)

For a moment, the gentle publishing folk in the audience didn't seem to know whether to be offended by Riggio, appalled, or, like the Zen monk who has just had his leg broken by the gatekeeper, enlightened. Then, softly, from the gilt edges of the Celeste Bartos Forum, there arose a low but viciously sibilant *hisssss*. These genteel tastemakers, the last of the old High-Low world of publishing, were hissing at Riggio, who sat there with all the smugness that controlling the point of sale gives a man.

The business side of *The New Yorker* had improved under Brown. But at some point in early 1997 the steady progress hit a plateau, and then the ad pages began to drop off again. As the year went on, and it became clear that Brown wasn't going to be able to celebrate her fifth year as editor by announcing that *The New Yorker* was finally back in the black again, a faint, high-pitched tea kettle of desperation began to pipe on the killing floor. Whatever we were doing, it wasn't enough. We needed more special issues, more promotional events, more parties for authors, more tables at black-tie PEN and Fashion Council dinners, more limos triple-parked in the street outside *New Yorker* parties at restaurants, or at starry soirees at Tina and her husband Harry Evans's apartment on East Fifty-seventh. But Brown, for all her dazzling energy and brilliance, could not make *The New Yorker* succeed as a highbrow version of *Vanity Fair*. It wasn't a bad idea: a smart Tom Cruise profile

or a smart Madonna profile. William Shawn himself had occasionally published some of that kind of writing, such as Truman Capote on Marlon Brando and Lillian Ross on Louis B. Mayer. But in Nobrow, the access to the celebrity that was necessary to produce a thoughtful piece of writing had been drastically curtailed. Because celebrities in particular and pop culture in general had become such an important way of selling magazines, especially on the newsstands, the editors and journalists had to trade ever more independence to get the star, and the star's people—the publicists, corporate communications people, press agents, and assorted flaks—had to give less.

The powerful publicists were the arbiters inelegantiae of Nobrow. "You know that there are some stars, like Tom Cruise, whose face will sell *x* number of issues," I was told by Susan Lyne, then the editor of *Premiere* magazine. "And you want to get them on your cover because you have to have the newsstand sales. You know that and they know that." Maybe *The New Yorker* could offer Tom Cruise something *Vanity Fair* couldn't offer—class, prestige, intelligence, and a sort of burnished quality to his image that was more attractive than the harsh klieg lights of most celebrity journalism—but what did Tom Cruise care about any of that? And anyway, why should the publicist who controlled access to Tom Cruise believe Brown's intentions were to do a high-minded *New Yorker* story, when she had already showed herself perfectly happy to dish the dirt at *Vanity Fair*? I interviewed Pat Kingsley, who was Cruise's main publicist, in the salon of woes at PMK in L.A., where journalists sold their souls (this required another delicate bit of relationship brokering: Pat Kingsley had called Brown a "cunt" when Tina was running *Vanity Fair*). Kingsley told me, "The fun is putting the actor together with the right

photographer and the right concept and making it work." She sounded just like an editor.

So where was the distinction within the megastore of culture on which *The New Yorker* could establish a beachhead? *The New Yorker* was caught in the dead space between the two grids. It couldn't do only small-grid culture, because that would sacrifice an essential middlebrow sanity and distance that was deep in the magazine's roots. But it couldn't just be big-grid either, because then it became just another upmarket media buy. Maybe if we could capture the small-grid styles just as they were streaking into the big grid—but the pace of change was so rapid, and so ceaseless, that no magazine could hope to hit this sweet spot in the grids more than a few times a year.

Into this atmosphere of not-so-quiet desperation came the Next Issue, a special issue devoted to trends and predictions. The whole concept of Next involved a degree of lowbrow trend-spotting and easy Buzz-making for advertisers that William Shawn would have abhorred. For the writers, the change in emphasis in doing a Next piece was subtle but absolute, a kind of Rubicon that separated the high-minded from the utilitarian impulses in writing. Trend forecasting was a big tent where culture and marketing practices got into bed together. If you wrote about technology, it was hard to resist the language of hype. If you did the next pop-music star, you were competing with every teen magazine on the newsstand, and that was not *The New Yorker*'s strength. However, the Buzz that the Next pieces brought into the magazine did sell a lot of advertising—the issue carried more ad pages than any single issue of *The New Yorker* ever had—and my feeling was that if the odd trick, turned once a year, was what it took to make the magazine solvent, so be it.

But then, with Brownian synergy, it was announced that there would be a Next Conference to go along with the Next Issue. Tina personally invited sixty people to a kind of think session. In the invitation, the guests were described as part of "an eclectic group, but what all its members have in common is that they are in one way or another the arbiters and purveyors of the future." The conference would take place at the Disney Institute, Michael Eisner's recently completed $35 million bid for highbrow credibility. Although Si Newhouse was footing the bill for the conference this year—Tina had finagled that—in the future the magazine would begin to charge attendees, who could be expected to pay handsomely for this privileged access to Nobrow tastemakers as well as to the wits and sophisticates who produced *The New Yorker*.

I secured an invitation by accepting the assignment of writing an essay on the relationship between the artist and the suit in the production of culture in the '90s, which would also be a panel discussion on which some of the purveyors would sit at the front of the stage, as after-dinner entertainment—Harvey Weinstein, Barry Diller, and Nora Ephron, among others. Was I a writer or an event planner in this transaction—the artist or the suit? Hard to say for sure.

That night at the Disney Institute, among the cabanas and the palmetto trees and golf carts that movie stars could be seen driving around the curving paths, the breathless frenzy of the Brown years seemed to explode over our heads like the fireworks over the Magic Kingdom. The Next Conference felt like a day and a night spent in the dawn of the new age of corporate patronage. This was the real future at the Next Conference, the future of the relationship between the people who supplied the content (it was hard to think of yourself as a writer down here) and the people who bought it and distributed it. At the welcoming sunset cocktail party hosted by *The*

New Yorker, where the arbiters and purveyors met on the first evening, an event presided over by Michael Eisner—the Pope Julius of Nobrow—you could see this future clearly, and it looked a lot like the pre-Romantic past, before the concept of the superior reality of the artist evolved. Whether you were a theater artist working for Disney, a fifteen-year-old-kid with a record contract, an installation artist competing for the Hugo Boss Prize, a young computer artist working for Lucasfilm, or a writer for *The New Yorker,* your creative independence would no longer be staked on your resistance to the marketplace. Your independence depended on your ability to attract a corporate patron. That's what we were doing down here—patron whoring.

Everyone from *The New Yorker* went with the flow—no one wanted to be uncool enough to make a public stink. It was okay to sit around late into the night with a hot Hollywood producer and a cute MTV veejay and, gesturing toward Eisner over there, quote Bob Dylan:

> *Now all the crim-in-als in their coats and their ties*
> *Are free to drink martinis and watch the sun rise.*

But in the daytime, at the public sessions, it was all about getting to know the suits, overcoming your hangups about the business side, and searching for the right mix between the money and the culture, the mix that served your creative interests without taking away your independence.

For me the parting image of the Next Conference was of Tina and Tom Florio (who was then, but not for much longer, the magazine's publisher) rushing out from the final session, where Michael Eisner had addressed us, and getting into a waiting car to be whisked to Harvey Weinstein's private plane. In my memory they are actually holding hands, though this

must be my invention. They look like the reluctant bride and groom in the new marriage of marketing and culture, their union blessed by the smiling pope himself. Eight months later, when I heard the news that Brown was quitting her job at *The New Yorker* and would be going to work for Harvey Weinstein at Miramax, a Disney-owned maker of up-market commercial movies, I remembered this moment of wedded bliss.

That night, back in New York City, I was driving into Manhattan from the airport with a young writer who had also been at the conference.

"What did you think of Eisner?" I asked him, prepared for the usual qualified praise or criticism—"Yes he's interesting, but he's the Antichrist," etc. At the final session that morning, one of the editors had asked Eisner, who was in the audience with a microphone, a question pertaining to the fact that Eisner earned $96,000 a day, while the average Haitian worker who made Disney's Pocahontas dolls received about $2.60 a day. You know, could you comment on that? Eisner had been a little testy in his reply, and several team-player types from *The New Yorker* told me afterward they thought the question had been in poor taste. After all, we were enjoying Eisner's hospitality here. It was uncivilized to attack him onstage—not at all *The New Yorker*'s style.

The younger writer turned to me in the car and said with complete conviction, "I think Michael Eisner is brilliant. I would *love* to work for him."

My head snapped backward as though I'd been struck in the face by a whip. I peered sideways to see if my colleague was joking. He wasn't, of course. As Tina Brown herself would soon decide, this writer thought that he would have more creative independence at a Disney-owned magazine, where William Shawn's notions of creative independence had never

been an issue, and where culture and marketing are as cozy as Mickey and Minnie.

My mind flashed on another animated image—that familiar bit from the Roadrunner cartoons, when the Coyote mistakenly runs off the edge of the cliff, but because he doesn't realize it, he doesn't fall, yet.

Back on the Broadway Local uptown again, reading the latest about the Monica Lewinsky scandal in the *New York Post*, and listening to the Wu-Tang Clan. Like Rauschenberg, the Wu made their art out of bits and pieces of utilitarian culture, which they found around them, usually on TV—pro wrestling, children's cartoons, Hong Kong B-movies, Pat Sajak, Häagen Dazs ice cream—mixed in with credible accounts of street life. The Wu didn't seem to know about anything that happened before 1975, which was around when they were born. If you told Ol' Dirty Bastard or GhostFace Killah about, say, World War II, he might say, "Whoa, that's some marvelous-ass shit," as though history were just something else to roll up in a blunt and smoke. But the Wu were real artists: they got that post-Jamesian flow of urban consciousness that goes through everybody's mind just right.

Coming up the subway steps into Times Square, I looked up and the first thing I saw was the steel structure of the new Condé Nast Building, towering above me. There was a big Gap on the south side of the building and a huge Warner store just to the west. All around the scaffolding were posters for Calvin Klein, showing young models in rugged outdoor American poses. The building would house all sixteen Condé Nast magazines, including *The New Yorker*. Yes, *The New Yorker*. "We" were moving to Times Square, too.

On buying *The New Yorker* Si Newhouse had promised that William Shawn could remain for as long as he wanted, but that was only in conversation. However, he had put into writing the promise that *The New Yorker* "will be operated on a stand-alone basis as a separate company," and that "all present departments, including accounting and circulation, personnel and production, will be maintained independently from those of Advance's other magazines." The news that *The New Yorker* would in fact become part of Advance had been delivered to all a month ago, not with a bang but a Tom Florio memo, slipped under everyone's office door, explaining that because of "changes in the way we run our business," the new building "offers us significant advantages and it is our plan to move there."

The strange thing was, the news did not even seem very surprising. In this climate of presidential slipperiness, the notion that a man's word should be his bond seemed somehow old-fashioned. Si's word had lasted for fourteen years, which is pretty good. These days. And anyway now that everything else that William Shawn had meant by "independence" was gone, and we were all steeped in Buzz to the eyelids, the final physical act of moving into this corporate tower with the rest of Si's magazine empire seemed almost anticlimactic.

Anyway, it wasn't really Newhouse's fault. Since the future *New Yorker* was likely to exist, if at all, as an act of Newhouse's patronage, its debts paid for by the profits from *Vogue*, *Glamour*, and *Vanity Fair*, it was a little unrealistic to expect that the magazine or its writers should remain in their former glory. Independence was the price we paid for survival.

In her years at *The New Yorker*, Tina Brown had proved herself to be a genius at getting attention for the magazine. She put out a quality product for a mass audience—the *Frasier* of the newsstands. But the magazine could never make adver-

tisers pay enough for all the attention Tina created. It was a curious thing: the circulation was up (though Brown's critics contended the high circulation figures were bought with publicity and reduced subscription rates), and the newsstand sales were great, and the Buzz was everywhere—thick clouds of it rolled in and settled on the editorial floors for days at a time. But the ads still didn't sell. Had the magazine actually been a TV show, its high ratings would have translated more or less directly into ad revenues. But the magazine business (being an older medium than TV) didn't work that way. The church-and-state separation of content and advertising was stapled into the culture.

There were successful examples of high-culture–pop-culture marriages all around us. There was the Disney-funded musical *The Lion King*—that Nobrow moment when Julie Taymor's avant-garde masks, lavishly realized as only a purveyor of schlock culture like Disney could afford to realize them, first came down the aisles. (That was the real jungle in *The Lion King*—the jungle of art and commerce that loomed from behind the multimillion-dollar scenery.) There was the orchestral computer music played by The Orb, a British techno group—pop music that met the standards of difficulty upheld by Milton Babbitt in his writing on modernism. There was the film director Gus Van Sant making a Hanson video, or Elton John playing "Candle in the Wind" in Westminster Abbey at Princess Diana's funeral, or the guitar playing of the premier Portuguese fado artist, whose greatest influence was James Brown. There were Helmut Lang ads on top of taxicabs.

And, reading was booming. The Borders and Barnes & Noble megastores were full of readers, reading. The universities were turning out more readers than ever before in history. Books that were a pleasure to read—"good" books—like *Cold Mountain* and *Angela's Ashes* were atop the best-seller lists, and

young readers stood in long lines to hear Salman Rushdie and Martin Amis read. Surely *The New Yorker* should be able to tap into some of that demographic? But neither the editors down below nor the salesmen upstairs could figure out how to do it. The essential problem—which was how to create distinction within the distinctionless wastes of Buzz, rather than basing distinction on the resistance to Buzz, as William Shawn had done—proved to be harder to solve than anyone had realized.

It was January again, and cold. I walked past the Condé Nast Building, funneling into the narrow catwalk of pedestrians that the construction created. I peered through a cutout in the plywood and saw a chaos of steel, wires, concrete, and earth. Soon it would be an ESPNZone restaurant.

At Forty-third Street I glanced back at the Astrovision screen. The president's deposition in the Paula Jones matter was three days ago and the president was asked under oath about having sex with Monica Lewinsky. I was getting used to this: hearing yet another amazing revelation about the president's personal conduct on MSNBC, while simultaneously watching the Dow Jones average, down there in the corner of the screen, to see how *that* number would react to what once would have been considered devastating information. Clinton's poll numbers had stayed high as his credibility steadily sank, which was surprising but might be explained by the fact that the public was already so confused that the polls were only a measure of the marketing Clinton had already done on them. But surely it was impossible that the Dow, a more puritanical judge, or rather the numerical collective of the ruthless puritanical heart that ran the capitalist enterprise, would remain so high.

It had. In the year that had passed since I heard Clinton is-

sue his call for personal moral responsibility, while standing in this very place, both the Dow and the polls remained high, even while the president's moral authority lay in ruins at his feet. Just as the people continued to support a president who had no moral authority, so were they willing to invest huge sums in Internet companies that had never made a profit. The old notion of the importance of telling the truth had faded along with the old notion of an honest day's pay. Here it was all about representing virtue or representing profitability. Bill Clinton had brought the pop value of style to the highest office: he was able to *represent* honesty while being thoroughly dishonest.

At Broadway on Forty-third, I ran into a *New Yorker* writer, one I'd known since I started at the magazine under Gottlieb. We stood there in the cold, bathed in the weird yellow tornado light of Times Square by day, gazing up at the magazine's new home. Soon the Nasdaq board, an eight-story-high electronic sign—the largest in Times Square—would rise right where we were standing.

"You know what makes me mad?" my friend said, as we looked up at the building. "People think they can do this stuff to you. I mean, Si Newhouse lied. He said he wouldn't fire Mr. Shawn, and he did. He said *The New Yorker* wouldn't move, and now it's moving. You know? I just think it should be duly noted, or something." We stood in silence for a while. "I think I'm going to write a letter," she said.

I said that I was all for writing a letter, if it would do any good, but it wouldn't. Shawn wrote a letter—an open letter to civilization—and look where it got him. Forces beyond our control and all that. I tried to remember some of the lines from Shawn's 1985 "Comment," written to reassure the readers after *The New Yorker* was bought by Newhouse that the spirit of the magazine would never change. "But what does this edito-

rial independence mean? What is it, actually? It is simply free-
dom. It frees us to say what we believe to be true, to report
what we believe to be true, to write what we want to write . . .
with no outside intervention, without fear, without con-
straints, in defiance of commercial pressures or any other pres-
sures beyond those of our own conscience and our own
responsibility." Responsibility: There was that word again.
"And if any single principle transcends all the others it is to try
to tell the truth. *The New Yorker* will continue to change, as it
has changed through the years, but our basic principles and
standards will remain exactly what they have been. With that
knowledge, and with the assurance that we freely asked
our prospective publishers to give us and that they freely gave,
we are confident that we will preserve *The New Yorker*—not
merely a magazine that bears its name but *this* magazine:
The New Yorker itself." Finally, Shawn came back to *The New
Yorker*'s independence. "We re-assert it with these few formal
words. We feel certain that the Newhouses will respect it."
What a loss of authority was felt in that *we*! Not just the *we* that
was the *we* of *The New Yorker*, but the *we* of civilization as it
used to exist.

My friend asked me if I'd heard anything from Tina lately,
and I said I hadn't. Both of us were still struggling to adjust to
the fact of Tina's quitting. The last time I saw her in her office,
she had Steve Wynn, the casino owner, in there, and David
Kuhn, her executive editor, and she was trying to persuade
Wynn to host the next Next Conference in his new Bellagio
Hotel in Las Vegas, while at the same time trying to persuade
me to write a piece about Steve Wynn and the making of the
Bellagio, no strings attached. At one point, as Wynn was go-
ing into his spiel about the wonders of the Bellagio, where the
high rollers get to gamble with the high art, Tina caught my
eye and gave me this look like "This could be great!" At that

moment I was ready to do the story, though it would have probably ended in disaster. She was a great girl in the wrong dress, as Trow had said. *The New Yorker*—its culture, its history, its place in a uniquely American culture—never quite suited her, and she didn't try very hard to make it fit. Anyway, the magazine didn't show off all her advantages, as the right dress should.

The next Next Conference never happened, because two weeks later Tina vanished—*poof!*—just as she'd arrived, in a cloud of Buzz. I was at home writing on the morning of the announcement and got a call from an editor friend who had heard it from a writer. And just as I had six years earlier, I said this news couldn't possibly be true. Tina Brown would never leave *The New Yorker*! I called the office and heard it was true, and then went in and found that people hardly knew what to say. Tina had saved *The New Yorker* from oblivion, and for that we all owed her a lot, but she had failed to make her vision for the magazine viable, and now it felt a little like she was leaving us in the lurch. (Our situation felt a lot less lurchlike a week later, when David Remnick, a Pulitzer Prize–winning author who was also a staff writer, took over the magazine, much to the relief of the staff.)

But when the Buzz cleared and you looked up, this is what you saw: a big, arrogant-looking office tower in the middle of Times Square, with a welter of branding going on all around you. The new building had been considered jinxed ever since a scaffolding fell from the top in the summer of 1998, killing an elderly woman in the Woodstock Hotel and shutting down Times Square for a week. A lot of Condé Nast people viewed the building with premillennial trepidation. Graydon Carter of *Vanity Fair* had a feng shui ceremony performed on his floor of the building before the magazine moved in.

For me, this was Nobrow—this building, here under my

nose all along. This is what the world after High-Low looks like. And it is all middle, I guess, though it doesn't look like the old middle, because there's no more high and low to define it. The architects had made it their design philosophy that all the editors and writers at every magazine would have exactly the same style cubicle or office, whether they worked for *The New Yorker, Vogue,* or *Mademoiselle.* Any sort of culture peculiar to a particular magazine—such as the shabby gentility that had long been *The New Yorker*'s style—was being purged and replaced with generic skyscraper-wide decor. None of the old furniture would go to the new place. All those old desks that were only beautiful if you knew E. B. White or Joseph Mitchell sat at them once would be left behind for the new tenant, an advertising firm, which was renting the place furnished. The style of the new offices had been described as "finest Italian cubicle": built-in modular furniture that was aesthetically pleasing, ergonomically correct, space-efficient, and environmentally responsible. There were four types of offices, A through D, depending on how important you were to the company: a Nobrow hierarchy. I was a C—an interior office with no window. But at least I got an office. Some of the other writers weren't so lucky.

Thus the same project that was almost complete all around us in Times Square—the strip mining of subculture into mainstream culture—would soon be put to work inside this building as well. In Nobrow, everything becomes the same in the end. Times Square and SoHo become the same. *The New Yorker* and *Vanity Fair* become the same. The Buzz abhors distinction.

For me, independence was only possible within the system—inside the corporate building. The old idea of independence was based on romantic ideas about culture that we learned in college and that the old *New Yorker* seemed to em-

body, but that had little bearing on Nobrow, in which five or six global media companies controlled everything—some the culture, some the marketing, and some both—and in which I was just one of millions of content providers. The starving artist, the visionary who can't make money from his art, had lost his resonance as a cultural archetype. In Nobrow, he had been replaced by the charismatic grifter—the nineteen-year-old who makes a movie on his parents' credit card. He won't starve if his movie flops; he'll roll his debt over onto a new credit card that offers a six-month, 6 percent grace period and try again.

As we stood there in Times Square shivering under the skyscraper in which the last of William Shawn's notions about editorial independence would be entombed, I felt I had reached Nobrow, ground zero, the exact midpoint at which culture and marketing converged.

Afterword

Marketing the Culture of Marketing the Marketing of Culture

Hi again. I'm out here in Minneapolis, marketing *Nobrow*. Between appointments today my escort took me to the Mall of America. It's the biggest mall in the world. They have a whole village built out of LEGO. I did a phoner with a reporter from the *Milwaukee Journal Sentinel* while walking around inside a gigantic Modell's Sports store. They had gear for sports I had never even heard of, and I follow sports.

On our way out we swung by Barnes and Noble, to see if they were stocking *Nobrow*. It took us a while to find it. One of the things I've learned since publishing the book is that while the content categories of "culture" and "marketing" are definitely converging, the marketing categories based on those distinctions remain. So in Barnes and Noble they shelve *Nobrow* in the "Cultural Studies" section, among the highbrows, while Borders sticks it in "Marketing and Advertising." After some searching, we finally found four copies, which I signed and left there with the manager. Seeing *Nobrow* in the Mall of America, a commodity of which I was now the chief salesman, I feel the project that was begun in the Virgin Mega-

tore on that cold January morning three years ago has reached a kind of logical conclusion.

Now I'm back in my room at the Marriott Courtyard. Earlier I had a couple of drinks downstairs in the bar while watching *Who Wants to Be a Millionaire* with the bartender and Jim, a salesman from Denver. Have you heard about the author of the book that was ranked below 100,000 on Amazon when he went on *Millionaire*, mentioned his book, and saw it shoot up to #3? That, in turn, got him an appearance on the *Today Show* — the kind of publicity a touring author can only dream about. My publisher should take the resources devoted to sending me around the country and concentrate them on trying to get me on Regis's show instead. And it would be so Nobrow.

Tonight's first contestant is an engineer from Tennessee. The $1000 question is an early tester, as is sometimes the case on the show. What TV family lived at 13 Mockingbird Lane: the Addams, the Munsters, the Partridges or the Haskells? I'm pretty sure it's C, the Partridges, and say so out loud in a kind of bar voice, the voice I would use if we were watching football, toned down slightly. I look over at Jim, feeling a burst of kinship for my fellow traveling salesman, but Jim is having none of my bonhomie. The engineer isn't sure, and spends a Lifeline, choosing to ask the audience. "OH come on," I say. The audience votes overwhemingly for B, the Munsters. The audience is right, of course. After that I keep quiet. Maybe I won't try to go on the show after all.

I dined at Sparkles, downstairs, and now I'm back here in my room, sitting on the bed. I have the Weather Channel on, in order to see the conditions in Los Angeles, where I'm headed tomorrow night. The OCMs (On Camera Meterologists) give their predictions in a confident but not too assertive manner, and then the computer-generated maps, seen a moment after the prediction, confirm what they're saying, in a re-

assuring way. I need to strive to achieve a more OCMish tone in my public appearances. Calm, confident, punchy.

Some authors don't like going out on the road to sell their books, but I don't mind it. What I like least are the brief TV appearances, though supposedly they sell the most books. TV is fake in a way radio isn't. It looks like a cosy study where you're having this lovely intimate chat, but in fact we are sitting in the middle of a dark, cold, cavernous warehouse with black walls and concrete floors and guys with huge pot bellies, who smell like ashtrays, miking you up. The people you deal with on TV aren't fake, but your relationships with them can be. They are based on flattery, which is often used to disguise the true agenda of the producer or reporter. Modern Media relations make me imagine what the Court must have been like in the days of Louis XVI: an elaborate politesse of self interest and deceit.

I like radio though. On radio you get time. Having fifteen minutes with the host to lay out the concept, then hearing from callers, is an opportunity I welcome. And here in the land of Jesse Ventura there are lots of Nobrow topics to discuss. The *Stars Wars* exhibit is at the Minneapolis Institute of Art, and museum officials are delighted by the attendance records. At WCAL, a classical music station, the host who interviews me says that the situation that the *New Yorker* faced under Tina Brown is exactly what his station faces now, with a loyal old guard that is hostile to change, crying loss of standards at any attempt to reach younger listeners with more pop cultural fare. Joel Scully, who is the host of a Charlie Rose style book show on Bloomington Public TV, which I taped this afternoon, said it seems as if bad taste – pro wrestling, pornography, Donald Trump – have become acceptable to the highbrows, because of the Buzz such topics generate. I say it

also works the other way around. In Chicago, every book store in the city was completely sold out of Seamus Heaney's translation of *Beowulf*. The highbrow is also becoming acceptable to the mainstream. At both ends, it seems, the importance of taste in the old elitist sense has been devalued.

Book tours remind me of the old scholastic tradition of the "viva voce," or examination by "living voice," which I had to go through at Oxford. It's not enough to write your thesis, you have to defend it orally, and if you can't defend it before live questioning, then all the writing you've done can't save you. Every now and then a degree candidate fails before his inquisitors, as the sophistry of his literary logic is exposed. The book tour is the commercial equivilant of that ordeal. The difference is that the author on tour is likely to be "viva-ed" not by unbiased judges, but by jilted sources, slighted characters in the narrative, or some other aggrieved parties who will emerge like Banquo's Ghost while you are on tour, to confront you.

The viva voce for *Nobrow* seems to have occurred in an Irish bar, Rocky Sullivan's, on 28th Street in Manhattan, where C J Sullivan, a local Irish American writer, (no known relation) had asked me to give a reading. I was reading from the first chapter of the book, where the high low scheme is neatly laid out with reference to the *New Yorker*. I had read the same bit at a cool downtown boîte called Halo, where it seemed to go over pretty well with the hipsters, but here at Rocky Sullivan's, among the guys just off their contracting crews stepping in for a bit of a beer and a laugh, it was all wrong. I sounded like an upper class twit. What had I been thinking?

About ten minutes into my reading, after I had navigated the shoals of high and low in the megastore, and arrived for my interview with Bob Gottlieb, I began to notice a large, scary looking guy at the bar who was throwing himself around, as though physically revolted by me. Now he seemed to be say-

ing something. Was he? Yes, he was heckling me. He began to bellow, "Say something real! Come on! Give us some poetry. Talk about something real!" He was very red in the face, from drink or from rage or both; his eyebrows were thick and black, and his forehead was creased in a way that made him seem to have no brow at all. "Say something real!" he kept shouting, until I was forced to stop reading. Faced with the propect of directly engaging him, I withdrew, riffing instead off a word in the text, (*joouuurnalism*, the way Gottlieb says "journalism") while C.J. escorted the man from the bar. I remained outwardly unpanicked, and even managed to remark, as the man left the bar, "I seem to be losing my audience," which got a nervous laugh from the crowd. Only when I was out of the bar althogether did allow the full horror of the situation to settle over me. I am haunted by the notion that I failed my viva. In the face of a drunk guy in an Irish bar, who probably had more to worry about than the convergence of marketing and culture, *Nobrow* seemed pretty highbrow.

Well, time for bed. I've got a big day tomorrow, promoting *Nobrow* in LA. You can catch me on *Air Talk*, Larry Mantle's show on KPCC, morning drive time, and tomorrow afternoon I'll be taping a TV interview with Warren Olney, and then Gil Friesen, former president of A&M Records, is throwing a *Nobrow* party at the Chateau Marmont, to which some celebrites have been invited.

Before turning in I check my Amazon ranking. I want to see if I got a "bounce" out of my swing through Chicago. Log on, bring up Netscape, choose the *Nobrow* page from Bookmarks, and wait with a pleasantly heightened sense of anticipation for the site to load. No better example of Nobrow than the obsessive way authors both high and low check these rankings, not only their own but each other's, and determine hierarchy

accordingly. Waiting for my number to load, I feel the marketplace is about to speak. A kind of judgement is about to be rendered, a certain number of consumers added to this commodity. What do we know about these people? We know they also bought Malcolm Gladwell's "The Tipping Point" and David Brooks' "Bobos in Paradise." This is good for me, because I'm linked to two books that sell better than mine, but it stings to be put lower on the hierarchy than those guys, especially since I know them. According to the page, Seabrook buyers also bought opera, and the DVD of the movie "Celebration. " And there's a link to an auction of smoked salmon. Sounds like kind of a highbrow crowd.

What is the allure of the Amazon ranking? It's the allure of the audience. A new entity, the audience, has entered the calculus of what is "good." Every culture product has an audience. Eminem has his audience, John Seabrook has his. The audience is compassionate, generally wants what's best for you. The audience is a trusty lifeline on *Millionaire*. But having an audience becomes an end in itself, not a means to an end. All kinds of behaviour is validated by the audience, which would not be supported by the family or the community. It's the logic of *Millionaire* – the audience is always right. Except that the audience is not always right. The audience is beholden not to traditional aesthetic/moral judgements of good or bad, but to the buzz-based considerations of what generates more audience.

This is the text or subtext of what we talk about when the interviewer asks about the recent scandal over *Who Wants to Marry a Multimillionaire*, on which Darva Conger, an emergency room nurse, married a reputed multi millionare on live television. How far can this new set of values, which is organized around the audience, go in replacing the old values, which were based on family, religion, and community

standards? Now there are websites that match people willing to do outrageous and humiliating acts with people willing to pay to watch them. Would you cover yourself in molasses and birdseed and let pigeons eat off your body for $300, as did a contestant at *www.darefordollars.com*? A Wall Street man stripped to his underwear and shoes for $700; a woman danced in public wearing a thong and her bra for $150, and a man ate dog shit for $400. Is this an outrage in taste, or is it something more, a fundamental misconception of what reality is – a mass delusion shared by an ever greater number of people everywhere?

Here comes my number . . . *Nobrow* is . . . 220. I was 250 this morning. Not bad, but so far the market isn't buying *Nobrow* in the quantities we dared hope. This seems like an error in the market's taste. How could people prefer 219 other books to *Nobrow*? But then how can I live in Nobrow, this market culture, and not accept its logic? I guess this is the koan at the end of the narrative.

But tomorrow is LA and LA is a Nobrow kind of a town – my kinda town.